LEONARDO DA VINCI

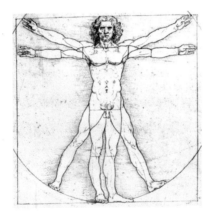

Publisher and Creative Director: Nick Wells
Commissioning Editor: Polly Prior
Senior Project Editor: Josie Mitchell
Art Director: Mike Spender
Production: Chris Herbert
Copyeditor: Ramona Lamport
Proofreader: Amanda Crook
Indexer: Helen Snaith

FLAME TREE PUBLISHING
6 Melbray Mews
Fulham, London, SW6 3NS
United Kingdom

www.flametreepublishing.com

First published 2019

19 21 23 22 20

1 3 5 7 9 10 8 6 4 2

LEONARDO DA VINCI

Author: Susie Hodge Foreword: Michael Kerrigan

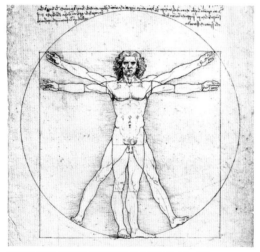

Leonardo da Vinci, *Proportions of the Human Figure (after Vitruvius)*, c. 1490

FLAME TREE
PUBLISHING

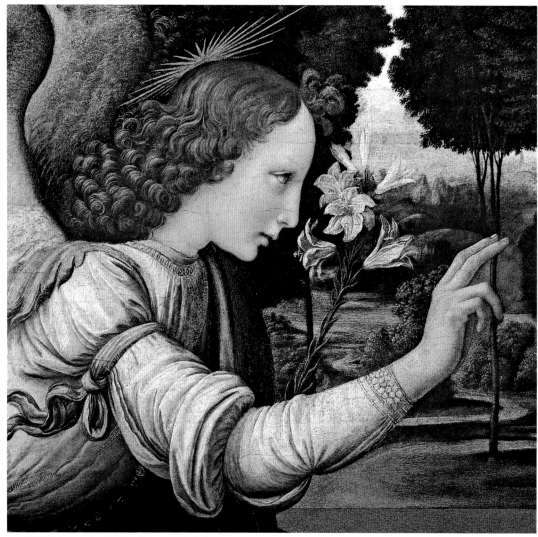

Leonardo da Vinci, Announcing Angel (detail from *The Annunciation*), *c.* 1472

Contents

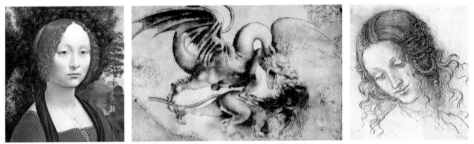

Leonardo da Vinci, *Ginevra de' Benci*, c. 1474–78; *Dragon Killing a Lion*, c. 1478–1517; *The Head of Leda*, c. 1505–10

Leonardo da Vinci, *The Adoration of the Magi*, 1481–82; *Salvator Mundi*, c. 1500; *Study of Marsh Marigold (Caltha palustris) and Wood Anemone (Anemone nemorosa)*, c. 1506–08

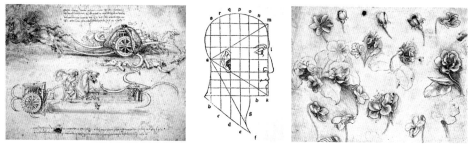

Leonardo da Vinci, *Scythed Chariot*, c. 1483–85; *Human Head from* De divina proportione, 1509;
An Ear of Greater Quaking Grass (Brisa maxima), *Violets* (Viola spec) *and perhaps Pear Blossom* (Pyrus communis), c. 1481–83

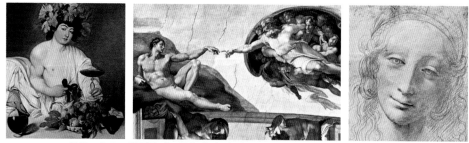

The Young Bacchus, c. 1598; Sistine Chapel Ceiling: *The Creation of Adam*, 1511–12; *Head of a Woman*, c. 1495–97

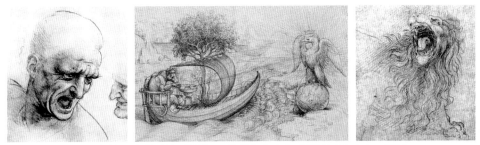

Leonardo da Vinci, *Study of the Heads of Two Soldiers*, 1504; *Allegory with a Wolf and an Eagle*, c. 1516; *Sketch of a Roaring Lion*, c. 1515–17

How To Use This Book

The reader is encouraged to use this book in a variety of ways, each of which caters for a range of interests, knowledge and uses.

- The book is organized into five sections: **Life**, **Society**, **Inventions & Observations**, **Influences** and **Styles & Techniques**.
- **Life** provides a snapshot of how Leonardo da Vinci's work developed during the course of his career, and discusses how different people and events in his life affected his work.
- **Society** explores how Leonardo's paintings, murals and drawings were impacted and inspired by the events of the Italian Renaissance and the fifteenth and early sixteenth centuries.
- **Inventions & Observations** looks at the works that made Leonardo da Vinci a true polymath, including his inventions, geometry, cartography and anatomical drawings.
- **Influences** reveals Leonardo's sources of inspiration and the artists who were, in turn, inspired by him.
- **Styles & Techniques** delves into the different techniques Leonardo used to produce his wide variety of works, from painting and sculpture to drawing and cartography.

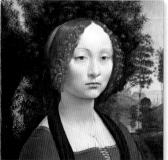

1. Title of work (Note all works are by Leonardo da Vinci, unless another artist's name is given at the foot of the page)

3. Picture credit

4. Place in which the work is held, or displayed

5. Place in which the work was created (if known)

6. Medium in which the work was created (if known)

7. Period to which the work belongs (if known)

2. Date of work (if known)

8. Information about the work and the context within which it was created

// 30

Ginevra de' Benci, c. 1474–78

© National Gallery of Art, Washington DC, USA/Bridgeman Images

Taught by tutors at home, Leonardo learned the basics of reading, writing and arithmetic, and he showed a precocious intelligence from the start, with particular talents in music, the sciences, natural history, mathematics and art, and he could sing and play the lyre. The biographer Giorgio Vasari writes that he was strong, kind, good-looking and loved animals. As many vocations were closed to illegitimate children, Leonardo was precluded from following the family tradition and becoming a notary. Instead, he was encouraged to pursue a creative career. Although his grandmother's family were also landowners and notaries, some were potters, with a successful business in Carmignano, just east of Vinci. As a child, Leonardo visited the pottery, and later his father inherited the family kiln. Piero was living and working in Florence as a notary, and he took a portfolio of Leonardo's drawings to his close friend, the goldsmith, sculptor, painter and draughtsman Andrea di Michele Cione, known as Andrea del Verrocchio, who ran a highly respected workshop there.

Executed when he was in his mid-twenties and still a student, this portrait is Leonardo's first secular painting. It was probably commissioned at about the time of the sitter's marriage when she was sixteen. The pose, naturalism, smoky veils of shadow and the open background set Leonardo apart from other young artists of his time and shows how innovative he was.

LOCATION

National Gallery of Art, Washington DC, USA

CREATED

Painted in Florence

MEDIUM

Oil and tempera on poplar panel

PERIOD

Early period

Foreword

Leonardo da Vinci is for us the very definition of the great artist; perhaps the greatest there has ever been. Words like 'masterpiece' come immediately and unhesitatingly to mind when we characterize his works. The age-transcending significance of the *Mona Lisa* ('older than the rocks among which she sits,' according to the Victorian critic Walter Pater); his *Last Supper* the last word in religious painting; the *Virgin and Child with Saint Anne*; the *Salvator Mundi* … As if his artistic attainments were not enough, he was, we know, the ultimate 'Renaissance Man', with achievements too in engineering, architecture, maths and science.

Leonardo himself took a very different view. He does not appear to have seen himself as an achiever at all. This was not a matter of modesty: rather, it was the mark of a restless spirit who was always moving on to the next thing – even as he fussed and fretted over what he had done before. As Susie Hodge points out in her Introduction, Leonardo 'rarely finished a work of art'. Even when he did, he struggled to accept that he had: to the vexation of many of his patrons, he held on to paintings pending reworking and refinement that never came, or were not concluded.

He was of course congenitally unsettled, Hodge reminds us in Chapter 1, set at a disadvantage both by birth and background, forced to play catch-up with the learning and the culture of his time. That time was itself, we see in Chapter 2, one of boundless intellectual and artistic curiosity – and of the confusion and change which inevitably went along with that. From our historical standpoint, we see the Renaissance (literally 'Rebirth') of European culture as a moment of immense achievement – and rightly so. We do well to remember, though, that being born is a messy, often painful business; by its very nature not a conclusion but a start.

Process was all. He was enthralled by the task itself, the technical challenge of actually producing a sculpture or painting. He was always open to fresh influences; constantly trying out new materials and techniques; forever seeking to 'fail better' in Samuel Beckett's terms. To an extraordinary extent, his was to be an oeuvre of works-in-progress: preliminary studies; sketches; the 'cartoon' drafts for frescoes. The same is true of his scientific interests – sometimes necessarily, because he was so far ahead of his time and the state of knowledge was so scanty. The famous helicopter; the tank; the parachute … these could never be much more than ideas: the technology did not exist to bring them into being.

But it does seem to have been at least in part a question of temperament too. 'Philosophy, anatomy, physiognomy, mathematics, geography, geology, geometry, warfare, botany, music and literature ...' these are just a few of the interests Hodge lists for Leonardo. He kept notes on all his studies – though he filed them chaotically, without apparent order. It would have been an exacting (and awesomely self-confident) instructor who picked Leonardo da Vinci up for lacking focus or failing to complete his tasks, but they would not have been entirely wrong.

Not that they could have faulted his application. His notes and journals run to more than 13,000 pages; his work-ethic was self-evidently stupendous. And it took him far beyond bookishness. As Susie Hodge shows us in Chapter 3, he studied science directly from nature, for the most part, testing his conclusions by practical experimentation. This was still a comparatively novel approach to intellectual enquiry, though it was to be central to the new thinking of the Renaissance.

A genius he may have been, but he built his brilliance on the most basic of observational foundations. He certainly was not afraid of getting his hands dirty. In his efforts to discover more precisely how the human body worked, he dissected in the region of 30 corpses. He was, records his first biographer, Paolo Giovio (1483–1552), 'undismayed by the brutal and repulsive nature of this study and only eager to learn'.

Again, in our natural admiration of the ultimate 'Renaissance Man', we are perhaps too quick to fasten on the astonishing scale and breadth of Leonardo's achievement. Not that this was not fully as extraordinary as has been claimed, of course. As impressive, though – and apparently much more important to the man himself – was the frenetic energy with which he kept on striving, studying, practising, improving.

It was in the sixteenth century that the famous French philosopher Michel de Montaigne (1533–92) began writing in a new form he called the *essai* or 'attempt' (the effort's 'failure' or 'success', it seems, was by the way).

'What do I care?' he, warned that he was unlikely to return from a long journey he was planning in his old age. 'I neither undertake it to return, nor to finish it: my business is only to keep myself in motion.' So it was with Leonardo, and it is surely this indefatigable endeavour that makes him such an inspiration, five centuries on.

Michael Kerrigan, *2018*

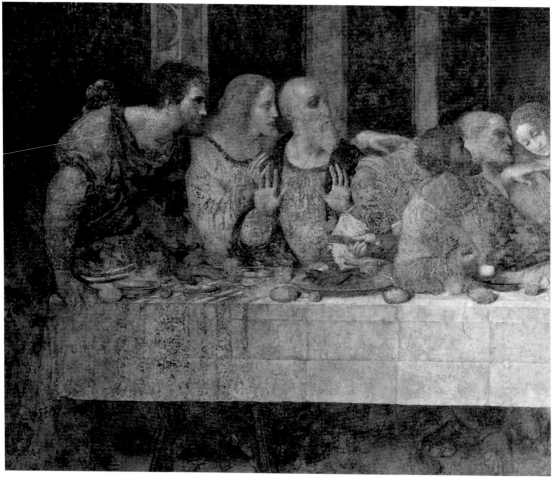

Introduction

'Learning is the only thing the mind never exhausts, never fears, and never regrets,' wrote the artist, inventor, engineer, scientist, architect and writer, Leonardo di ser Piero da Vinci (1452–1519), a polymath whose voracious appetite for knowledge, breadth of thought and depth of vision resulted in him being commonly recognized as the supreme 'Renaissance Man', a legend and one of the greatest artists in history.

The extent of Leonardo's abilities – and his art in particular – continues to fascinate and inspire millions, and his reputation is quite incomparable. From humble beginnings, he grew up to become one of the most famous people in history, a household name and the creator of some of the most celebrated drawings and paintings in the world. Centuries after his death, the self-taught intellectual continues to inspire and fascinate, and remains recognized for his exceptional draughtsmanship, boundless curiosity and incredible inventions, many of which were designed hundreds of years before they could be produced. While much of his work has not been found, what is known comprises extensive notes, sketchbooks and artworks which demonstrate that Leonardo had one of the most prolific and focused minds ever recorded. From his investigations into such things as the flow of blood and the function of arteries in the body to his detailed studies of light, and from his ambitious architectural and engineering designs to his complex maps, wide appreciation of music and literature, fascination with mathematics and astronomy, and his unique, delicate painting technique, his enquiry about the world never wavered. In the twentieth century, the art historian, museum director and writer Kenneth Clark (1903–83) described him as 'the most relentlessly curious man in history'. Yet, although he excelled in so many areas, and despite his fame, Leonardo remains an enigmatic character, with few verified or finished works of art and somewhat scant early biographical details.

Even during his own lifetime, Leonardo was revered for his genius. His zealous desire for knowledge about so many subjects led him to make profuse notes that he tied together in loosely-bound notebooks, but he neither dated nor organized these, and he wrote them all in back-to-front or mirror handwriting. These notes explore a vast range of subjects, including philosophy, anatomy, physiognomy, mathematics, geography, geology, geometry, warfare, botany, music and literature, and his ideas were so progressive that at the time he was working many of his designs and inventions, such as a parachute, an armoured tank, the use of solar power and a calculator, could not be made

because technology was not as advanced as he was. Many of Leonardo's ideas could only function centuries later when it became possible to make the necessary components.

While other Renaissance artists, such as Michelangelo Buonarroti (1475–1564), Raphael (1483–1520), Sandro Botticelli (c. 1445–1510), Albrecht Dürer (1471–1528), Donatello (c. 1386–1466) and Titian (c. 1488–1576) had a huge impact on the period and beyond, it is Leonardo who is usually perceived as embodying the Renaissance with his humanist ideals, his wide range of interests and accomplishments, his breadth of enquiry, and his fusion of science and art. His view of the world was holistic; he saw it as one entity in which everything worked together in harmony, flowing and moving like cogs in a machine, and he had an insatiable desire to understand how we co-exist and evolve with the universe. Some of his broad-ranging ideas and inventions are fantastic, while others are practical. They include a crane for emptying ditches, a mixer tap, folding furniture, an aqualung, automatically opening and closing doors, a giant siege crossbow, 'defensive curtains' that would deflect any known weapon, an automatic engraver, a mechanism for repelling enemy ladders during an attack on a fortress and a more efficient way to pour burning oil on to enemy heads below. Leonardo devised an ambitious plan to save Venice from the Turkish army by building a collapsible dam and then removing it to drown the attackers, and he also designed devices for making sequins and spaghetti, for sharpening knives, slicing eggs and pressing garlic. He was the first to realize that counting tree rings reveals the age of the tree, and three centuries before the British physicist Lord Rayleigh (1842–1919) discovered molecular scattering, Leonardo could explain why the sky was blue. Yet, in spite of all this, Leonardo had almost no impact on the progress of science – most of his notes were illegible and were not studied until the nineteenth century, by which time many of his ideas had been arrived at independently. Instead, for centuries, his fame relied on approximately 30 paintings that are known – and not all are finished.

Every year, millions of people jostle in the Musée du Louvre in Paris to get a glimpse of Leonardo's small portrait, *Mona Lisa* (1503–06), the most enigmatic and famous painting in the world. The *Mona Lisa* has been the subject of songs, films and a robbery. Thousands of words have been written analysing it, and yet it remains as elusive as ever, with theories abounding about Leonardo's methods, the sitter's identity and its ability to fascinate.

Leonardo's astonishing creative abilities were recognized early on, even before his apprenticeship as a young teenager in the workshop of the sculptor and goldsmith Andrea del Verrocchio (c. 1435–88) in Florence, and he was soon helping Verrocchio with his commissions. His earliest known independent painting, *The Annunciation* (c. 1472),

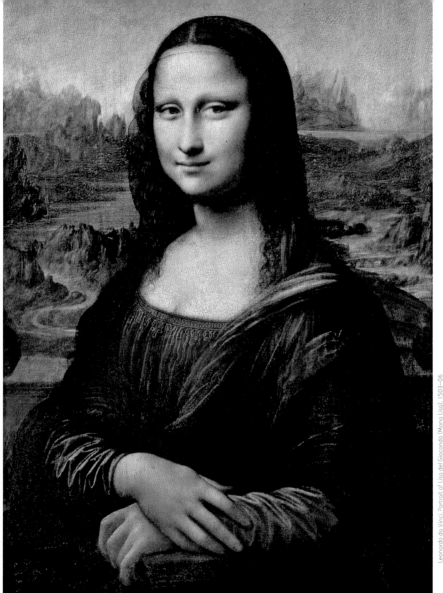

Leonardo da Vinci: *Portrait of Lisa del Giocondo (Mona Lisa)*, 1503–06

was probably produced while he was still in Verrocchio's workshop, and demonstrates how original he was even then, when he broke with his master's style. While Verrocchio used lead-based paint and heavy brushstrokes, Leonardo's brushstrokes were light and he avoided lead-based pigments. Over his lifetime, he was commissioned by some of the most influential patrons, including Cesare Borgia (1475–1507), Isabella d'Este (1474–1539), Lorenzo de' Medici (the Magnificent) (1449–92), Giuliano de' Medici (1453–78) and Francis I of France (1494–1547).

Soon after completing his apprenticeship, Leonardo moved to Milan for employment at the court of Duke Ludovico Sforza (1452–1508) as a musician, engineer and artist. Sforza was a generous patron and Leonardo worked for him and his court on many diverse ideas including war machines, town planning, designing sets for theatrical productions, scenery and props for celebrations such as feasts and weddings, and as a painter and sculptor.

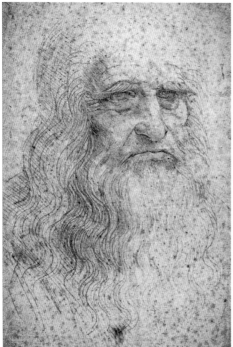

Leonardo da Vinci, Self Portrait, c. 1512

Among the qualities that make Leonardo's art so unique and admired are his detailed knowledge of such subject matter as anatomy, light, botany and geology; his keen interest in capturing how humans show emotion through expression and gesture; his innovative techniques in paint application and his subtle gradations of tone. His understanding of anatomy far exceeded anything that had been studied before, and as well as human anatomy, he studied the anatomy of many other animals, including cows, birds, monkeys and frogs. He dissected and drew cross-sections of the human body, including the brain, lungs, appendix, reproductive organs and a foetus in the womb. He wrote a treatise on anatomy that included more than 200 drawings. These intense and focused explorations informed every painting Leonardo produced. For instance, he drew detailed and meticulous studies of plants in silverpoint for paintings such as *The Virgin of the Rocks* (1483–86), and quick, loose chalk sketches of heads in preparation for *The Last Supper* (1495–98). He drew rapid sketches for equestrian statues and loose drawings of figures for the Holy Family from different viewpoints, all layered on top of each other. Constantly

questioning and experimenting, Leonardo worked with intense energy, departing from many traditional artistic approaches and replacing them with his own innovative ideas. Although, for instance, many have tried to emulate his unique and original sfumato method of painting soft, blurred lines and smoky tones, the technique has never been successfully imitated by anyone else. Yet, because of his wide variation of interests, the intensity of his focus and his perfectionism, Leonardo rarely finished a work of art – or did not accept that he had – so many remained incomplete or were not given to the patrons who had commissioned them.

Leonardo da Vinci, *Leda and the Swan, c. 1500*

According to descriptions that have come down to us, Leonardo was tall, slim, handsome and graceful. He was also kind, patient, eloquent and generous. Left-handed and a vegetarian at a time when this was rare, he was unconventional in many ways, including his flamboyant way of dressing. Most men had short hair, closely-cropped beards and wore long, flowing gowns in sombre hues, while Leonardo wore short, fitted, brightly coloured tunics and grew his curly hair and beard long. In 1550, approximately 30 years after his death, the painter, architect, writer and historian Giorgio Vasari (1511–74) published the first edition of his *Lives of the Most Excellent Painters, Sculptors and Architects*, including in it, a biography of Leonardo. It was not the first biography of the artist, but it was Vasari's publication that has had a huge effect on shaping the image that most people have of Leonardo. For instance, Vasari wrote: '... He was marvellously gifted and he proved himself to be a first-class geometrician in his work as a sculptor and architect. In his youth, Leonardo made in clay several heads of women, with smiling faces of which plaster casts are still being made, as well as some children's heads executed as if by a mature artist. He also did many architectural drawings, both of ground plans and of other elevations, and while still young, he was the first to propose reducing the Arno to a navigable canal between Pisa and Florence.' Vasari's *Lives* has been reprinted many times, and remains commonly perceived as one of the most important sources for our understanding of Renaissance art.

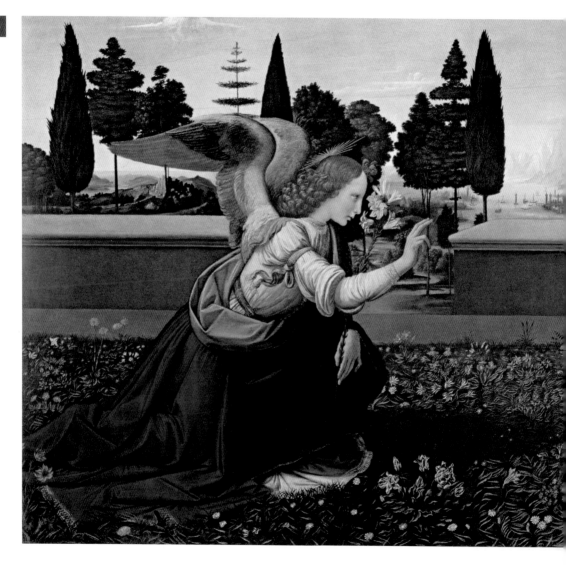

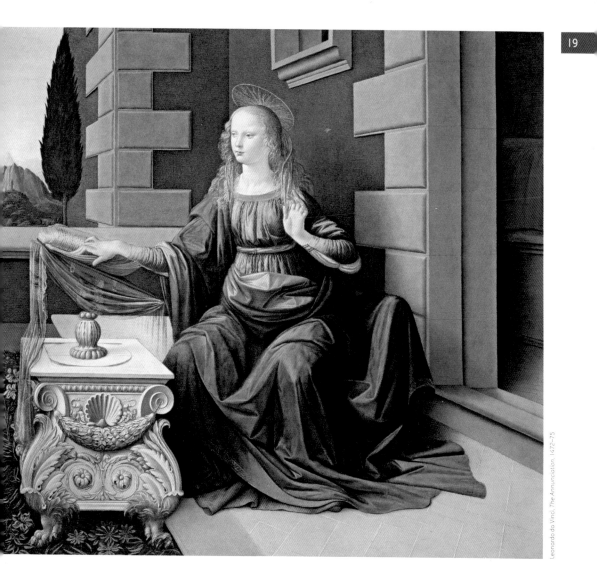

Leonardo da Vinci, *The Annunciation*, 1472–75

Leonardo da Vinci

Life

Study for the Head of a Girl, *c.* 1483

'In the normal course of events, men and women are born with various remarkable qualities and talents; but occasionally, in a way that transcends nature, a single person is marvellously endowed with beauty, grace and talent in such abundance that he leaves other men far behind....' wrote the biographer Giorgio Vasari about Leonardo da Vinci.

Leonardo has become a legend; a man who surpassed all his contemporaries in the fields of art, science and invention – and he continues to inspire and fascinate. Yet although his paternal family was quite prosperous, he was not given the education or opportunities of legitimate children, and spent his life working, researching, examining and striving to understand, achieve – and earn a living. His unparalleled insights and breadth of thought have led him to be perceived by subsequent generations as the ultimate Renaissance Man.

This drawing is a study for an angel that Leonardo made in preparation for his painting, *The Virgin of the Rocks*. It was described by the eminent art historian Bernard Berenson (1865–1959) as 'one of the finest achievements of all draughtsmanship'.

LOCATION

Biblioteca Reale di Torina, Piedmont, Italy

CREATED

Drawn in Milan

MEDIUM

Silverpoint heightened with white on buff prepared paper

PERIOD

Early period

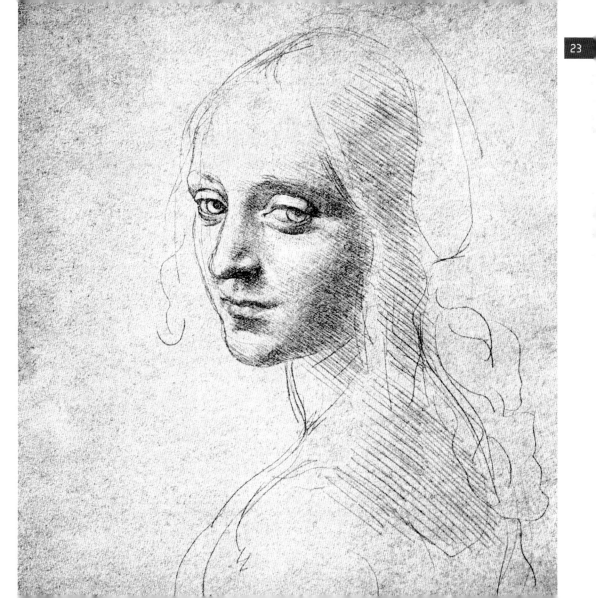

Dragon Killing a Lion, *c.* 1478–1517

'At the third hour of the night' on 15 April 1452, Leonardo di ser Piero da Vinci – meaning 'Leonardo, son of Piero from Vinci' – was born out of wedlock in Tuscany, Italy. This exact time was written down by his paternal grandfather, Antonio da Vinci (1373–*c.* 1465). The 'third hour of the night' was 10.30p.m., but although the date and time was recorded, the location was not. As an illegitimate child, Leonardo da Vinci's birth was not documented in official records. For years it has commonly been believed that he was born in a house now known as the 'Casa Natale', in the village of Anchiano, 2.8 km (1.7 mi) from Vinci, but as this property was not owned by his family until many years later, this remains equivocal. More recent research suggests that Leonardo's probable birthplace was his grandfather Antonio's house in Vinci, 46.5 km (30 mi) west of Florence.

Throughout his life, Leonardo often created imaginary beasts by drawing different parts of various insects and animals, such as lizards, geckos, grasshoppers, locusts and bats. This is a facsimile of one of his drawings.

LOCATION

Galleria degli Uffizi, Florence, Italy

MEDIUM

Collotype

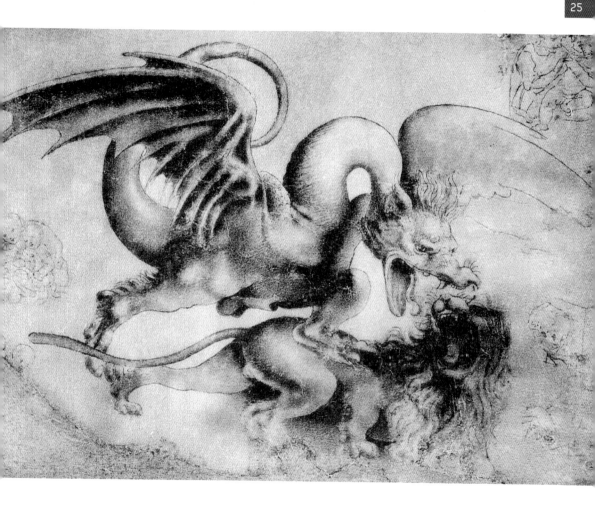

Profile of an Ancient Captain, also known as *Condottiero* (The Warlord), 1475–80

Leonardo's father was Piero Fruosino di Antonio da Vinci (1427–1504), who followed in the family tradition and worked in Florence as a notary. His mother's identity is less verifiable. A great deal of research has been undertaken about her, but nothing is definitive. Her name was Caterina di Meo Lippi and her dates were possibly 1427–95, which means she was twenty-five years old when she gave birth to Leonardo. She may have been a peasant, descended from slaves, a servant, a farm girl, or a tavern-worker. Or none of these. Some believe she was an orphan, others say she was a local farmer or woodcutter's daughter, and she may have been seduced by Piero, or they may have been in love. Whatever the truth, about a year after Leonardo's birth, the da Vincis paid a small dowry to a local man, a lime-burner and manual labourer, Antonio di Piero Buti del Vacca, nicknamed Accattabriga or Accattabrighe, and he and Caterina married.

Leonardo had a strict grounding in drawing with metalpoint from Verrocchio, who was one of the finest draughtsmen of his generation. Probably based on a bas-relief by Verrocchio, this ancient warrior is one of Leonardo's most finished early drawings, made when he was in his early twenties using silverpoint, which required control and discipline. His attention to detail is exceptional, including in the armour with the projecting lion's head on the warrior's breastplate, the helmet, the hair, the facial features and the delicate indications of shadows and tones.

LOCATION

British Museum, London, UK

CREATED

Drawn in Florence

MEDIUM

Silverpoint on cream prepared paper

PERIOD

Early period

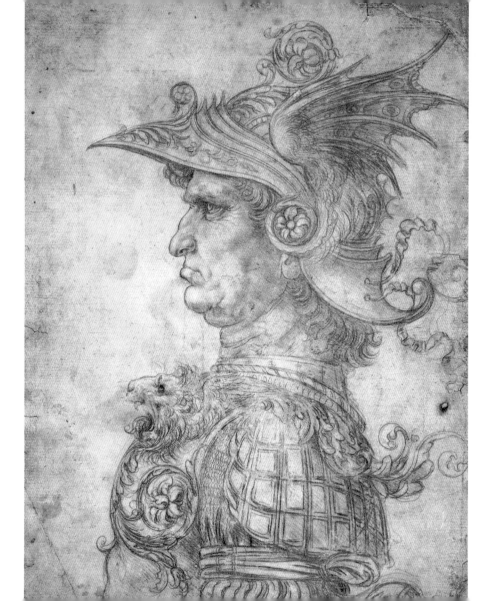

Head of a Man, 1470–1519

On 16 April 1452, Leonardo was baptised, probably at the Chiesa di Santa Croce in Vinci. A priest named Piero di Bartolomeo di Pagneca conducted the service and five prominent citizens were registered as the infant's godparents. In common with illegitimate Italian children at that time, Leonardo was welcomed into his family. Soon after his birth, his father married a sixteen-year-old girl from a wealthy Florentine family, Albiera di Giovanni (1436–64). Initially, Leonardo probably lived with his mother, but by the age of five he was with his grandparents in Vinci.

In the hills of Montalbano, the town of Vinci is surrounded by lush vineyards and olive groves. Also living with Leonardo's grandparents was their younger son Francesco (1436–1506), who owned a mill nearby, and Leonardo became especially close to this uncle, who later bequeathed Leonardo his estate and encouraged him to study and sketch the natural world.

Later in life, Leonardo had many followers. Little is known about the Master of the Pala Sforzesca, but he closely followed Leonardo's drawing style. Unlike Leonardo, however, he drew with his right hand.

LOCATION

Musée du Louvre, Paris, France

MEDIUM

Metalpoint on grey-green paper

ARTIST

Master of the Pala Sforzesca (fl. 1490–1500)

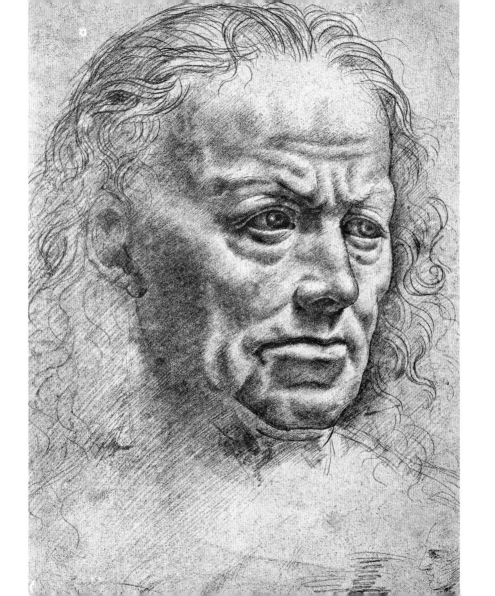

Ginevra de' Benci, c. 1474–78

Taught by tutors at home, Leonardo learned the basics of reading, writing and arithmetic, and he showed a precocious intelligence from the start, with particular talents in music – he could sing and play the lyre – the sciences, natural history, mathematics and art. The biographer Giorgio Vasari writes that he was strong, kind, good-looking and loved animals. As many vocations were closed to illegitimate children, Leonardo was precluded from following the family tradition and becoming a notary. Instead, he was encouraged to pursue a creative career. Although his grandmother's family were also landowners and notaries, some were potters, with a successful business in Carmignano, just east of Vinci. As a child, Leonardo visited the pottery, and later his father inherited the family kiln. Piero was living and working in Florence as a notary, and he took a portfolio of Leonardo's drawings to his close friend, the goldsmith, sculptor, painter and draughtsman, Andrea di Michele Cione, known as Andrea del Verrocchio, who ran a highly respected workshop there.

Executed when he was in his mid-twenties and still a student, this portrait is Leonardo's first secular painting. It was probably commissioned at about the time of the sitter's marriage when she was sixteen. The pose, naturalism, smoky veils of shadow and the open background set Leonardo apart from other young artists of his time and shows how innovative he was.

LOCATION

National Gallery of Art, Washington DC, USA

CREATED

Painted in Florence

MEDIUM

Oil and tempera on poplar panel

PERIOD

Early period

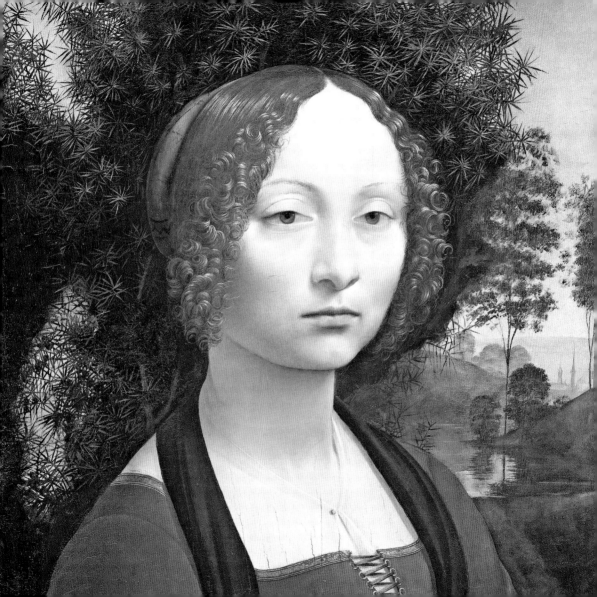

St Jerome, *c.* 1480–82

Vasari wrote that Ser Piero asked Verrocchio 'to tell him whether Leonardo, by devoting himself to drawing, would make any proficience'. Vasari continues that Verrocchio was amazed at the boy's skills and urged Ser Piero to send Leonardo to him. Consequently, Leonardo entered Verrocchio's Florentine workshop sometime between 1466 and 1469. As was customary, he lived there with the other apprentices.

Verrocchio's nickname derives from the Italian '*vero occhio*', meaning 'true eye'. He had studied under the great Florentine sculptor Donatello and was an accomplished goldsmith, woodcarver, painter, musician and sculptor. He was also an outstanding teacher, and Leonardo received an excellent grounding in technical skills, drawing, painting, sculpture, architecture and lute playing. At first, he learned to prepare coloured pigments and canvases, and then moved on to perspective and figure drawing. Next, he was taught to paint in oils and make studies of Verrocchio's and other artists' works. Vasari (whose book *Lives of the Most Excellent Painters, Sculptors and Architects* was first published in 1550), wrote about Leonardo's 'marvellous progress'.

Years after his training, Leonardo started, but never completed, this painting of St Jerome. It was a popular subject at the time, and Leonardo shows the emaciated saint striking himself with a stone. A lion reclines near to him. The unfinished painting shows his understanding of anatomy and perspective; elements of art that he learned while he was an apprentice.

LOCATION

Pinacoteca Vaticana, Rome, Italy

CREATED

Painted in Florence

MEDIUM

Tempera and oil on walnut panel

PERIOD

Early period

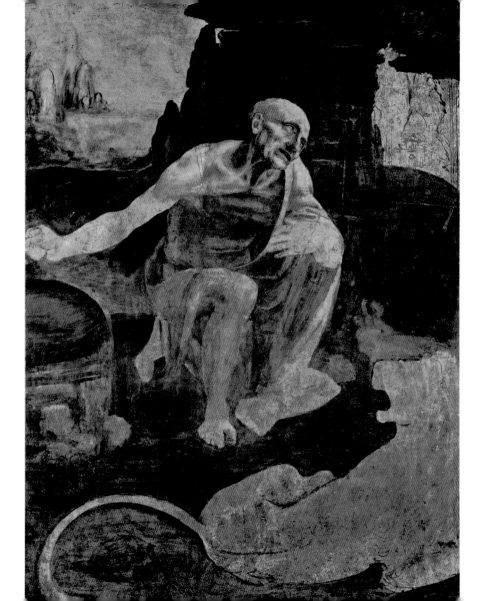

Study of a Head of a Child in Profile, *c.* 1490

In *c.* 1466–70, Verrocchio was commissioned by the Medici family to create a bronze sculpture of the biblical hero David, and many believe that Leonardo was the model for the resulting statue. By 1472, at the age of 20, he had completed his training, and was accepted into the Compagnia di San Luca (the Company of St Luke), a confraternity of painters that had been founded in the mid-fourteenth century. The Company's account book in the summer of 1472 records that 'Lyonardo di Ser Piero da Vinci dipintore' (Leonardo di Ser Piero da Vinci painter) was charged 32 soldi to join. However, although he was now a practising painter, Leonardo continued to work for Verrocchio; it was usual for artists to remain with their master for at least a few years after their training.

Giovanni Antonio Boltraffio (1466–1516) was one of Leonardo's pupils. This drawing, that closely follows Leonardo's style, was made while he was in Leonardo's studio in Milan. It was probably a preparatory work for a painting Boltraffio made of *The Virgin and Child* (1490s, Szépmüvészeti Múzeum, Budapest). The sensitivity of his handling of metalpoint and creation of soft tones show a direct emulation of his master's work.

LOCATION

Musée du Louvre, Paris, France

MEDIUM

Metalpoint with traces of pen and ink heightened with white with some traces of black chalk on prepared paper

ARTIST

Giovanni Antonio Boltraffio (1466–1516)

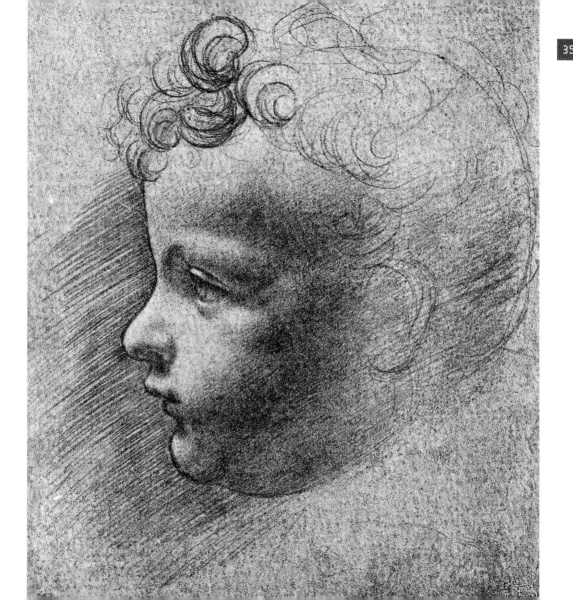

Feminine Head, 1470–1519

Precisely what Leonardo and Verrocchio collaborated on is not clear. Verrocchio's painting, *The Baptism of Christ* (*c.* 1470–72 and 1475–78), features elements that seem to have been painted by Leonardo. According to Vasari, Verrocchio was so impressed by Leonardo's contribution that he swore never to paint again. Although Vasari may have exaggerated, at around that time Verrocchio did abandon painting, but it was probably because he had decided that Leonardo was now skilled enough to take over that side of things, leaving Verrocchio to focus on sculpture, which he preferred. As Leonardo did not sign his work, it is difficult to attribute most of his early paintings. This drawing or painting is a later copy, likely from the sixteenth century, of Leonardo's early style.

When Leonardo was twelve, his father's wife, Albiera, died in childbirth. Ser Piero's second wife also died young, and Leonardo had no siblings on his father's side until 1476, when Ser Piero's third wife gave birth to a boy, who was legitimate, and so became his father's heir.

LOCATION

Galleria degli Uffizi, Florence, Italy

MEDIUM

Pen and ink on canvas

ARTIST

Artist unknown

The Madonna of the Carnation, c. 1472–78

In around October 1478 Leonardo set up his own workshop in Florence, and immediately began creating two paintings that he referred to as 'the two Madonnas'. One of these was *The Madonna of the Carnation*. With pale skin and curly blonde hair, wearing fashionable fifteenth-century clothing, the image follows other contemporary Italian representations of the Virgin. Soft textures and tones, and folded and draped fabrics are emphasized, skills at which Leonardo excelled. The brooch is an element that he used in later works, and overall the painting shows how he began to distance his style from that of Verrocchio. The other 'Madonna' is commonly named the *Benois Madonna*, which also shows his increasingly sophisticated techniques. By 1480, Leonardo was commissioned to paint an altarpiece for the chapel of the Florentine town hall, the Palazzo Vecchio, but he never produced it. Similarly, a painting of St Jerome (*see* page 98) was started but not finished, and in 1481 he began a large painting, *The Adoration of the Magi* (*see* page 32) for the monastery of San Donato a Scopeto (Leonardo's father was the monastery's notary).

LOCATION

Alte Pinakothek, Munich, Germany

CREATED

Painted in Florence

MEDIUM

Tempera and oil on poplar panel

PERIOD

Early period

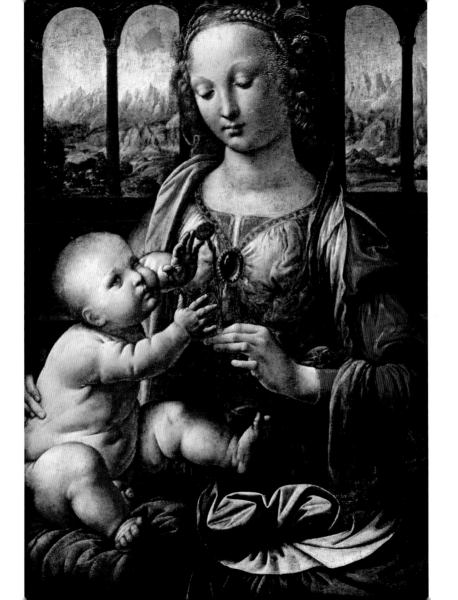

Study of a Horse and Rider, *c.* 1481

While not all Leonardo's drawings have survived or been found, several are known that are believed to have been studies for his commissioned altarpiece, *The Adoration of the Magi* (*see* page 98). This dynamic sketch of a horse and rider demonstrates his attempt at capturing reality, his understanding of horses, of anatomy and physiognomy, and his artistic advances in the depiction of natural movement. Leonardo placed the horse and rider in the unfinished painting between two trees behind the Holy Family. It is not known when, but he abandoned *The Adoration of the Magi* without completing it, but before he stopped working on it, he had planned its geometric structure and sketched out the main elements in brown or black wash with white heightening. After he received the last payment for it in 1481, Leonardo made plans to leave Florence. He was last documented there in September 1481 and seems to have arrived in Milan in February 1482, apparently bearing a *lira da braccio* (a precursor to the violin) that he had made in silver in the shape of a horse's skull.

LOCATION

Private Collection

CREATED

Painted in Florence

MEDIUM

Metalpoint on pale pink prepared paper

PERIOD

Early period

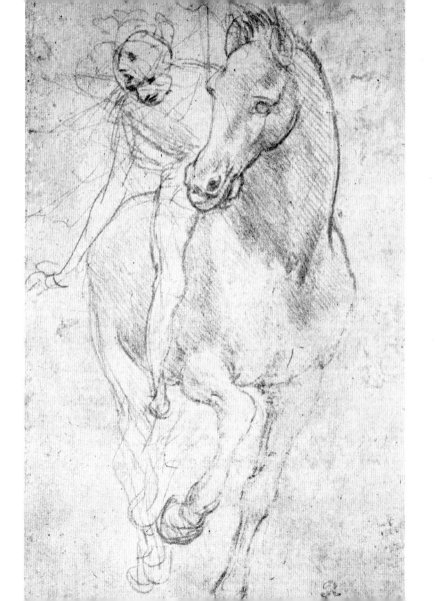

Animal Studies: Cow Skull, *c.* 1500

Why Leonardo moved to Milan in 1482 is not clear. Some believe that Lorenzo de' Medici sent Leonardo to secure peace with Duke Ludovico Sforza, some suggest that others introduced him, and some think that the duke invited him to create a huge equestrian statue. According to Vasari, when Leonardo arrived in Milan, he played his horse's skull *lira da braccio* for 'Il Moro' (Ludovico's nickname, meaning 'The Moor', after his dark colouring) who was entranced by it. So it is possible that Leonardo first entered the duke's employment as a musician. He then wrote to Sforza, describing the things he could do, including building portable bridges, ships and armoured vehicles, catapults and other war machines, and that he knew the techniques of constructing bombardments and of making cannons: '... methods of destroying any citadel or fortress ... secret underground tunnels ... covered vehicles, safe and unassailable ... bombards, mortars (and) other unusual machines of marvellous efficiency....' Finally, he commended his own abilities as a painter and sculptor. The letter worked. Leonardo was employed by the duke, bestowed with the title 'Painter and Engineer', and he remained in Milan for 17 years.

Filippino Lippi (1457–1504) made these drawings in a similar manner to Leonardo, but unlike Leonardo's scientific drawings, Lippi drew this purely for creative purposes. The studies are made directly from a real goat's skull and were preparatory drawings for the heads of two goats in his frescoes in the Strozzi Chapel in the Basilica of the Santa Maria Novella in Florence.

LOCATION

Galleria degli Uffizi, Florence, Italy

MEDIUM

Metalpoint and white gouache on pink prepared paper

ARTIST

Filippino Lippi (1457–1504)

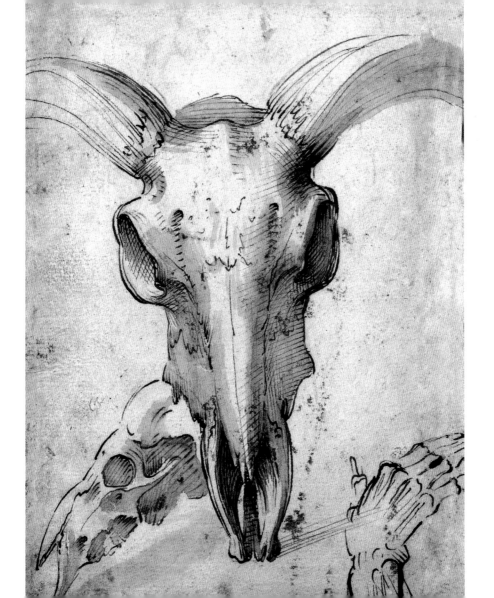

Head of a Woman, *c.* 1465–1519

Accompanying Leonardo from Florence was Tommaso Masini (1462–1520), also known as Zoroastro da Peretola, Leonardo's friend, collaborator and assistant, as well as a magician and engineer, and a fellow vegetarian. At the time they arrived, Milan was a lively place. Artists, architects, musicians and masons were working there from all over Italy and beyond, including the artist-architect-engineer Donato Bramante (1444–1514) from Urbino, who designed several churches for Sforza. Although an eight-year age gap existed between the two men, they became good friends, and Leonardo nicknamed Bramante 'Donnino'. Leonardo also befriended and often collaborated with the de Predis family of artist brothers, including Ambrogio (*c.* 1455–*c.* 1508), Cristoforo (1440–86) and Evangelista (*c.* 1440–1510). In 1483, Leonardo, Ambrogio and Evangelista received a commission to paint an altarpiece for the Confraternity of the Immaculate Conception in their chapel at San Francesco Grande in Milan. The de Predis brothers were to assist Leonardo in painting and gilding: Leonardo was to paint the central panel, Ambrogio the two side panels, and Evangelista would paint and gild the carvings on the frame. They agreed to complete the work within seven months.

This bust of a young woman in three-quarter profile, turning slightly to the left, wearing a cap with curling hair touching her shoulders, was possibly drawn by one of Leonardo's pupils.

LOCATION

Galleria degli Uffizi, Florence, Italy

MEDIUM

Silverpoint and chalk on paper

ARTIST

Follower of Leonardo da Vinci

Head of a Woman
with a Pearl Necklace

In 1484–85, Milan suffered an epidemic of the bubonic plague. Some reports estimate that during the period nearly a third of the Milanese population died, although this has not been substantiated. On 16 March 1485, there was a total eclipse of the sun, which was seen by most as being an ill omen. Leonardo wrote that he viewed it through a large piece of perforated paper, but does not seem to have been duly affected by the fear and concern that would have accompanied the epidemic. Once the swellings, or 'buboes' appeared, most were dead within a few hours. Leonardo's cleanliness may have helped him, and he took refuge in solitude, working on his commissioned altarpiece that became the mysterious and original painting, *The Virgin of the Rocks*; a dark painting of the Virgin Mary with the baby Jesus, St John the Baptist and an angel in a dark, flower-strewn cave. Once the plague had subsided, a new interest in town planning and sanitation developed, and Leonardo made copious notes and drawings on the subject, featuring piazzas, loggias, wide streets and tall chimneys.

The unknown artist who drew this head has been called the Master of the Pala Sforzesca, after an altarpiece created in 1494/5 that includes portraits of Ladovico 'il Moro' Sforza, the Duke of Milan, and his family as donors. The artist blends an earlier style of painting and drawing with the more modern approach of Leonardo.

LOCATION

Biblioteca Ambrosiana, Milan, Italy

MEDIUM

Pen and ink on paper

ARTIST

Master of the Pala Sforzesca (fl. 1490–1500)

The Virgin of the Rocks (detail), 1483–86

'Likewise in painting, I can do everything possible,' Leonardo had added in his letter to Il Moro. At the time, although Milan was larger than Florence, Ludovico aimed to raise its cultural status to rival that of Florence and other Italian Renaissance cities such as Urbino and Mantua. Soon Leonardo was not only designing war craft, military equipment and fortifications – plus architectural plans, sets and stage mechanisms for pageants and other court celebrations – but was also painting portraits and creating sculpture. Sforza probably paid Leonardo a salary and he was also paid separately for commissions, as he established his own workshop and took on pupils, including Giovanni Antonio Boltraffio and Marco d'Oggiono (c. 1470–c. 1524). However, although he had agreed to complete *The Virgin of the Rocks* by December 1483, it was not finished until three years later, and it became the object of disagreements and a lawsuit between him and the Confraternity of the Immaculate Conception. Mysterious and spiritual, the painting is unlike anything that had been created before. Sometime around 1493, Leonardo began a second version of the painting that he completed in 1508, and which now hangs in the National Gallery, London.

LOCATION

Musée du Louvre, Paris, France

CREATED

Painted in Milan

MEDIUM

Oil on wood, transferred to canvas

PERIOD

Early period

Lady with an Ermine, 1489—90

Described by a contemporary as 'A man of outstanding beauty and infinite grace,' Leonardo was a flamboyant dresser, excellent musician and popular at court. In the summer of 1490, he employed a ten-year-old boy, Gian Giacomo Caprotti (*c.* 1480–1524) from a poor farming family. Although curly-haired Gian looked angelic, Leonardo noted in his diary '*ladro* (thief), *bugiardo* (liar), *ostinato* (obstinate), *ghiotto* (glutton)' and wrote how he found the boy stealing money from his purse. He named him Salaì, meaning 'the Devil', 'Demon', or 'Little Unclean One', yet Salaì remained with Leonardo as his servant, pupil and companion throughout his life.

Leonardo's workshop became known for the refined and elegant work it produced. In about 1489, he was commissioned to paint this portrait that probably depicts Sforza's mistress, Cecilia Gallerani (1473–1536). In Greek, ermine is *galē*, and the animal also symbolized purity. Only sixteen, Gallerani was nonetheless renowned for her beauty, scholarship and poetry. The poet and courtier Bernardo Bellincioni (1452–92) wrote: 'Whom do you envy, O Nature? Only Vinci, who has painted a portrait of one of your stars.'

LOCATION

National Museum, Kraków, Poland

CREATED

Painted in Milan

MEDIUM

Oil on walnut panel

PERIOD

Middle period

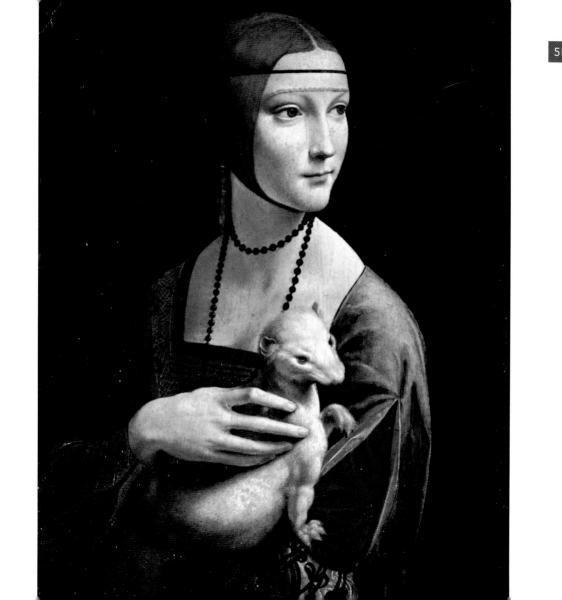

Study of a Woman's Hands, *c.* 1490

This drawing was probably a study for Leonardo's portrait of Ginevra de' Benci (*see* page 30), but the painted arms and hands were later cut off the bottom of the panel. His attention to detail spread beyond drawing and painting. As well as designing theatricals for court festivals, Leonardo was consulted as a technical adviser about military matters, engineering and architecture. At around this time, he began making extensive notes of his ideas and investigations. He drew weapons of all kinds, fortifications, complex defence systems and siege equipment. He designed floats and pageants, a dome for Milan Cathedral and a clay model for a huge equestrian statue to glorify Francesco Sforza (1401–66) – Ludovico's father – that became known as the *Gran Cavallo*. Seventy tons of bronze were set aside for casting the statue that would be more than 7 m (23 ft) high, the largest bronze ever to be cast. Leonardo made extensive preparations for casting the statue and finished the clay model in 1495, but in the end the bronze was used to make cannons to defend Milan from French invasion.

LOCATION

Royal Collection Trust, London, UK

CREATED

Painted in Milan

MEDIUM

Metalpoint with white heightening over charcoal on pale buff prepared paper

PERIOD

Middle period

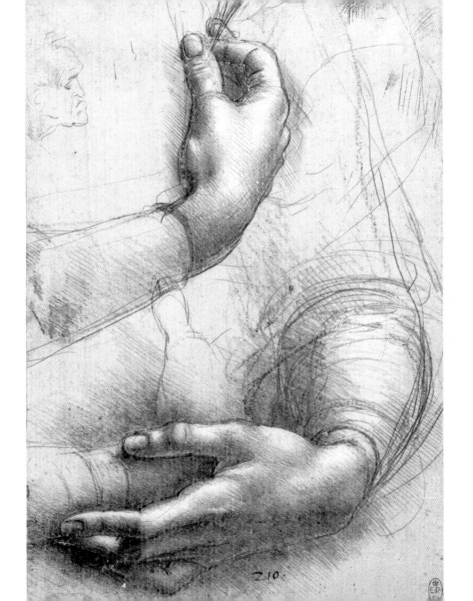

Portrait of an Unknown Woman (*La Belle Ferronière*), c. 1490–95

In 1488, Gian Galeazzo II Maria Sforza (1469–94), Il Moro's nephew (and the rightful duke), married his cousin, Isabella of Aragon, the Princess of Naples (1470–1524). Leonardo's *Festa del Paradiso* for the occasion included children dressed up as angels on mythological planets that revolved around Jupiter. It was a huge success, and three years later he was commissioned again to organize the festivities for a double wedding: of Il Moro to Beatrice d'Este (1475–97), and Beatrice's brother Alfonso d'Este (1476–1534) to Gian Galeazzo's sister, Anna Sforza (1476–97). Beatrice had been promised to the duke since she was five years old. Within a few months, she discovered that he had two mistresses: Cecilia Gallerani (*see* page 50) and Lucrezia Crivelli (1452–1508). This portrait, also called *La Belle Ferronière*, after the Lombard-style headband the woman wears, is probably of Lucrezia. In one of his notebooks, Leonardo wrote in Latin: 'She whom you see, whose name is Lucrezia, To whom the gods have given all with a generous hand, Was given rare beauty, Leonardo first among painters, Painted her; Moro, first among princes, loved her.'

LOCATION

Musée du Louvre, Paris, France

CREATED

Painted in Milan

MEDIUM

Oil on walnut panel

PERIOD

Middle period

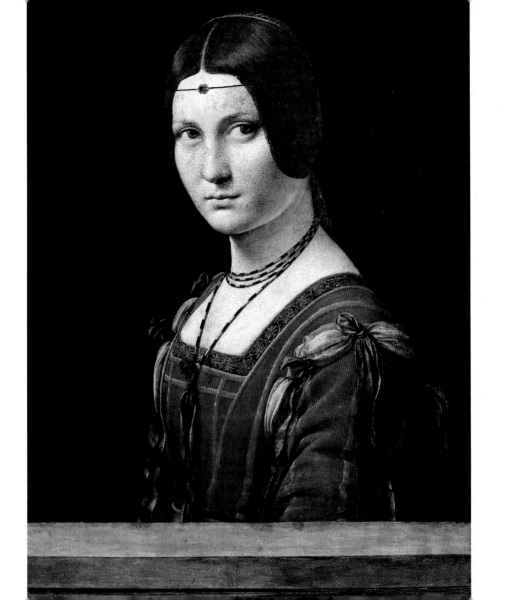

The Court of Ludovico il Moro, 1823

This painting was created in the early nineteenth century by the Italian artist Giuseppe Diotti (1779–1846), imagining the moment when Leonardo was commissioned to paint *The Last Supper*. While Leonardo was planning the *Gran Cavallo* in 1495 (*see* page 52), Sforza asked him to paint a wall in the refectory of the Convent of Santa Maria delle Grazie in Milan. Through Sforza's patronage, the Santa Maria delle Grazie was undergoing restoration and expansion, and the New Testament story of *The Last Supper* was traditionally painted by artists in convent and monastery refectories. Leonardo's large painting filled an entire wall of the Dominican monks' refectory. At almost 9 m (29 ft) wide, it is his largest painting. Using one-point perspective, he created an optical illusion so that the monks in the refectory felt as if they were also present at the Supper; Leonardo depicted the doors of their cells at the sides of the painting. With unparalleled expressive intensity (for the time), he portrays the dramatic moment at the Passover meal when Jesus announces that one of the apostles would betray him.

LOCATION

Museo Civico, Lodi, Italy

MEDIUM

Oil on canvas

ARTIST

Giuseppe Diotti (1779–1846)

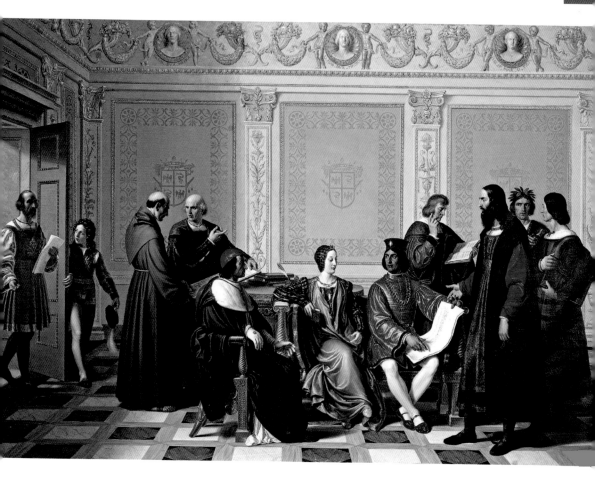

The Last Supper (detail), 1495–98

The dialect in Lombardy was different from that of Florence, and by the late 1490s Leonardo was being called 'the Florentine Apelles' in Milan, a reference to his home city and the ancient Greek painter Apelles (370–306 BC). He painted *The Last Supper* to appear as an extension of the Santa Maria delle Grazie's refectory, and added the Sforza family coats of arms in the three lunettes above the 'room' where the meal is taking place. The painting was ground-breaking. The lively scene conveys Jesus pointing to the bread and wine, about to conduct the first Eucharist, while most of the apostles are busily discussing which one of them is a traitor. They are arranged at the table in four groups of three, and these three men at the far left of the table are Bartholomew, James the Less and Andrew. Bartholomew is in profile, looking across at Jesus. James the Less is between Bartholomew and Andrew. Judas is wearing green and blue and is in shadow. Andrew turns his head towards Jesus, his arms raised as if in surprise.

LOCATION

Refectory of the Monastery of Santa Maria delle Grazie, Milan, Italy

CREATED

Painted in Milan

MEDIUM

Fresco

PERIOD

Middle period

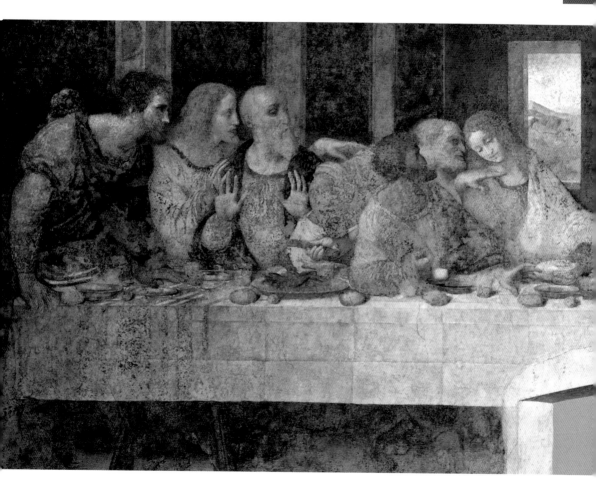

Two Studies of Children's Heads, c. 1490–95

As he had not learned the art of fresco with Verrocchio, Leonardo painted *The Last Supper* (*see* page 320) using his own mixture of oils and pigment. Admirers flocked to see the painting, some describing it as 'miraculous', and it became especially coveted by the French king in particular.

From Leonardo's notes, it seems that his mother Caterina stayed with him as his dependant from July 1493 until her death in 1495, when he paid for her funeral. During that decade, Il Moro commissioned him to paint a large, vaulted room, the *Sala delle Asse* in Sforza Castle. Leonardo painted a complex design of mulberry tree branches intertwining up the walls and across the ceiling, and around the coats of arms of Sforza and of his wife Beatrice. Mulberry trees were grown in Milan for the production of silk, and so were an important economic resource. The Italian term for 'dark mulberry' is '*gelso moro*', a reference to Il Moro, and mulberry trees symbolize prudence, which Leonardo implied referred to Sforza's rule.

By this time, Leonardo was attracting many followers who tried to emulate his style, and this delicate drawing of a child's head from two viewpoints can be seen to have evolved directly from his techniques.

LOCATION
Musée des Beaux-Arts, Caen, France

MEDIUM
Pen and ink and wash heightened with white on prepared paper, mounted on wood

ARTIST
Follower of Leonardo da Vinci

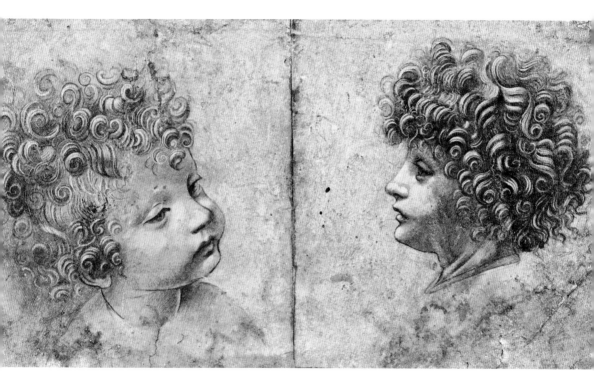

Anatomical drawing of the heart and blood vessels, *c.* 1513 and Study of the Arteries and Veins of the Head, Neck, Chest and Arm, *c.* 1506

With his broad range of interests, Leonardo befriended several learned figures at the Milanese court, including Bramante and the Franciscan monk and mathematician Luca Pacioli (*c.* 1445–*c.* 1517). Bramante and Leonardo discussed many subjects, including architecture, painting, sculpture and philosophy, and Bramante dedicated a book of poetry to Leonardo, calling him a '*cordial caro ameno socio*' (cordial, dear, delightful associate). Pacioli praised *The Last Supper* in his treatise *De divina proportione* (published in 1509), for which Leonardo contributed the illustrations, including the frontispiece: *The Proportions of the Human Figure*, now known as *Vitruvian Man* (*see* page 182). Pacioli described Leonardo as 'the excellent painter, architect and musician, a man gifted with all the virtues', and taught him mathematics as well as advising him on his treatise on painting and movement (now lost). Pacioli also helped Leonardo with calculations for his *Gran Cavallo* (*see* page 52), recording that the statue was 8 m (26 ft) tall, and would have weighed 91 t (200,000 lbs) had it been cast.

As Leonardo had little or no access to human material at this time, his dissection on the left-hand side here is of an ox's heart, thorax and diaphragm. On the right-hand side is a study of the arteries and veins of the neck and shoulder of a man seen in profile.

LOCATION

Royal Collection Trust, Windsor Castle, UK

CREATED

Drawn in Rome

MEDIUM

Pen and brown ink on paper / Pen and two shades of brown ink over traces of black chalk on paper

PERIOD

Late and Middle periods

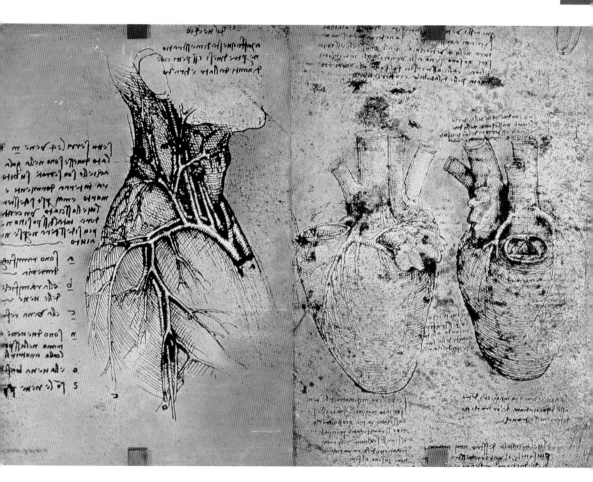

The Virgin and Child with St Anne, and the Infant St John the Baptist, *c.* 1499–1500

Leonardo constantly sought new commissions, commending his abilities to potential patrons. He wrote: 'I know very well that because I am unlettered, some presumptuous people will think they have the right to criticize me, saying that I am an uncultured man. What stupid fools!' In 1487 he sought a prestigious architectural project, designing a *tiburio*, or domed crossing tower, for Milan Cathedral. Although he was paid for a large wooden model of his design, ultimately two Milanese architects were commissioned. In 1496, Leonardo sought to design two bronze doors for Piacenza cathedral, writing to the patrons: '... the city of the Florentines (has) grand works in bronze.... I can assure you from this region (Lombardy) you will only get cheap and coarse masters.... Here there is no man of merit, believe me, except Leonardo da Vinci.' He was not given the commission.

In this large cartoon, the Virgin Mary sits on her mother's lap, and Jesus blesses his cousin St John the Baptist. St Anne points to heaven, indicating God's presence. In 1501, Leonardo drew a similar cartoon in the Santissima Annunziata in Florence in front of an appreciative crowd.

LOCATION

National Gallery, London, UK

CREATED

Drawn in Milan

MEDIUM

Charcoal heightened with white chalk on paper, mounted on canvas

PERIOD

Middle period

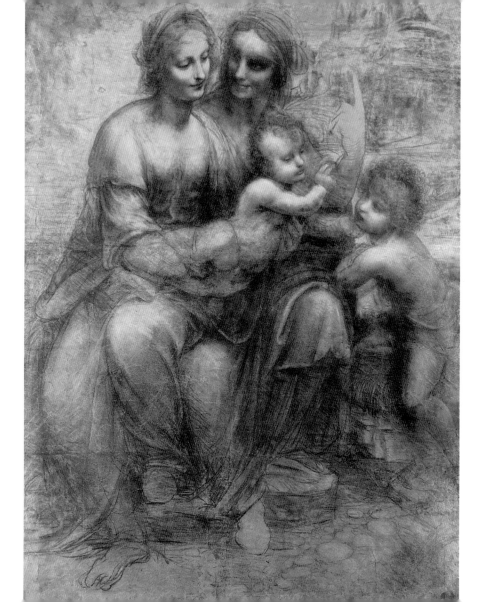

La Gioconda Nude, *c.* 1515

In 1499, Ludovico Sforza fled from Milan to escape the invading army of Louis XII (r. 1498–1515), the new King of France. As French troops entered Milan, Leonardo left with Pacioli and his assistants and servants, and travelled back to Florence, via Mantua and Venice. He stayed in Mantua as a guest of Isabella d'Este, who was related to nearly every ruler in Italy either by birth or marriage. For instance, she was the sister of Beatrice Sforza, daughter of the Duke of Ferrara and wife of Francesco Gonzaga, Marquess of Mantua (1466–1519). Well-educated, intelligent, a humanitarian and patron of the arts, Isabella longed for Leonardo to paint her portrait, and in 1498 she had borrowed his portrait of Cecilia Gallerani – her sister's husband's mistress. It is not known how long Leonardo stayed in Mantua, but while he was there, Isabella sat for him (*see* page 304). Several copies of the drawing he made exist and debate continues about which, if any, is the original. He possibly painted her portrait from his drawing, but it is now lost.

This is a charcoal study, probably of a lost drawing by Leonardo.

LOCATION

Musée Condé, Chantilly, France

MEDIUM

Gouache and charcoal on paper

ARTIST

Follower of Leonardo da Vinci

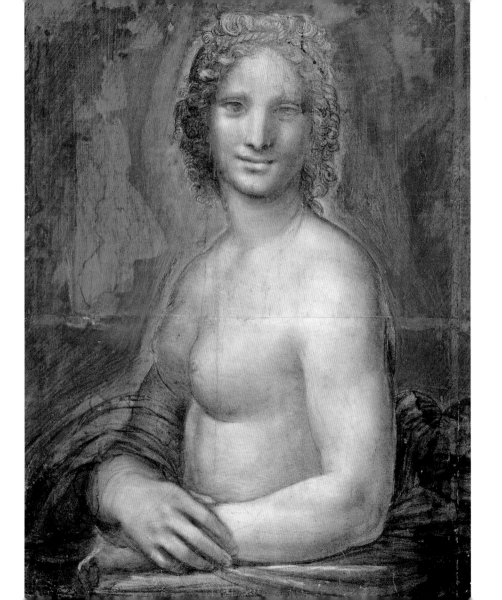

Head of a Young Woman, *c.* 1508

Soon after leaving Mantua, Leonardo went to Venice where he met Giorgione (1478–1510), who became especially inspired by his painting style. By April 1500, Leonardo had returned to Florence. Great changes had occurred since he had last lived there; the Medici were in exile, the rule of the fanatical Dominican friar Girolamo Savonarola (1452–98) was over, and several artists he had known had died. On the reputation of *The Last Supper*, Leonardo was now respected as a great master. The Servite friars of the church of Santissima Annunziata gave him lodgings and commissioned him to paint an altarpiece. Leonardo began preparing the work that was to be *The Virgin and Child with St Anne* (*c.* 1503–19). Vasari relates how he drew the cartoon in front of admiring crowds. For two days, people flocked to see it, but Leonardo never completed the painting. A contemporary wrote that he was 'weary of the paintbrush' and was instead working 'fervently at geometry'. Early in 1501, he took a brief trip to Rome.

This painting of a young woman is often called *La Scapigliata* (meaning The Dishevelled) after the tousled hair that was probably added later. Leonardo drew it with a brush and pigment, creating a strong contrast between the refined and detailed face, and the sketchy hair and shoulder. In monochrome, Leonardo created his characteristic demure downward glance, with soft highlights on the cheeks, nose, eyelids, chin and forehead.

LOCATION

Galleria Nazionale di Parma, Parma, Italy

CREATED

Painted in Florence

MEDIUM

Oil on wood panel

PERIOD

Late period

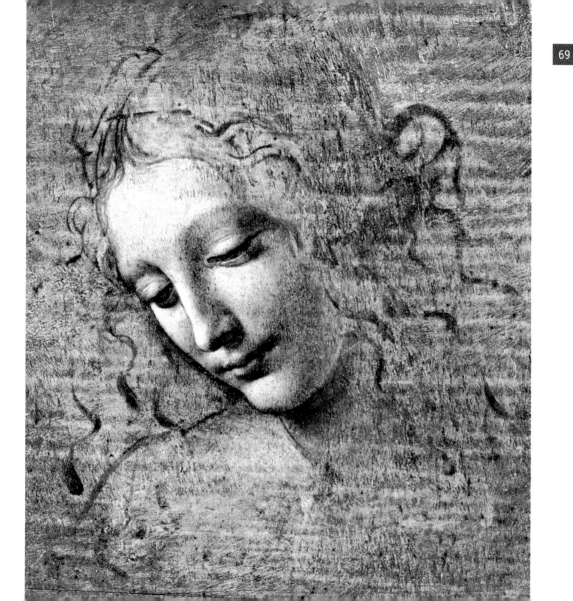

View of the Organs of the Chest and Abdomen and of the Vascular System of a Woman, *c.* 1508

© Granger/Bridgeman Images

In the summer of 1502, Leonardo was employed by Cesare Borgia, the Duke of Valentinois, *condottiero*, politician, cardinal, illegitimate son of the pope, and one of the most powerful and violent men in Europe. For ten months, Leonardo worked for Borgia under the title 'Senior Military Architect and General Engineer', and travelled with him and his entourage through central Italy, advising on defence systems, designing military equipment, inspecting fortifications and making topographical drawings. As Borgia's military campaigns needed precise knowledge of the terrains he was invading, Leonardo created some of the first maps. His detailed plan of the city of Imola, as well as maps of Tuscany, Umbria and the Chiana Valley that all included place and river names, for instance, show his precision and technical achievement, and he made plans for a canal to run from Florence to the sea by damming Lake Chiana. Also travelling with them for a time was the diplomat, philosopher, humanist and writer, Niccolò Machiavelli (1469–1527), whom Leonardo befriended.

This anatomical drawing demonstrates Leonardo's understanding of the internal organs of the body, gained through his dissection of cadavers.

LOCATION

Royal Collection Trust, Windsor Castle, UK

CREATED

Drawn in Milan

MEDIUM

Pen, brown ink and wash, with traces of black and red chalk and yellow wash on ochre-washed paper, pricked for transfer

PERIOD

Middle period

The Head of Leda, *c.* 1505–10

After Florence became a republic in 1494, a large assembly hall – the Salone dei Cinquecento (Hall of the Five Hundred) – was constructed in the Palazzo Vecchio for the new government, who decided to commission two large murals depicting recent successful Florentine battles: at Anghiari and Cascina. By March 1503, Leonardo was back in Florence, a celebrated artist and engineer. Among other commissions, he began painting *The Virgin and Child with St Anne* and started preparing *The Battle of Anghiari* for the Hall of the Five Hundred. In 1505, Michelangelo, who was acclaimed for his *Pietà* in Rome and *David* in Florence, was asked to paint *The Battle of Cascina*. Leonardo made many preliminary studies and started painting, using a special wooden scaffolding that he had created, but he never finished the work. Michelangelo, however, never progressed from the drawing stage, as before he began painting he was summoned to Rome by the pope.

This female head is a study for a lost painting by Leonardo of *Leda and the Swan*. He made several studies and painted two versions of the subject, but neither survive.

LOCATION

Royal Collection Trust, Windsor Castle, UK

CREATED

Drawn in Milan

MEDIUM

Pen and ink over black chalk on paper

PERIOD

Middle to Late period

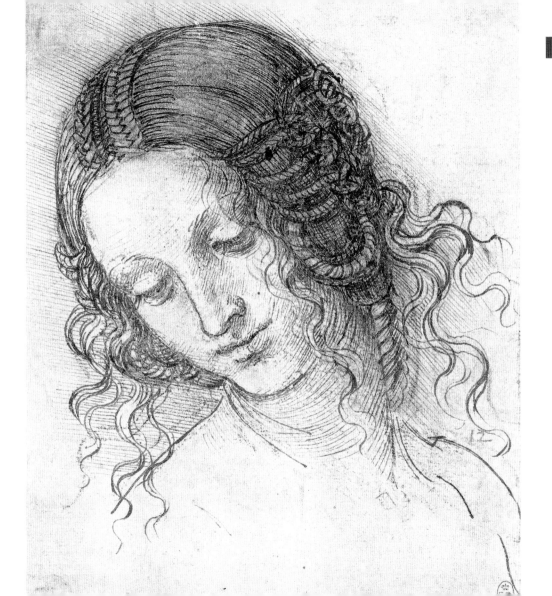

Portrait of Lisa del Giocondo (Mona Lisa), 1503–06

Of this, the most famous painting in the world, Vasari wrote: 'For Francesco del Giocondo, Leonardo undertook to execute the portrait of his wife, Mona Lisa. He worked this painting for four years and then left it still unfinished.' Whether or not Mona Lisa is the real name of the sitter has been fiercely debated. In Italy, until the nineteenth century the painting was known as *La Gioconda*, and in France as *La Joconde*, which either refers to Lisa del Giocondo, or to the word's literal meaning, the Jocund (the Cheerful or the Light-hearted). Vasari continues his account by explaining that Leonardo employed singers and musicians or jesters to entertain his sitter. *Mona Lisa* is one of the first portraits to depict a sitter in front of an imaginary landscape, and Leonardo innovatively created a sense of aerial perspective. It is mysterious in many ways; for the sitter's eyes that appear to watch every viewer, the mouth that seems to flicker, the pale, slender, long-fingered hands, the sense of depth, detailed landscape and the depiction of light and sfumato, from the Italian word *fumare*, meaning smoke.

LOCATION

Musée du Louvre, Paris, France

CREATED

Painted in Florence

MEDIUM

Oil on poplar panel

PERIOD

Middle period

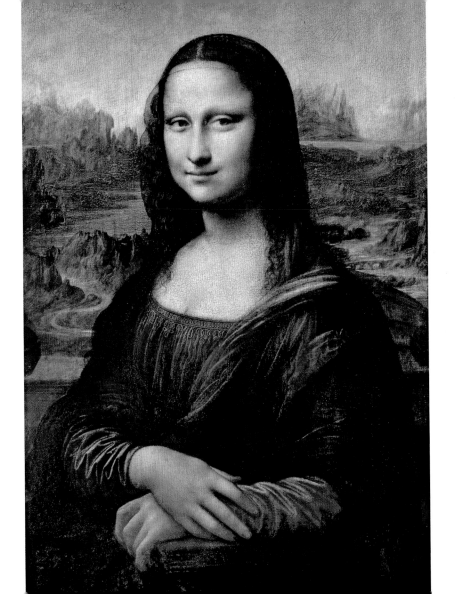

Anatomical Studies of the Muscles of the Neck, Shoulder, Chest and Arm, *c.* 1509/10

By 1506, Milan was ruled by the French governor, Charles d'Amboise (1473–1511), who asked the Florentine government to allow Leonardo to return to Milan, even though he had not finished painting *The Battle of Anghiari*. He was wanted in Milan because of a lawsuit over *The Virgin of the Rocks*. Leonardo was granted three months away, and although he was reluctant to return to Milan, he had little option. When he arrived there, he was given several further commissions, mainly painting and architecture, including the design of a villa for Charles d'Amboise and a new equestrian statue. After three months, Louis XII of France wrote to the Florentine government asking if Leonardo's stay in Milan could be extended. An agreement was reached, and Leonardo divided his time between Florence and Milan until Il Moro's son, Massimiliano Sforza (1493–1530) overthrew the French in 1512.

In 1506, another significant event occurred in Leonardo's life. His beloved uncle Francesco died, bequeathing Leonardo his estate – and a battle between his younger, legitimate siblings ensued.

During that time Leonardo began making extensive anatomical studies of the human body through dissections of cadavers. One of the first artists to do so, this is one of several studies that he made of muscle formation.

LOCATION

Royal Collection Trust, Windsor Castle, UK

CREATED

Drawn in Milan

MEDIUM

Pen, brown ink and wash over traces of black chalk with small red chalk strokes

PERIOD

Late period

St John the Baptist, 1513–16

In September 1513, Leonardo travelled to Rome at the request of Giuliano di Lorenzo de' Medici (1479–1516), the brother of Giovanni di Lorenzo de' Medici (1475–1521) who had just become Pope Leo X. They were both sons of Lorenzo de' Medici whom Leonardo had known in Florence when he was a young artist. In Rome, Leonardo was given rooms in the Belvedere wing of the Vatican, where he remained for three years, with his assistants, including Francesco Melzi (1491–c. 1570) and Salai. Bramante was also in Rome at the time, working on the construction of St Peter's Basilica, although he died in 1514. Two men whom Leonardo was less pleased to see there were Michelangelo and Raphael, who were working for the pope. As Giuliano's engineer, Leonardo received a generous stipend, and travelled and worked in his studio on mathematical studies and technical experiments, or surveyed the ruins of ancient Rome and antique marbles in the Vatican.

St John the Baptist was probably Leonardo's last painting. With his enigmatic smile, St John looks directly at viewers and his pointed gesture alludes to a higher sphere.

LOCATION

Musée du Louvre, Paris, France

CREATED

Painted in Rome

MEDIUM

Oil on panel

PERIOD

Late period

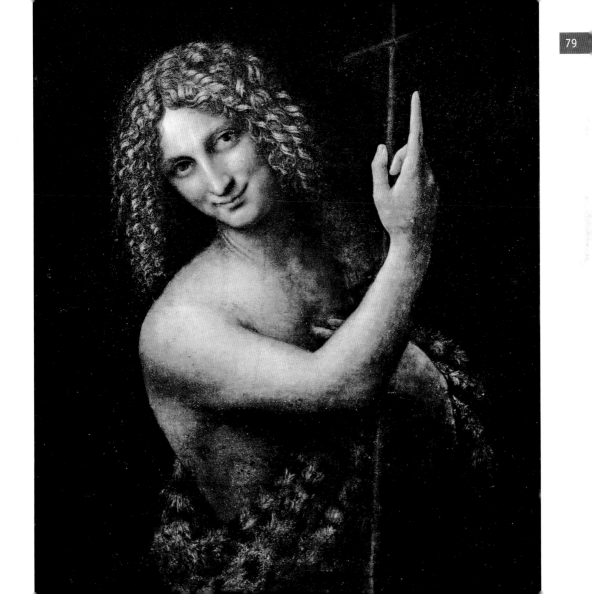

A Woman in a Landscape, c. 1517–18

With Giuliano's death in 1516, Leonardo realized that the admiration now held for Michelangelo, Raphael and Titian meant that he was unlikely to find another great Italian patron, and so he accepted the invitation of King Francis I and moved to France. Welcomed in Amboise on the River Loire, he lived in the small residence of Cloux (later called Clos-Lucé), connected to King Francis I's summer palace by an underground passageway. Bestowed with the title '*Premier peintre, architecte et méchanicien du Roi*' (First painter, architect and engineer to the King), he once again designed court theatricals and was given a generous salary. Francis treated him as an honoured guest and Leonardo painted little while there, but he did produce architectural designs, and with the help of Melzi, who was now his chief assistant and carer, he began organizing his scientific and engineering studies, his treatise on painting and some of his anatomy treatise. He began suffering with paralysis of his right hand and arm, but as he was left-handed he continued to draw and write.

By the time he lived in France, Leonardo did little painting, but he undertook many drawings, and this delicate work may have been a costume design for a pageant. It was fashionable at that time to put on plays and theatricals, and this dainty figure probably represents Matelda from Dante's *Purgatory*. The drawing encompasses Leonardo's belief that a drawing should convey both the surface appearance and the underlying intention; here, the young woman is beckoning Dante to follow her and discover the secrets of Paradise.

LOCATION

Royal Collection Trust, Windsor Castle, UK

CREATED

Drawn in Amboise

MEDIUM

Black chalk on white paper

PERIOD

Late period

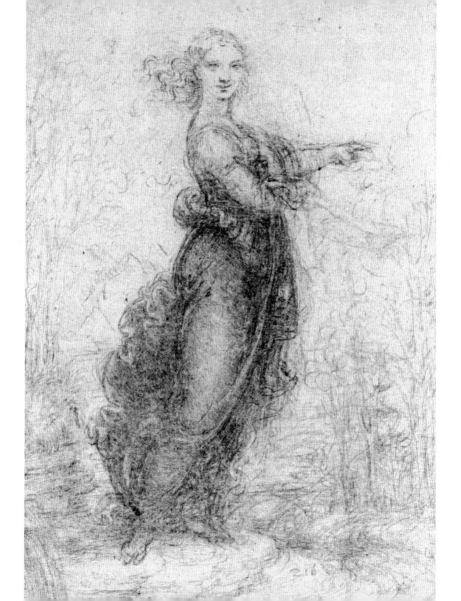

Head of a Bearded Man (so-called Self-portrait), *c.* 1510–15

© Biblioteca Reale di Torino, Italy/Bridgeman Images

Leonardo began to develop plans for a vast new palace and gardens at Romorantin, east of Amboise, but as work began, his health deteriorated. He was 67. On 19 May 1519, according to Vasari, he 'breathed his last in the arms of the king,' and Vasari continues, 'All those who knew him grieved without measure the loss of Leonardo.' Buried in the palace church of Saint-Florentin, Leonardo left alms for the poor, some money for his half-siblings, and Melzi and Salaì inherited the rest. Almost a month after his death, Melzi wrote to Leonardo's half-brothers, saying: 'I believe you have been informed of the death of Master Leonardo ... who was also a brother and the best of fathers to me. As long as I have breath in my body I shall feel the sadness, for all time.'

This is probably a self-portrait of Leonardo, although some suggest it could represent God. In 1512, Michelangelo finished the Sistine Chapel ceiling, featuring his innovative depiction of God as an old man with long hair and beard. Leonardo may have been inspired by it when he was in Rome in 1513.

LOCATION

Biblioteca Reale di Torino, Piedmont, Italy

CREATED

Possibly drawn in Vaprio or Parma

MEDIUM

Red chalk on paper

PERIOD

Late period

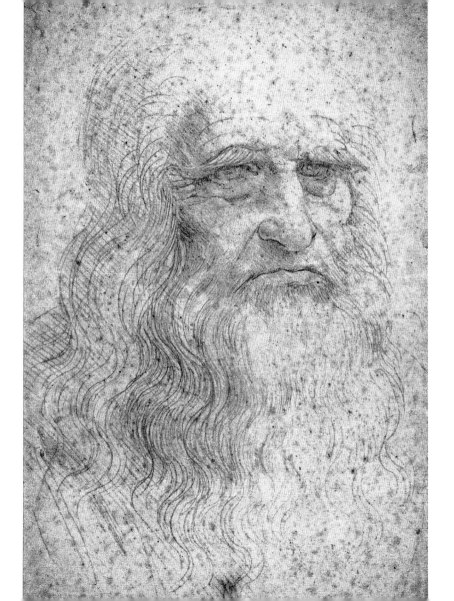

Leonardo da Vinci

Society

The Adolescent Saviour, *c.* 1490–95

For about 200 years, approximately from the late fourteenth to the late sixteenth centuries, a spirit of intellectual adventure and experimentation evolved in Europe. Now known as the Renaissance, it was an intensely creative period, and marked the transition from the medieval era to the modern age. The name 'Renaissance' was given retrospectively to describe the 'rebirth' of ideas that occurred. It was not a sudden period of change, but over time ideas, beliefs and ways of life evolved and changes occurred that built on developments of the medieval period. In Italy, there was a rise in the popularity of humanism; a philosophical approach that values human achievement. The Renaissance arose partly with the breakdown of the medieval feudal system that had dominated Europe, but it was also initiated by events, including trade developments and the subsequent rise of a merchant class. The period included developments of new ideas in science, philosophy, literature and art, and emerged initially primarily in Florence when Leonardo was growing up nearby.

This painting of an adolescent Jesus was created by Leonardo's pupil, Boltraffio, probably to Leonardo's design and under his supervision.

LOCATION

Lázaro Galdiano Museum, Madrid, Spain

MEDIUM

Oil on wood panel

ARTIST

Giovanni Antonio Boltraffio (1466–1516)

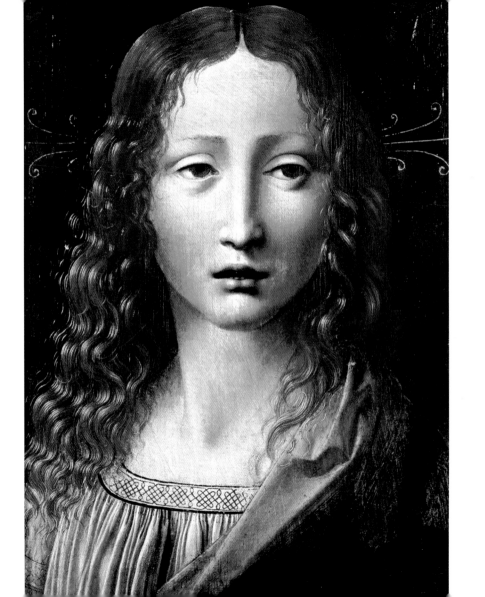

Horse Studies, *c.* 1480–90

The range of creative activity during the Renaissance can be seen in the legacy left by artists, sculptors, architects and writers, as well as by inventions and discoveries, such as the mariners' compass, telescope and gunpowder, and effective printing methods. In addition, modifications in behaviour and attitudes occurred among the patrician class. For instance, in general there was greater respect for women, which gave them more independence; hence Isabella d'Este's power and influence. The period also witnessed the discovery and exploration of new continents, in part caused by the fall of the Byzantine Empire. When Leonardo was a year old, Mehmed II, Sultan of the Ottoman Turks (1432–81), conquered Constantinople and destroyed the Byzantine Empire that had lasted for nearly 1,500 years. This event ultimately was perceived as bringing an end to the Middle Ages and the changes it forced in Europe were later seen as a rebirth.

Leonardo's realism and attention to detail became a large part of the evolving 'rebirth'. This is one of his preparatory sketches for the equestrian monument he planned while in Milan.

LOCATION

Royal Collection Trust, Windsor Castle, UK

CREATED

Drawn in Milan

MEDIUM

Silverpoint on prepared paper

PERIOD

Early to Middle period

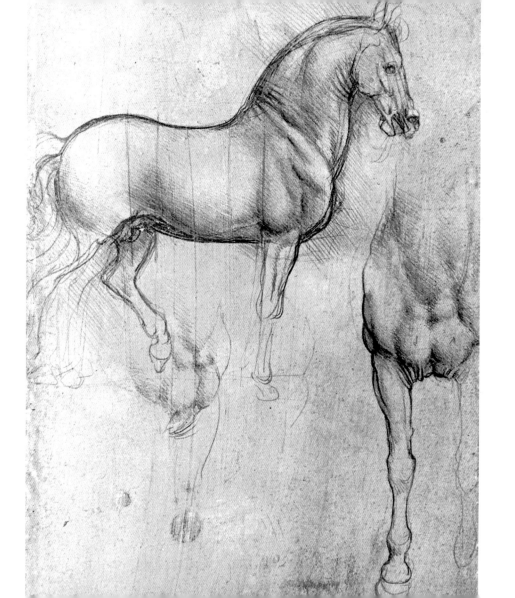

Head of Christ, 1500–10

During the Quattrocento (fifteenth century), Florence became one of the most prosperous and progressive cities in Italy. Initially it was a republic, governed by its guild members who came from a range of backgrounds. From 1434, however, total control was taken by Cosimo de' Medici (1389–1464) and his successors, who ruled Florence until 1494, when there was a brief revival of the republic. At the time of Leonardo's birth, the Medici family was the wealthiest in Florence, and possibly the whole of Europe. Lorenzo de' Medici was a cultured man and an enthusiastic patron and promoter of art, and Ser Piero da Vinci worked for him at the Palazzo della Signoria, from where the Medicis governed at the time. Leonardo later worked on the restoration of Lorenzo's collection of antique marbles that were housed in his garden.

This drawing is an emulation of Leonardo's style and artistic approach, although the artist is unknown. Produced in Lombardy, it was probably by one of the 'Leonardeschi', a large group of artists who worked for Leonardo in his studio, mainly as pupils or assistants.

LOCATION

Pinacoteca di Brera, Milan, Italy

MEDIUM

Charcoal on paper

ARTIST

Lombard artist

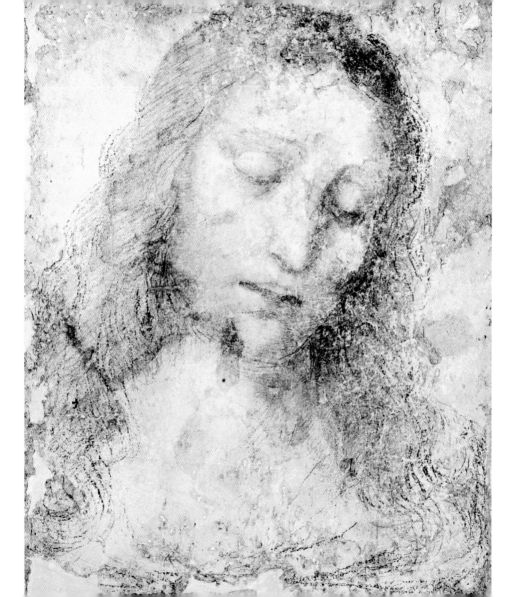

Resting Dog in a Collar, *c.* 1475–1519

One of the consequences of the Ottoman destruction of Constantinople in 1453 was that Greek scholars fled the city, many finding refuge in Florence. Most stayed as guests in monasteries or with noble families, and several acted as tutors or lectured in universities. They brought with them ancient documents and an in-depth knowledge of the history of the rich cultures of ancient Greece and Rome. This inspired a new fascination among many educated Italians with the classical past, and the works of ancient philosophers such as Plato (428/7 or 424/3–348/347 BC), Aristotle (384–322 BC) and Virgil (70–19 BC) were studied. Greek and Roman art and architecture were emulated, and humanism and Neo-Platonism were embraced.

The fall of Constantinople also led to the closure of the Silk Road by the Ottomans, which initiated what later became called the Age of Discovery or the Age of Exploration, that lasted from 1453 to 1660, as merchants sought new trade routes to meet the demand for goods from the East. This in turn impacted on life as explorers found new trade routes and new countries, and ideas were exchanged.

This dog in a collar with his head turned back was drawn by Maso Tommasoii Finiguerra (1426–64), a Florentine goldsmith, draughtsman and engraver. The style of drawing was fashionable in Florence during the period.

LOCATION

Galleria degli Uffizi, Florence, Italy

MEDIUM

Pen and ink on paper

ARTIST

Maso Tommasoii Finiguerra (1426–64)

Woman's Head, *c.* 16th century

In 1492, the humanist scholar Marsilio Ficino (1433–99) wrote of the excitement he felt about the times in which he lived: 'This century, like a golden age, has restored to light the liberal arts, which were almost extinct: grammar, poetry, rhetoric, painting, sculpture, architecture, music, the ancient singing of songs to the Orphic lyre, and all this in Florence. Achieving what had been honoured by the ancients, but almost forgotten since, the age has joined wisdom with eloquence, and prudence with the military art....' Ficino was not alone; others also believed that they were living in a golden age.

Florence had become the centre of humanist learning, mainly among the nobility, although other citizens shared the benefits of a more thoughtful society. The Quattrocento, however, was also a period of war. Absolute monarchies controlled parts of Europe, and Italy was divided into republics, oligarchies and princely states. While all this was happening, Leonardo was growing up. When he moved to Florence as a young teenager, the city was flourishing, and he found himself in a brilliant world of literary and artistic evolution.

Leonardo's followers have always tried to emulate his soft, sensitive approach to drawing and painting. This drawing by an unknown artist demonstrates the widespread admiration Leonardo inspired. It was not only his method of drawing that was copied, but these followers also attempted to capture the beauty, grace, modesty and humility of Leonardo's depictions of the Virgin Mary in particular.

LOCATION

Biblioteca della Stamperia d'Arte Fratelli Alinari

ARTIST

Artist unknown

Profile of a Young Fiancée, *c.* 1495

© Private Collection/Bridgeman Images

In 1453, the same year as the conquest of Constantinople, the long conflict between France and England that had started in 1337 came to an end. Later called the Hundred Years' War by historians, it was a series of intermittent battles over the right to rule the Kingdom of France. Mercenaries from Italy fought on both sides, and over the period major developments in military strategy and technology evolved. The last battle of the war was in 1453, but as there was no peace settlement, tensions remained across Europe for several years.

Highly disputed among experts, this drawing has not been attributed to Leonardo, although several experts are convinced he created it. With various titles, including *La Bella Principessa* (The Beautiful Princess), *Portrait of Bianca Sforza*, *Young Girl in Profile in Renaissance Dress* and *Portrait of a Young Fiancée*, the drawing is made with materials not previously known to be used by Leonardo, but it is drawn by a left-handed artist with comparable techniques, and the sitter wears the fashionable clothing and hairstyle of a Milanese woman of the 1490s.

LOCATION

Private Collection

MEDIUM

Chalk, pen, ink and wash tint on vellum

ARTIST

Artist unknown

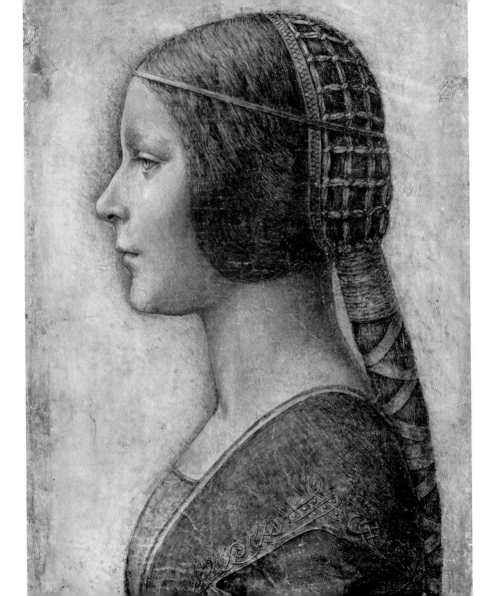

The Adoration of the Magi, 1481–82

In 1450, Milan had been conquered by Francesco Sforza, who was succeeded by his eldest son Galeazzo Maria (1444–76). After Galeazzo's assassination, his seven-year-old son Gian Galeazzo inherited, but Francesco's brother Ludovico took control and ruled as regent until Gian died in 1494, when Ludovico ruled in his own right. In 1482, when Leonardo arrived, the Sforza court was one of the most magnificent in Europe, Milan was a thriving metropolis and its dukes – especially Ludovico – were great patrons of art and architecture.

Although Leonardo made many preliminary studies for this painting, he never completed it. In March 1481 he signed a contract with the monastery of San Donato a Scopeto to paint it and deliver it within 30 months, and he began working out some original ideas. Surrounding the serene Madonna and Child are dynamic-looking figures. The architectural and landscape background and the activity in the scene departed from traditional renditions of the biblical story. However, after waiting for the painting for 15 years, the monks of San Donato a Scopeto gave the contract to Filippino Lippi.

LOCATION

Galleria degli Uffizi, Florence, Italy

CREATED

Painted in Florence

MEDIUM

Underpainting in oil and bistre on wood

PERIOD

Early period

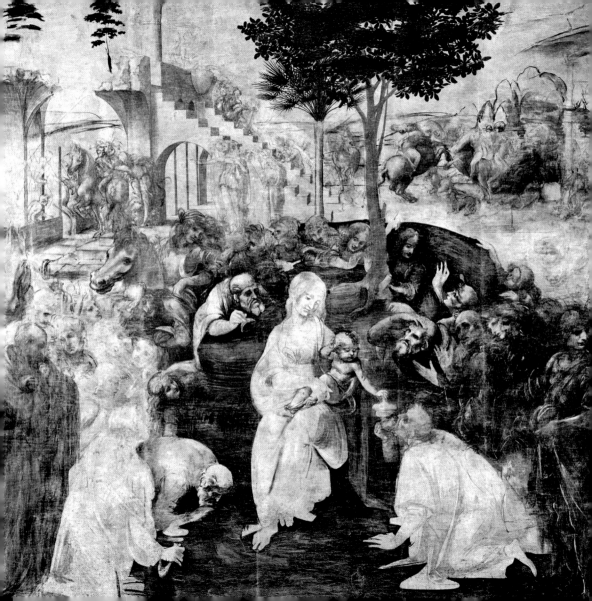

Female Portrait, 1470—1519

Published in 1454 or 1455, the Gutenberg Bible was the first major printed book made in Europe using mass-produced movable metal type. The German goldsmith Johannes Gutenberg (c. 1397—1468) had introduced mechanical movable type to Europe in 1439, which revolutionized printing. Gutenberg did not invent the printing press but he did introduce a combination of changes, including using the new mechanical movable type, oil-based ink, adjustable moulds and a wooden printing press. Gutenberg thus enabled the mass-production of printed books that were economically viable, which made information accessible to many, and which fuelled and augmented the new interest in learning. Printing in this way was a massive improvement on the handwritten manuscript or woodblock printing, the previous established methods of book production in Europe, and it instigated a rise in literacy in Europe. Twenty-three years after the Gutenberg Bible was published, Leonardo designed two new versions of the printing press, which greatly improved on Gutenberg's model.

This drawing of a woman's head was made by the Master of the Pala Sforzesca. Although this artist's actual identity is not known, it is clear that he was extremely influenced by Leonardo, so was possibly one of his pupils or assistants.

LOCATION

Musée du Louvre, Paris, France

MEDIUM

Pen and ink on paper

ARTIST

Master of Pala Sforzesca (fl. 1490—1500)

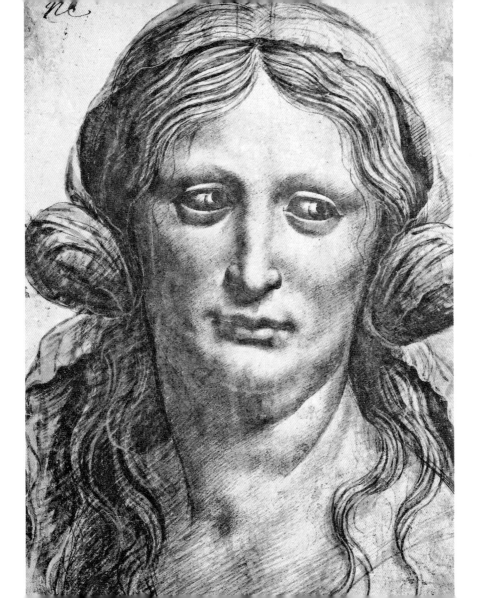

Litta Madonna, *c.* 1490

Improved literacy and the subsequent wider learning inspired the questioning of many accepted ideas about religion, art and science, but at the same time, various wars ravaged the continent. From 1494–1559, conflicts across Italy later became known as the Italian Wars. They began through papal interference, initially in 1489 when Pope Innocent VIII (1432–92) offered Naples to Charles VIII of France (1470–98). Innocent's inflammatory intervention was continued by Pope Alexander VI (1431–1503).

Once attributed to Leonardo, this painting is now thought to have been painted by his pupil Boltraffio, following Leonardo's design and instruction. The breastfeeding Virgin Mary was a fairly common devotional subject known as the 'Madonna Lactans'. Here, mother and child are in a dark interior in front of two arched openings, as in Leonardo's *The Madonna of the Carnation* (*see* page 38), with the sky and a mountainous landscape in aerial perspective beyond. Mary's red, gold and blue clothing was traditional colouring, the goldfinch in Christ's left hand symbolizes his future Passion, and his gaze towards the viewer was the type of human touch at which Leonardo excelled.

LOCATION

State Hermitage Museum, St Petersburg, Russia

MEDIUM

Tempera on canvas transferred from panel

ARTIST

Giovanni Antonio Boltraffio (1466–1516)

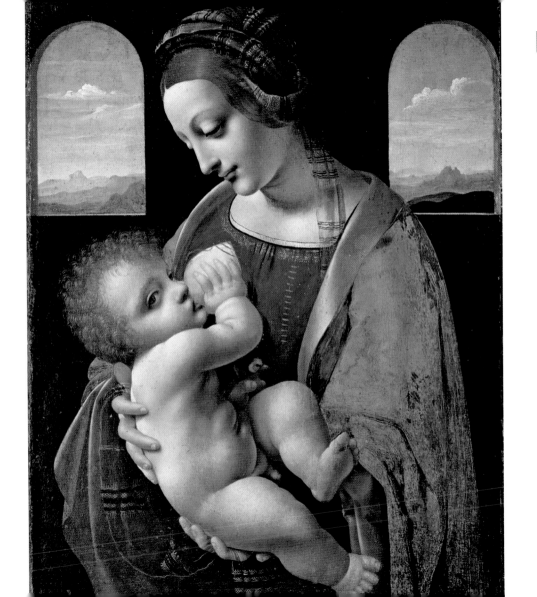

Study of a Male Head

In Florence, Lorenzo de' Medici died in 1492, leaving the city under the control of the fanatical Dominican friar Girolamo Savonarola. Ironically, Lorenzo had brought Savonarola to Florence a few years earlier, where he gained a favourable reputation for his piety, learning and asceticism. However, the friar soon began preaching against the autocratic government, which led to the Medici's downfall, and condemned the increase in materialism, immodesty and greed of so many Florentines in particular.

As his zeal grew, Savonarola criticized the Church, including the pope, and from February 1495, each year until his death, he initiated a *Falò delle Vanità* (Bonfire of the Vanities). These huge bonfires were held in the Piazza della Signoria, built with people's luxury belongings (so sinful), including jewellery, paintings, sculpture, tapestries, mirrors, musical instruments and valuable manuscripts. Savonarola became so influential that even the great artists Botticelli and Lorenzo di Credi (*c.* 1459–1537) committed some of their own paintings to his bonfires.

This three-quarter profile of a man was drawn by Ridolfi del Ghirlandaio (1483-1561), the son of Domenico Ghirlandaio, probably in the first decade of the 16th century. Ridolfi grew up and worked in Florence and had a long and respected career, closely following an amalgamation of his father, Leonardo and Raphael's styles and also the influence of Fra Bartolommeo (1472-1517).

LOCATION

Musée du Louvre, Paris, France

MEDIUM

Pen and ink, wash and chalk on paper

ARTIST

Ridolfi del Ghirlandaio (1483-1561)

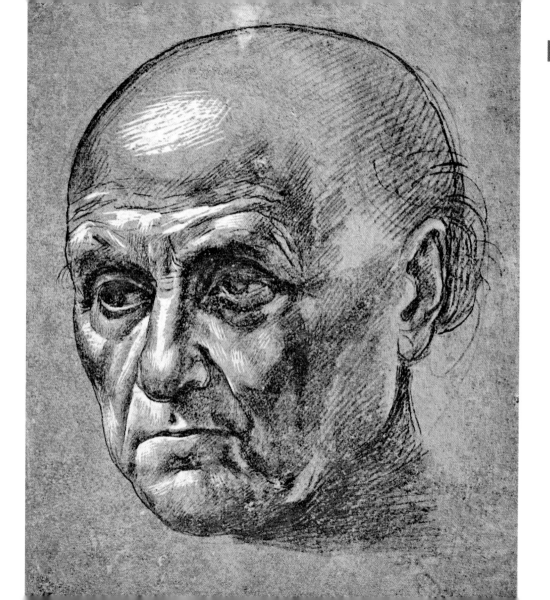

Madonna with a Flower, or Benois Madonna, *c.* 1478

© State Hermitage Museum, St Petersburg, Russia/Bridgeman Images

The Age of Discovery or the Age of Exploration began after traditional sea routes were prohibited by the Ottoman Turks in Constantinople. Within a short time, in various parts of Europe, investments were made into exploration to find new land and sea crossings to enable trade. In addition to seeking potential trade routes, a consequence was that lands were discovered that had previously been unknown to Europeans (although they were seen as invaders to the indigenous peoples). This global exploration began with the Portuguese discoveries of the Atlantic archipelagos of Madeira and the Azores, the coast of Africa, the discovery of the sea route to India, and the transatlantic voyages of the Genoese navigator Christopher Columbus (1451–1506) to the Americas between 1492 and 1502.

Never before had the Virgin Mary been depicted with such freshness and naturalism as in this painting by Leonardo soon after the birth of his new half-brother. The intimacy between mother and child was taken from life; the baby clutches a flower his mother holds and she laughs with pleasure at his concentration. The spontaneity of the gestures was astonishing to viewers at the time.

LOCATION

State Hermitage Museum, St Petersburg, Russia

CREATED

Painted in Florence

MEDIUM

Oil on wood transferred to canvas

PERIOD

Early period

Portrait of a Musician, c. 1485

Explorations and discoveries of unknown lands led to the expansion of global trade and European colonial empires, as well as the exchange of plants, food, animals – including humans – and diseases.

In 1487–88, Bartolomeu Dias (1450–1500) became the first European to sail round the Cape of Good Hope. Ten years later, Vasco da Gama (c. 1460s–1524) sailed across the Indian Ocean to the west coast of India. In 1492, Columbus sailed across the Atlantic Ocean and discovered the West Indies, and in 1502, the Florentine Amerigo Vespucci (1454–1512) reported that Columbus had found an entire continent.

This painting of a man holding a sheet of music has been attributed to Leonardo, but in consideration of aspects such as the rigidity of the pose and less than usually sensitive areas of paint, it is also considered to be at least partly painted by Boltraffio or another of Leonardo's assistants. As there are similarities with the *Lady with an Ermine* (*see* page 50), it is possible that Leonardo painted parts of it, but the pose and paint application contradict his advice about how to paint figures.

LOCATION

Pinacoteca Ambrosiana, Milan, Italy

CREATED

Painted in Milan

MEDIUM

Tempera and oil on wood panel

PERIOD

Early period

ARTIST

Giovanni Antonio Boltraffio (1466–1516) and Leonardo da Vinci (1452–1519)

Study for a Kneeling Leda and the Swan, c. 1505–10

Despite the loss of half of Florence's population through the plagues of 1340 and 1348, internal and external conflicts, the rising power of guilds and individual families, and a period of religious zealotry, Florence flourished. Before and after the Savonarola period, the city became known for its tolerance and modern outlook, its financial and political acumen and its innovations in art, literature and architecture, as ideas were exchanged between philosophers, scholars, politicians, writers, artists and architects. By the Quattrocento, it had absorbed the territories of many of its hostile neighbours and was the largest city in Europe.

This drawing was made by Leonardo for a painting, now lost, depicting a scene from ancient Greek mythology. Leda, the wife of the King of Sparta, was seduced by the god Jupiter when he transformed into a swan. The consequence can be seen at Leda's feet; human babies are hatching from eggs, who will become Helen – later of Troy – Clytemnestra, and Castor and Pollux. Leonardo's light touch includes curving, hatched lines to convey form, energy and a sense of movement.

LOCATION

Chatsworth House, Derbyshire, UK

CREATED

Possibly drawn in Florence

MEDIUM

Pen and brown ink over black chalk on paper

PERIOD

Middle to Late period

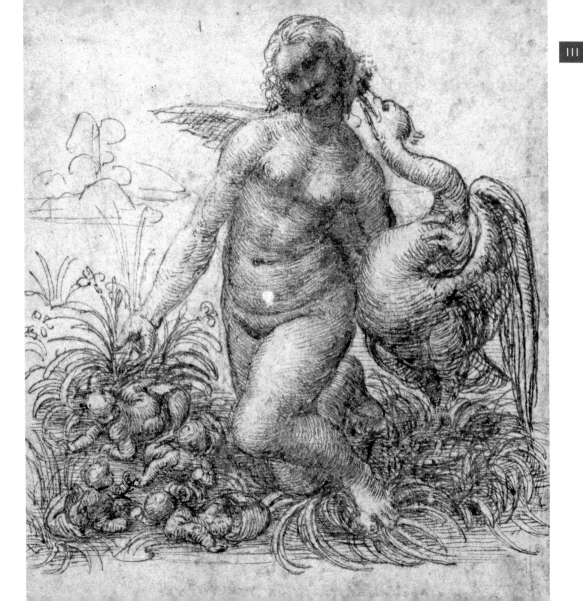

Architectural Studies for a City on Several Levels, *c.* 1487–90

© Bibliothèque de l'Institut de France, Paris, France/Bridgeman Images

In the year of Leonardo's birth, the architect and humanist Leon Battista Alberti (1404–72) completed *De Re Aedificatoria* (On the Art of Building), the first architectural treatise of the Renaissance, inspired by ancient Rome and *De Architectura*, written by the Roman architect, Marco Vitruvius Pollio (*c.* 75–*c.* 15 BC). Alberti covered a wide range of subjects, including history, town planning, engineering, sacred geometry, humanism, elements of architecture and ideal proportions, and the book became profoundly influential. Alberti's first major architectural commission had been in Florence in 1446 for the façade of the Palazzo Rucellai, and the extensive building programme in Florence continued as those in power sought to make the city a model of beauty, order and harmony, adhering to Alberti's theories.

A few years later, to meet Sforza's aspirations, Leonardo's architectural duties in Milan included the design of both religious and secular buildings. These drawings show how he helped to plan the city's redevelopment. Some of his proposals featured improvements to standards of hygiene, including building pedestrian walkways on a higher level than streets that were used for vehicles, where the drains sometimes overflowed.

LOCATION

Bibliothèque de l'Institut de France, Paris, France

CREATED

Drawn in Milan

MEDIUM

Pen and ink on paper

PERIOD

Early to Middle period

16

Baptism of Christ (detail), 1473–75

Italian Renaissance architects based their designs on classical Roman examples. Most went to Rome to study the ancient buildings and ruins, and many adopted humanism to raise their status and reputations. In about 1415, Filippo Brunelleschi (1377–1446) had discovered the technique of drawing linear perspective, which led to the development of detailed architectural drawings, and about 20 years later his unique and massive dome of Florence Cathedral was completed. Other new buildings in Florence as Leonardo was growing up included the Pazzi Chapel, built from 1441–78, the Palazzo Pitti, commissioned in 1458, and the Palazzo Medici that was completed by 1460.

Close examination of this painting reveals how individual parts have been treated differently. Verrocchio clearly started the work and Leonardo probably added this kneeling angel seen from behind and twisting around with softly curling hair, as well as painting over the figure of the unclothed Christ with fine layers of thinly glazed oil paint. Leonardo's touch is more delicate than that of Verrocchio. Even the landscape background demonstrates the soft sfumato technique that he would later use so prominently.

LOCATION

Galleria degli Uffizi, Florence, Italy

CREATED

Painted in Florence

MEDIUM

Oil and tempera on wood panel

ARTIST

Andrea del Verrocchio (c. 1435–88) and Leonardo da Vinci (1452–1519)

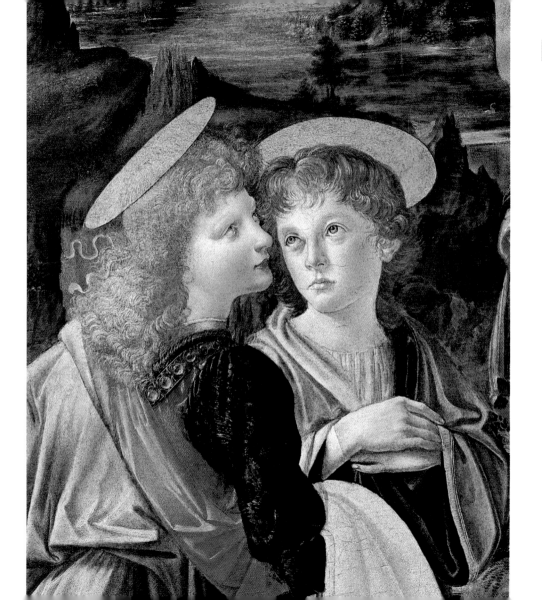

Announcing Angel (detail from *The Annunciation*), c. 1472

Italian architects soon became renowned and were hired by rulers and other important figures across Europe. For instance, when Prince Ivan III (1440–1505) began ruling Russia in 1462, he decided to have the Kremlin in Moscow built as a modern structure using the most advanced technology. Accordingly, he sent his servants to hire the best architects from Italy to turn the fortified complex into a grand and powerful work of architecture. Two of the most well-known of the architects he hired were Pietro Antonio Solari (*c.* 1445–93) and Marco Ruffo, who constructed the walls and towers of the Kremlin between 1485 and 1495, and remained in Moscow for several years.

Leonardo worked on *The Annunciation* before leaving for Milan and his attention to detail is unmistakable. The Angel Gabriel greets Mary with a raised hand and holds a white lily in the other, which was a traditional symbol of both Mary's purity and the city of Florence. It is commonly believed that Leonardo originally copied the angel's wings from that of a bird, but they were painted over and lengthened by a later artist.

LOCATION

Galleria degli Uffizi, Florence, Italy

CREATED

Painted in Florence

MEDIUM

Oil and tempera on panel

PERIOD

Early period

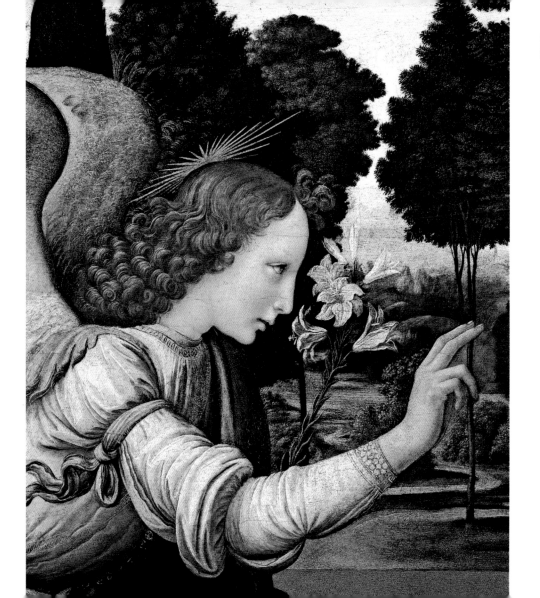

Young Man in Profile Facing to the Right

In 1492, the important cities of Italy were ruled by powerful families who had either been at war with each other, continued to be rivals, or were connected through marriage. For many years before Leonardo's birth, Florence had been an independent republic, run by the city's guilds. Every few months, a new head of state (or *Gonfaloniere*) was elected – from any background. This system ignited huge ambition among a few families who wanted to take control, including the Medici, the Albizzi, the Alberti, the Pazzi and the Rucellai. For a time, the Medici Bank was one of the most prosperous and respected institutions in Europe, and because of this, the Medici took control of Florence.

Similar families elsewhere included the d'Este family in Ferrara and Modena, the Sforza in Milan, the Gonzaga in Mantua, the Montefeltro in Urbino and the Aragon family in Naples. Other powerful dynasties included the Orsini, the Colonna and the Malatesta, but the most notorious of all was the Borgia, especially Cesare, who was known to be cruel, incestuous and a killer – and for employing Leonardo in 1502.

The image of a youth with flowing locks of hair occurs frequently in works by members of Leonardo's circle and this drawing has at times in its history been identified as drawn by Boltraffio. It has also been variously attributed to Salai and the Master of the Pala Sforzesca. Whoever drew it, it is possibly an idealized depiction of the poet Gerolamo Casio (1464–1533).

LOCATION

Musée du Louvre, Paris, France

MEDIUM

Metalpoint on bluish-grey prepared paper

ARTIST

Artist unknown

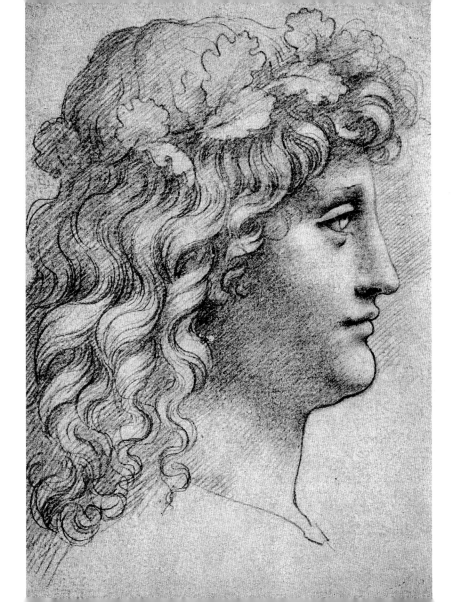

Head of Bacchus (Head of a Young Man with a Grapevine Wreath), *c.* 1480–1520

© Gallerie dell'Accademia, Venice, Italy/Alinari Archives, Florence, Italy/Bridgeman Images

The Medici began as wool merchants, and then bankers, and later became popes and monarchs. Originating in the Mugello region of Tuscany, the family eventually owned the Medici Bank, which became the largest in Europe. Once in power, they became prominent patrons of art and architecture, creating an environment in Florence where art and humanism thrived. When Leonardo was training in Verrocchio's workshop, the Medici dominated Florentine life. Aeneas Sylvius, Bishop of Siena and later Pope Pius II (1405–64) remarked about Cosimo de' Medici, 'He is king in all but name.'

As the first family of Florence, the Medici also had powerful enemies. On Easter Sunday in 1478, in Florence Cathedral during Mass, an attempt was made on the lives of Lorenzo de' Medici and his brother, Giuliano. Giuliano was murdered, but Lorenzo escaped. The assassins were supported by the delle Rovere and the Pazzi families, and over the following months approximately 80 people who may have been connected with the plot were hunted down and killed. Leonardo made a sketch of one of the hanging bodies on display in the city.

Boltraffio was one of Leonardo's closest followers and this sensitive drawing can be seen to have been drawn carefully following the master. It also resembles a painting Boltraffio executed, *Portrait of a Boy as Saint Sebastian* (late fifteenth century, Pushkin Museum, Moscow), for which he probably used the same model.

LOCATION

Gallerie dell'Accademia, Venice, Italy

MEDIUM

Metalpoint and black chalk on grey-blue prepared paper

ARTIST

Artist unknown

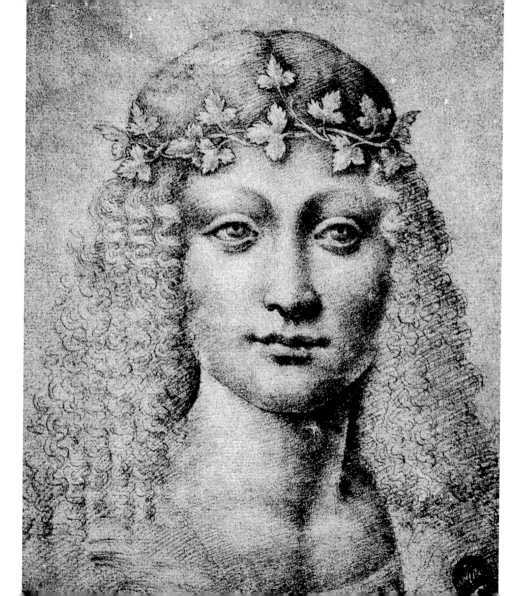

A Unicorn Dipping its Horn into a Pool of Water, c. 1481

The rediscovery of Vitruvius by, among others, Pacioli, Alberti and Leonardo, meant that the architectural principles of ancient Rome were revived, and the new humanist attitude encouraged architects and artists to strive to exceed the achievements of the ancient Greeks and Romans. Renaissance humanists did not reject Christianity, but the new ideals developed against a Christian backdrop. This led to new beliefs and perceptions of the relationship between man and God, as humanists sought to become more worldly and move away from the religious rigidity that had dominated Europe for so long. This new consciousness had repercussions across society.

A number of Leonardo's drawings demonstrate the period's continuing fascination with Christian symbolism. He was familiar with bestiaries – illustrated volumes featuring various beasts, often also including moral lessons as many of the beasts were symbolic. Unicorns were associated with the feminine and were also a symbol of chastity, purity and divine power. Leonardo made this tiny drawing of a unicorn dipping its horn into a pool of water before he left Florence for Milan.

LOCATION

Ashmolean Museum, Oxford, UK

CREATED

Drawn in Florence

MEDIUM

Pen, ink and metalpoint on paper

PERIOD

Early period

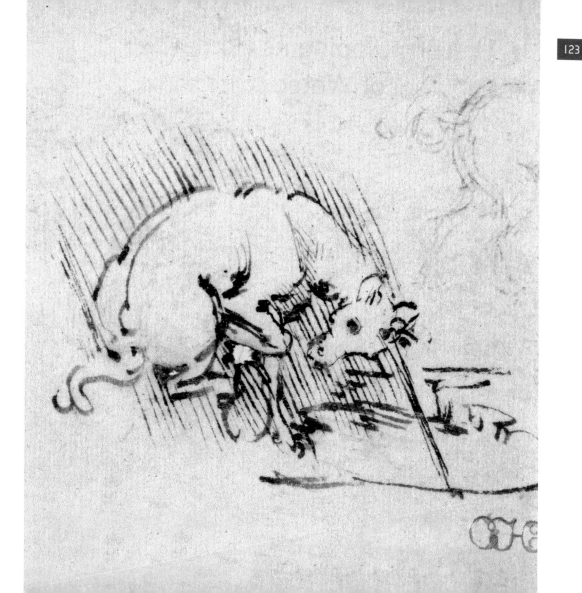

Study of Marsh Marigold (*Caltha palustris*) and Wood Anemone (*Anemone nemorosa*), c. 1506–08

Often called the Father of Italian humanism, the scholar and poet Francesco Petrarch (1304–74) inspired this philosophical stance by arguing that God had given humans their intellectual and creative potential to be used fully, and humanism emphasized individual thought, expression and independence. Expansion of trade and increasing literacy generated a greater focus on interest in worldly pleasures, which was echoed in the ancient texts that were being discovered. Humanists believed that everyone should be able to speak and write eloquently and clearly, and by the mid-fifteenth century humanist education was usual among the Italian upper classes. Many prominent humanists, including Petrarch, were connected to the Church, while others were often well-educated and respected secular figures. The Italian focus on humanism soon spread to France, Germany, the Low Countries and Britain.

From early in his life, Leonardo made plant studies. As he developed as an artist, these botanical studies became preparatory drawings for paintings, and this is one of his more mature drawings that reveals his remarkable sensitivity, meticulous observational powers and the ways in which he adapted his method of drawing to suit his subjects.

LOCATION

Royal Collection Trust, Windsor Castle, UK

CREATED

Drawn in Milan

MEDIUM

Pen and ink over black chalk on paper

PERIOD

Middle period

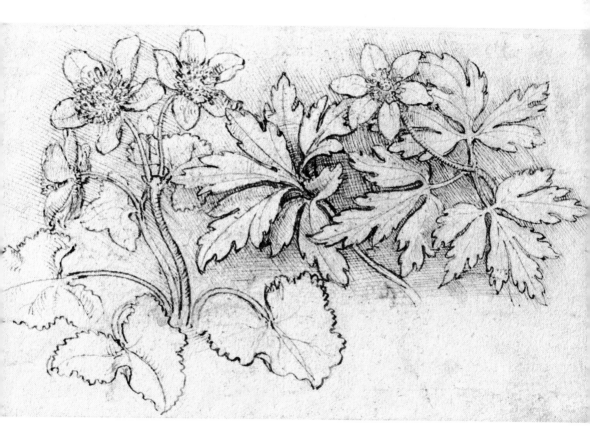

Male Portrait, *c.* 1519

© Louvre, Paris, France/Alinari Archives, Florence, Italy/Bridgeman Images

Following what became called the Western Schism or the Papal Schism, the Renaissance began in times of religious turmoil, when three men simultaneously claimed to be the true pope and caused a split within the Catholic Church that lasted from 1378 to 1417. From that period, the Church became besieged with accusations of corruption. Alongside all this came the rise in humanism and Neo-Platonism, mainly evolving out of the study of ancient Greek and Roman manuscripts. It also led scholars to question many of the strict ideas that the Church had promoted for so long. Yet, while many medieval superstitions were abandoned, the Church remained in control, and most who embraced the more liberal ideas saw no contradiction in using one's intellect while still believing in God and in following the doctrines of Catholicism.

Scholars still debate whether or not Leonardo was a Christian. Vasari writes that before he died, he 'lay sick for several months and feeling that he was near to death, he earnestly resolved to learn about the Catholic faith and of the good and holy Christian religion'.

Although the right-handed artist who drew this man's head is unknown, it shows an influence of Leonardo.

LOCATION

Musée du Louvre, Paris, France

MEDIUM

Metalpoint on prepared paper

ARTIST

Assigned to Lorenzo Sciarpelloni (1459–1537)

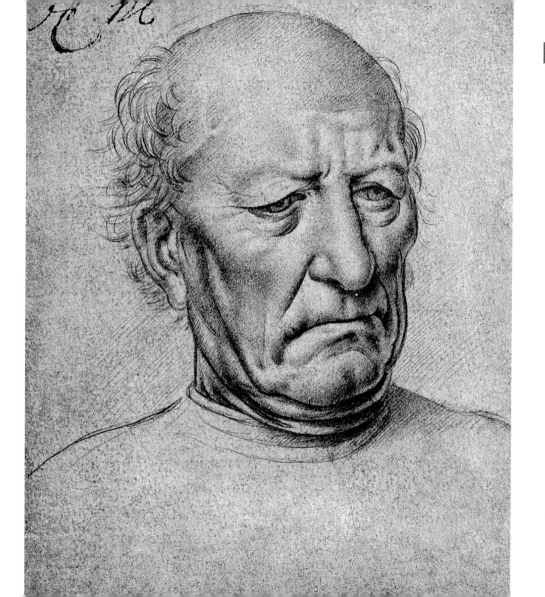

Portrait of a Noblewoman, *c.* 1520–50

During the Renaissance period, popes acted as both the head of the Church and as powerful rulers, signing treaties with sovereigns and fighting wars. These enriched them and their families, and enforced their power. Pope Julius II (1443–1513) became known as 'the Warrior Pope' for his use of military force to increase the territory and property of the papacy. He also commissioned artists and architects to make Rome magnificent. One of his most prominent projects was the rebuilding of St Peter's Basilica, and under his papacy Rome rose in importance. Several Renaissance popes had mistresses, fathered children, and engaged in intrigue and even murder, such as Alexander VI, born Rodrigo de Borgia, who was pope from 1492–1503, and father of Cesare and Lucrezia Borgia (1480–1519). After Julius II, other popes also patronized the arts and architecture in an effort to increase their own prestige and the prestige of the papacy. Pope Leo X (Giovanni di Lorenzo de' Medici) especially favoured Raphael, and Pope Sixtus IV (1414–84) ordered the construction of the Sistine Chapel, summoning numerous artists to Rome.

Francesco Ubertini, known as il Bacchiacca (1494–1557) was an Italian Florentine painter, a pupil of Pietro Perugino (1446–1523) who was influenced by Andrea del Sarto (1486–1530), Michelangelo, Raphael, Dürer and Leonardo. This is his portrait of a young noblewoman, her arms folded, crimped hair tied in a net headdress, wearing a chain around her neck and a high-necked blouse.

LOCATION

Galleria degli Uffizi, Florence, Italy

MEDIUM

Red chalk on paper

ARTIST

Francesco Ubertini, known as il Bacchiacca (1494–1557)

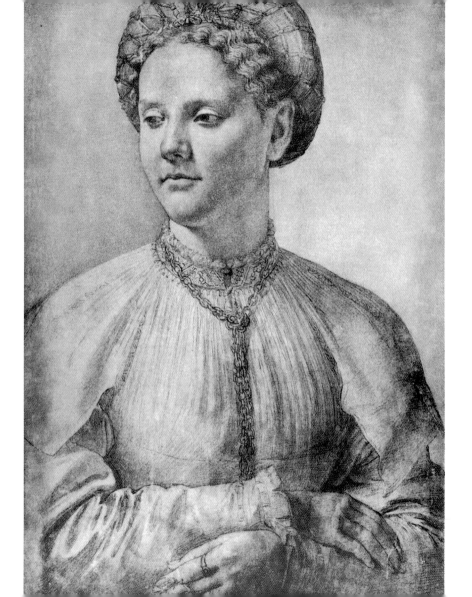

Bust of a Man in Profile, 1469–1519

Dominating the Italian peninsula in the fifteenth century were the cities of Florence, Milan, the Papal States, Venice and the kingdom of Naples. Most had their own rulers, for instance the pope in Rome, the Medici in Florence, the doge in Venice and the Sforza in Milan. As they vied for dominance early on, many of these rulers fought each other. On land, wars were generally fought by mercenaries (or *condottieri*), who often deliberately prolonged conflicts to continue their employment. Fighting also occurred at sea until the 1454 Treaty of Lodi, which was a peace agreement between Milan, Naples and Florence. A related agreement was signed in Venice later that year between Milan, Venice and Florence, and other cities soon joined. But the peace did not last. In 1483, Venice and the pope fought against Milan, and in 1494 French troops invaded Florence and then Naples, initiating the Italian Wars.

The ideas of the Renaissance first developed in Florence and then spread, as many ruling families who had gained their positions through brutality and violence became committed to learning, art, architecture, literature and humanism. This profile drawn by an unknown right-handed artist shows the styles of clothing worn during the period in which Leonardo lived and worked.

LOCATION

Galleria degli Uffizi, Florence, Italy

MEDIUM

Metalpoint on paper

ARTIST

Artist unknown

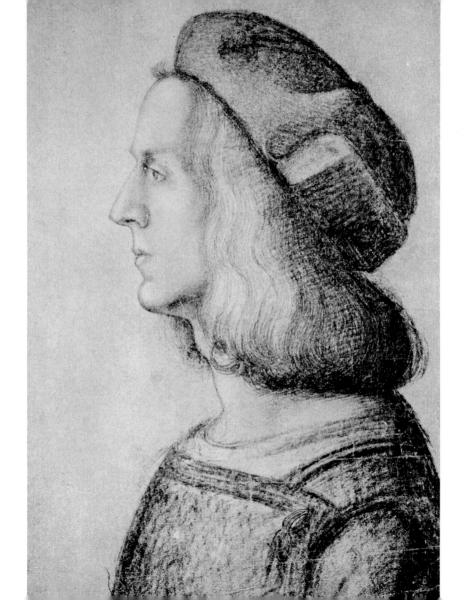

Fantastical Dragon, *c.* 1515–17

When he came to power, Francesco Sforza, Ludovico's father, rapidly transformed medieval Milan into a major centre of art and learning, attracting some of the greatest intellectuals of the time. Because of its control of the Adriatic Sea, Venice had become one of the wealthiest cities in Europe and also a centre for Renaissance culture. Smaller cities such as Ferrara, Mantua and Urbino also developed culturally. As the fifteenth century came to a close, Rome began to rise as the cultural centre of the Renaissance. From 1447, Pope Nicholas V (1397–1455) started a dramatic programme of rebuilding that was continued by Pope Sixtus IV, who also reorganized the city's streets. Subsequent popes continued, preserving the city's ancient Roman buildings and commissioning new art and architecture. For ten years from 1503, Pope Julius II initiated many ambitious art and architectural projects to glorify the papacy as successor to the ancient Roman Empire.

Although it is not clear for which celebration this drawing was made, it was Leonardo's design for one of the costumes or mechanical objects that he produced for various festive pageants.

LOCATION

Royal Collection Trust, Windsor Castle, UK

CREATED

Drawn in Rome

MEDIUM

Black chalk, pen and ink on paper

PERIOD

Late period

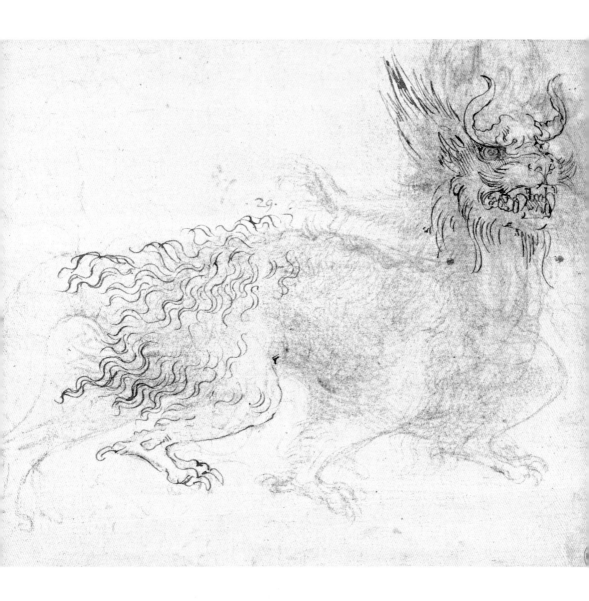

29.

Grotesque Portrait of an Old Woman, *c.* 1515

The Renaissance had little effect on most of the population, including tradesmen, the semi-skilled and unskilled, the unemployed and nearly all those living in rural locations. But in the cities nobles and merchants were involved, especially after cheaper printing enabled wider literacy. Social mobility allowed many Italian artisans and guild members to become more educated and to gain significant power in the republican governments.

As part of his creation of pageants and theatricals for various patrons, Leonardo made masks and costumes. Probably related to this are his drawings of grotesque faces. This drawing by Melzi was probably copied from one of Leonardo's drawings that closely follows a work by Flemish painter Quentin Massys, also known as Quinten Matsys or Massys (1466–1530). Profoundly influenced by Leonardo, Massys probably spent time in Italy and it is likely that the two artists met and later corresponded, as several works by Massys follow Leonardo's. In *c.* 1513, in Antwerp, Massys painted *An Old Woman, the Ugly Duchess* (National Gallery, London) of a woman possibly suffering with Paget's Disease. This drawing is a direct copy.

LOCATION

Royal Collection Trust, Windsor Castle, UK

MEDIUM

Red chalk on paper

ARTIST

Francesco Melzi (1491–*c.* 1570), after a painting by Quentin Massys

Studies of an Old Man and a Youth in Profile, Facing Each Other, *c.* 1500–05

At the start of the Renaissance, artists were seen as craftsmen and had little prestige or recognition. By the later period however, the most skilful artists acquired elevated reputations and could charge high fees, and increasingly, rather than coming from lower- or middle-class backgrounds, many came from wealthier families as the job became more prestigious.

Executed with extreme care, this drawing was probably produced for a special occasion. The bald-headed old man with a bent nose, protruding chin, wrinkled neck and downturned mouth looks directly at a smooth-skinned youth facing him, who has regular features and an abundance of thick curly hair. Leonardo wrote down some of the recommendations he gave to his apprentices and assistants, stating that they should 'closely intermingle direct opposites, because they offer a great contrast to each other, and the more so the more they are adjacent. Thus have the ugly one next to the beautiful, the large next to the small, the old next to the young, the strong next to the weak. In this way there is as much variety, as closely juxtaposed as possible.'

LOCATION

Galleria degli Uffizi, Florence, Italy

CREATED

Possibly drawn in Florence

MEDIUM

Red chalk on paper

PERIOD

Middle period

Study of a Woman, 1475–80

This drawing was made by Leonardo during his apprenticeship. By the late 1480s, his own workshop (or *bottega*) in Milan was thriving, following the style and organization of that of Verrocchio. Apprentices – called *garzoni* – lived with the master, his family and other *garzoni*. Workshops were busy places and commissions could include painting furniture, frescoes, reliefs, festival decorations, book covers, altarpieces or stage sets, for example. Some of the art was largely completed by the master, while other works were produced by assistants following close instructions. Historian, physician and emblem-maker, Paolo Giovio, Bishop of Nocera (1483–1552), wrote about Leonardo in the late 1520s, in *Dialogus de viris et foeminis aetate our florentibus* (Dialogues concerning men and women famous in our time), and noted that Leonardo 'would not permit youngsters under the age of twenty to touch brushes and colours, and would only let them practise with a lead stylus'. The head of the Carmelites in Florence, Fra Pietro da Novellara, described a visit to Leonardo's later studio in Florence: 'Two of his assistants make copies, and he from time to time puts his own hand to them.'

LOCATION

Galleria degli Uffizi, Florence, Italy

CREATED

Drawn in Florence

MEDIUM

Fine brush drawing on greenish background

PERIOD

Early period

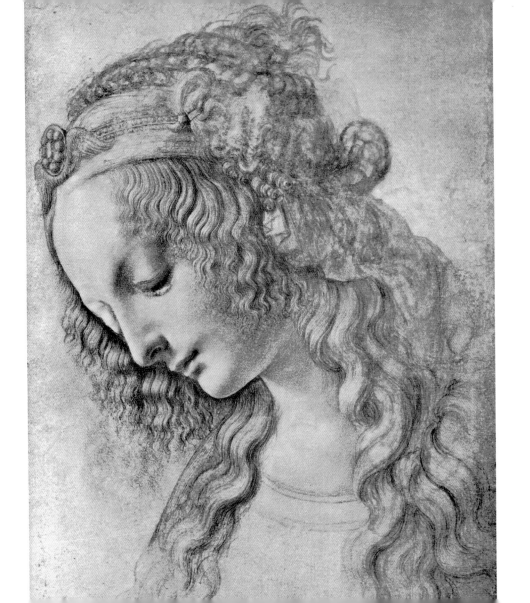

Study of a Male Head, 1502

While an apprentice, Leonardo had learned the techniques of sculpture from Verrocchio, who had been taught by the great Donatello. During the period, paintings, statues and reliefs were commissioned by guilds, powerful families and the Church, and a competitive atmosphere developed between artists who each sought to be more innovative than the other, while guilds vied with each other in the decoration of their civic buildings, frequently commissioning grand works of art. In Florence, Leonardo often visited the Medici (some accounts say he lived there, as Michelangelo did later). Lorenzo de' Medici filled his gardens with sculpture by some of the greatest artists, both ancient and contemporary. However, although Leonardo made plans for several bold, innovative works of sculpture, he produced little during his career, and few sculptures can be firmly attributed to him.

Generally thought to be portraits of Cesare Borgia, these studies of one head from different angles were created by Leonardo between the summer of 1502 and January of 1503, while he was employed by Borgia as chief engineer and architect, but there is no known finished painting or sculpture of Borgia by Leonardo.

LOCATION

Biblioteca Reale di Torina, Piedmont, Italy

CREATED

Drawn in Romagna

MEDIUM

Red chalk on paper

PERIOD

Middle period

Madonna and Child, 1469–1519

As he was training and embarking on his career, Leonardo was familiar with other artists working in Florence, and was aware of the increase in status of the most skilful. In earlier years, through their innovations and skills, artists such as Masaccio (1401–28/29), Paolo Uccello (c. 1397–1475), Fra Angelico (1395–1455), Piero della Francesca (c. 1415–92) and Fra Filippo Lippi (c. 1406–69) had built up elevated reputations. Most of these pioneering artists worked in Florence, and so Leonardo was extremely conscious of his place in the next generation of respected men who could command high payments for their work. His contemporaries included Botticelli, who became known for his elegant depictions of mythological stories; Domenico Ghirlandaio (1449–94), who excelled in fresco painting; Filippino Lippi, the son of Filippo Lippi and friend of Botticelli who painted sensitive figures; and the brothers Antonio del Pollaiuolo (c. 1432–98) and Piero del Pollaiuolo, also known as Piero Benci (c. 1441–96), who frequently collaborated, painting in a classically influenced style, and who, like Leonardo, reportedly carried out dissections of cadavers to improve their knowledge of human anatomy.

This is a drawing by an unknown artist after Leonardo's *Madonna with the Yarnwinder (Spindle)* of 1507 in the Uffizi, Florence. Leonardo's painting was probably commissioned by Florimond Robertet d'Alluye (1458–1527), the Secretary of State for King Louis XII of France in 1501, after Leonardo had returned to Milan from Florence. The painting depicts the Virgin as a figure from the apocryphal Gospels in which she spun the purple cloth for the Temple. On her lap, Jesus reaches up to hold the cross-shaped distaff, symbolizing his destiny.

LOCATION

Galleria degli Uffizi, Florence, Italy

MEDIUM

Pencil on paper

ARTIST

Artist unknown

Salvator Mundi, *c.* 1500

In April 1476, Leonardo was anonymously accused with three others of engaging in sodomy with the apprentice goldsmith and prostitute Jacopo d'Andrea Saltarelli (1459–unknown). By June, however, with no evidence, the case was dropped, but had it been proven Leonardo's punishment could have been imprisonment, banishment or death, as homosexuality was illegal in Florence (although it was also probably widespread). Attitudes conflicted. Leonardo was homosexual, and though in some circles it was tolerated, priests frequently denounced it vehemently. In 1484, a papal bull stated that the 'heretical perversions' of homosexuals were almost the same as having 'carnal knowledge with demons'. Yet humanism and Neo-Platonism focused on Plato's beliefs – he had written about ideal love between men and boys.

This painting of Jesus, raising one hand in benediction and holding a transparent rock crystal ball in the other, portrays His role as saviour of the universe. Long believed to be a copy of a lost original, in 2011–12 the painting was restored and attributed to Leonardo by several experts, while still disputed by others. Leonardo was commissioned to paint it in *c.* 1500 by Louis XII of France.

LOCATION

Louvre Abu Dhabi, UAE

CREATED

Painted in Florence

MEDIUM

Oil on walnut

PERIOD

Middle period

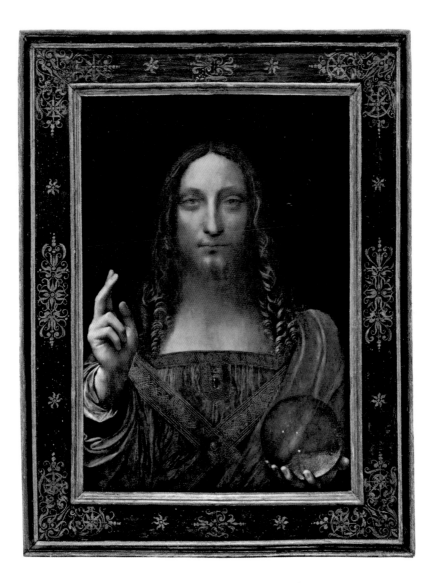

Male Profile

Overall, the Renaissance encouraged independent thought, a belief in learning, and in extending the mind and attaining skills for life. Acquiring a range of knowledge and personal endeavour was encouraged, and a good education was perceived as a status symbol and an essential way of cultivating one's moral and intellectual character. Renaissance humanists followed the Greco-Roman idea of being a universal man (*l'uomo universale*) — intelligent and physically strong with a well-rounded education. It was generally believed that the humanities should be learned, which included grammar, rhetoric, history, literature, poetry and philosophy, as well as other subjects. Numerous schools and institutions were established that focused on certain areas, such as Abacus schools for boys intended for careers in trade or commerce. Abacus schools taught arithmetic, algebra, astronomy, book-keeping and geometry. Over the course of the sixteenth century, many of these educational ideas spread across Europe.

This small sketch of a man in profile demonstrates Leonardo's approach to drawing and his recommendation to his pupils to 'commit to memory the four variations of the four different features ... the nose, the mouth, the chin and the forehead'.

LOCATION

Galleria degli Uffizi, Florence, Italy

MEDIUM

Pen and ink on paper

Leonardo
da Vinci

Inventions & Observations

Hydraulic Devices for Transporting Water, c. 1482

© Tallandier/Bridgeman Images

Leonardo had an obsessive fascination with water; he described it as a *vetturale di nature* (vessel of nature), and he made many drawings and notes, devising schemes to harness its inherent power. One of these plans was for a water pump that could drain an entire port. His *Codex Atlanticus* contains many designs for water-controlling devices, including this hydraulic device for transporting water. The *Codex Atlanticus* is a twelve-volume bound set of drawings and writings that Leonardo made between 1478 and 1519, comprising a huge variety of subjects, including flight, weaponry, mathematics, botany, hydraulics, mechanics, astronomy, philosophical ideas, inventions such as parachutes, musical instruments, and studies and sketches for paintings. Some of the devices include sluice gates and movable panels in canals that can drop to divert the flow of a river. His invention for the canal lock was one of his most enduring achievements. The enthusiasm with which he filled the notebooks that we know about demonstrate that he was not exaggerating when he wrote to Ludovico Sforza describing himself predominantly as an engineer, even though he had received absolutely no training for this role.

LOCATION

Biblioteca Ambrosiana, Milan, Italy

CREATED

Drawn in Milan

MEDIUM

Pen and ink and Indian ink on paper

PERIOD

Early period

Hydraulic Devices (Archimedean Screw) and other studies, *c.* 1478–80

© Granger/Bridgeman Images

Among the many designs that Leonardo devised for the control and harnessing of water was a design to improve the Archimedean screw. This is a machine used for transferring water from a low-lying body of water into irrigation ditches, and works by water being pumped through a long turning screw. The ancient Greek mathematician, physicist, engineer, inventor and astronomer, Archimedes of Syracuse (*c.* 287–*c.* 212 BC) who is generally regarded as one of the leading scientists and mathematicians of antiquity, designed the pump originally, and Leonardo improved on it by using pipes wrapped around a cylinder. By turning the cylinder, the water is raised through the pipes. Leonardo was the first to investigate the subject with such intensity, and through his observations, experiments and detailed drawings, he came close to understanding the laws of hydrostatics that were formulated centuries after his death. On the left-hand side of this sheet is his design for a diver with an oxygen tube in his mouth, which is carried above water level using a cork disc, and also a drawing illustrating the mechanics of a well pump.

LOCATION

Biblioteca Ambrosiana, Milan, Italy

CREATED

Drawn in Florence

MEDIUM

Pen and ink on paper

PERIOD

Early period

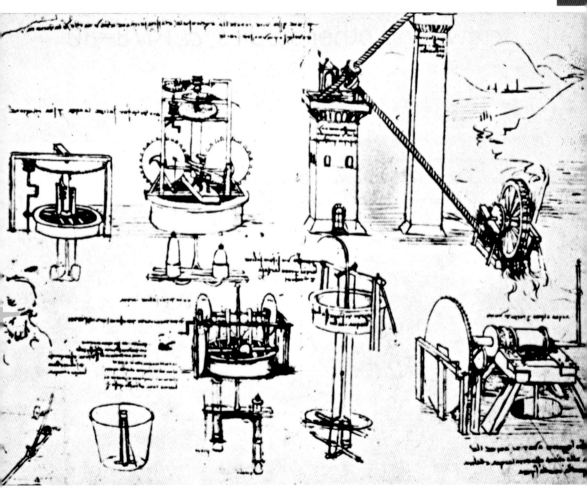

Scheme for a Canal to Bypass the Arno, *c.* 1503

When Leonardo returned to Florence after working for Cesare Borgia, he was employed by the Florentine government to assist in its war against Pisa. In July 1503, he advised on a project to divert the River Arno, so it would bypass Pisa, depriving it of water, and so forcing it to surrender to the besieging Florentines. The canal would flow from Florence and through a pass in the hills to the north before re-joining the river beyond Pisa.

The scheme was devised between Leonardo and Machiavelli, who was Second Chancellor in Florence at the time. They had collaborated on several military-engineering projects previously, and believed that this drastic measure would end their problems with Pisa. Leonardo believed he could re-route the Arno to make it navigable all the way to the sea, so turning Florence into a port. Several *maestri d'acque* (hydraulic engineers) were consulted and a start was made on the project in 1504 (when Leonardo was busily drawing plans for his painting *The Battle of Anghiari*). Two thousand labourers were hired to dig, but by October the project was abandoned.

LOCATION

Royal Collection Trust, Windsor, UK

CREATED

Drawn in Florence

MEDIUM

Brush and ink over black chalk, pricked

PERIOD

Middle period

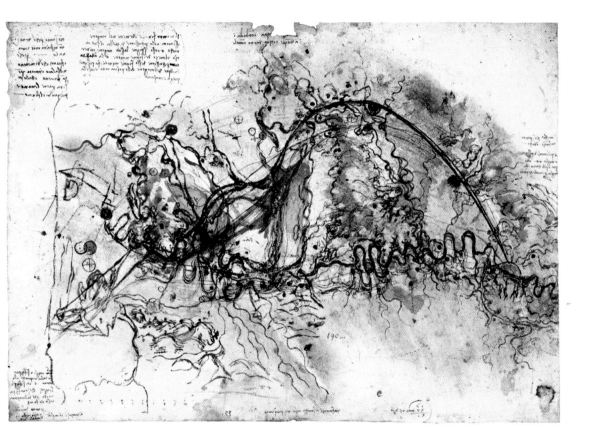

Designs for a Scythed Chariot and Armoured Car, *c.* 1485–88

Leonardo was a gentle man, a vegetarian who cared about all life, but this was a time of almost constant war between countries and city-states, and his expertise in engineering was in great demand. He designed bridges and weapons – such as a catapult and crossbow – and one of his largest military vehicle designs was for an armoured tank, seen here. The concept was simple and deadly; the tank would protect passengers inside and destroy those outside. Leonardo did not specify what would power this huge machine but his notes indicate that it would either have been drawn by horses or hand-cranked. Next to it, the tank's roof is removed and he writes: 'the way the car is arranged within – eight men operate it, and the same men turn the car and pursue the enemy.' In the upper part of the drawing is a design for a horse-drawn chariot with four large scythe-like blades attached to the axles. The notes read: 'when this travels through your men, you will wish to raise the shafts of the scythes so that you will not injure anyone on your side.'

LOCATION

British Museum, London, UK

CREATED

Drawn in Milan

MEDIUM

Pen and ink and brown wash on paper

PERIOD

Early period

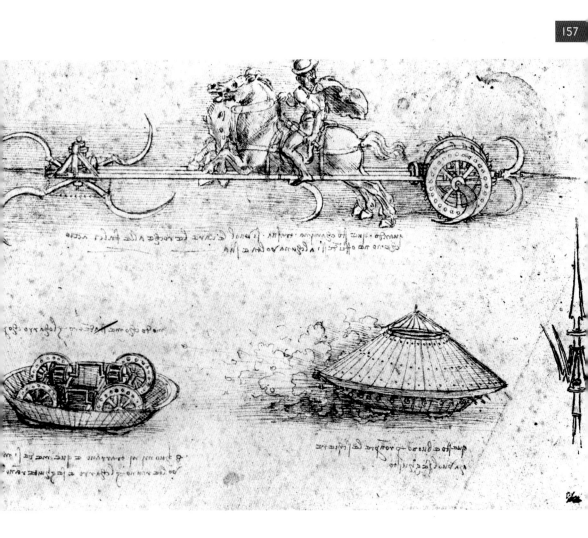

Scythed Chariot, *c.* 1483—85

Leonardo's extensive studies of weaponry appear to live up to the expansive claims he made in his letter to Ludovico. This sheet shows two of his many schemes for deadly scythed chariots, including the resulting sliced and severed victims on the side to emphasize how effectively the machine would work. In the top design, two horses lead a rotating chariot with large scythes that spin as it moves, and in the lower design, there are two rotating scythe machines on wheels at the front and back with two horses moving it in the centre. A chariot with knives or blades extending from the wheels was not a new idea, but Leonardo's machines are mechanized versions that did not need men to do the slicing. They are just two of several similar designs he contrived, that may or may not have worked. They may seem incongruous creations for such a humane, animal-loving man, but despite the new learning he lived in barbarous times. Ultimately, Leonardo realized that these machines could potentially do 'as much injury to friends as they did to enemies'.

LOCATION

Biblioteca Reale di Torino, Piedmont, Italy

CREATED

Drawn in Milan

MEDIUM

Pen and ink on paper

PERIOD

Early period

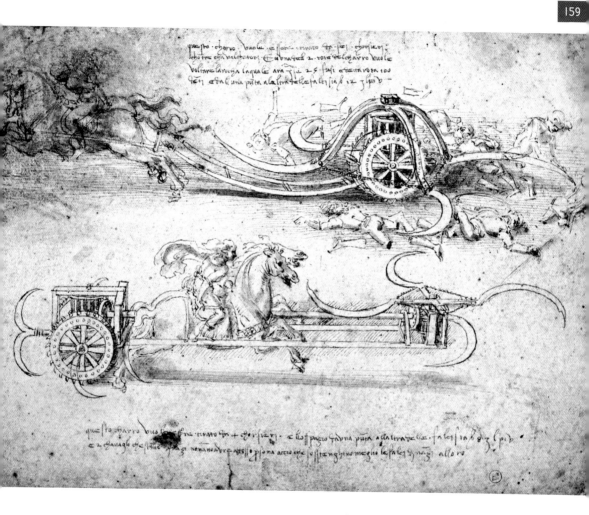

Sketch for Gears Designed to Control Counter-weight, *c.* 1500

Leonardo painstakingly studied machines and their components and made many drawings synthesizing his observations with his imagination in his plans. Some of his ideas had been considered previously by engineers, but his concepts often involved a new angle or an original and more practical change. Leonardo did not see any difference between art and science, and so his ideas often simply echoed forces and workings that he saw in nature, and thus his designs worked in harmony with nature. Also fascinated by proportion and ratio, he designed with precision. Many of his inventions used ropes and pulleys – for instance, he designed a revolving bridge for Ludovico that could be quickly packed up and transported for use by armies on the move so they could pass over bodies of water. The bridge would swing across a stream or moat and set down on the other side so that the soldiers could cross with little trouble. The device had wheels and incorporated a rope-and-pulley system for both speed of use and easy transport. It also had a counterweight tank, so that it would balance.

MEDIUM

Pen and ink on paper

PERIOD

Middle period

ARTIST

Attributed to Leonardo da Vinci

Design for a Flying Machine, c. 1488–90

© Bibliothèque de l'Institut de France, Paris, France/Alinari Archives, Florence, Italy/Bridgeman Images

Obsessed with the notion of flight, Leonardo made many illustrations and notes for flying machines, even though the first working helicopter was not built for over 400 years. Yet his designs were the predecessors of modern-day flying machines, although as with many of Leonardo's ideas, he never actually built them, as most of the component parts were unable to be made at that time. Nevertheless, his notes and drawings mapped out exactly how his machines would operate. Next to these sketches he wrote: 'If this instrument made with a screw be well made – that is to say, made of linen of which the pores are stopped up with starch and be turned swiftly, the said screw will make its spiral in the air and it will rise high.' Also known as the 'Helical Air Screw' or simply the 'airscrew', it was designed to compress air in order to fly, using a similar mechanism as is used in contemporary helicopters. This would have been made from reed, linen and wire, and was to be powered by four men standing on a central platform turning cranks to rotate the shaft.

LOCATION

Bibliothèque de l'Institut de France, Paris, France

CREATED

Drawn in Milan

MEDIUM

Pen and ink on paper

PERIOD

Middle period

Take-off and Landing Gear for a Flying Machine, 1487–90

© Bibliothèque de l'Institut de France, Paris, France/Alinari Archives, Florence, Italy/Bridgeman Images

In his notebooks, Leonardo wrote of his first memory; as a baby, he was lying in a cradle outside when a hawk-like bird, possibly a kite, landed on him and flapped its tail feathers into his open mouth. This 'memory' has been discussed extensively but no definitive interpretation has been made, although it appears to be connected with his obsession with flying. No other project preoccupied Leonardo as persistently as flight. He began writing his thoughts on it in his *Codex on the Flight of Birds*, and his desire to create a flying machine occupied him for almost his whole career, as his first sketches of them began during his early period in Florence. Later, in Milan, he invested even more time and energy in these ideas, considering such things as air resistance, and this drawing reveals that he invented the world's first landing gear system for an aircraft. To test the potential of his ideas, Leonardo often built small models from paper and wax. This retractable component would have been inside his machine and would enable it to take off and to land.

LOCATION

Bibliothèque de l'Institut de France, Paris, France

CREATED

Drawn in Milan

MEDIUM

Pen and ink on paper

PERIOD

Middle period

Diagram of a Mechanical Wing, 1487–90

'The bird is an instrument which functions according to mathematical laws, and man is capable of making such an instrument with all these movements,' wrote Leonardo in one of his many notes about flying. For years he tried to design something that would enable humans to achieve flight, but the technology available was not as advanced as he was. His fascination increased over time, and he filled notebooks with numerous ideas and inventions, including a form of helicopter and parachute. In his earliest studies on the subject, approximately between 1485 and 1490, Leonardo made diagrams for a machine that would be powered directly by a pilot, but he soon realised that no man would be able to lift himself off the ground by power of his arms alone. So he began considering how to use the strength of the legs to power wings, and made extensive visual and written notes on birds' wings, then articulated some mechanical wings, closely following the span and movement he had observed. For a while, he believed that human muscle power and his mechanical wings would be enough to raise a human into the air. Concurrently, he was making working machines, including flying machines in small scale for festivities and celebrations.

LOCATION

Bibliothèque de l'Institut de France, Paris, France

CREATED

Drawn in Milan

MEDIUM

Pen and ink on paper

PERIOD

Middle period

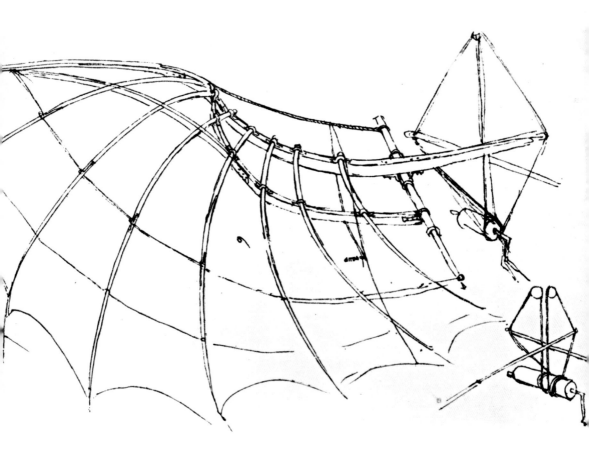

Study for a Flying Machine, 1487–90

© Bibliothèque de l'Institut de France, Paris, France/Bridgeman Images

After studying the flight of birds and bats, Leonardo began to design machines such as this, based on natural wing mechanisms. In his *Codex on the Flight of Birds*, he wrote: 'Remember that your flying machine must imitate no other than the bat, because the web is what by its union gives the armour, or strength to the wings.' For this machine, the pilot would lie on a board, or would be suspended horizontally by a belt or a semi-circular metal hoop, with their feet in two stirrups at the back. Pushing down on one of the stirrups would make the wings move up, and pushing down on the other would make the wings move down.

He wrote: 'Man when flying, must stand free from the waist upwards, so as to be able to balance himself as he does in a boat, so that the centre of gravity in himself and in the machine may counterbalance each other.' Although elements of these ideas had been considered before, no one before Leonardo had made so many intense explorations.

LOCATION

Bibliothèque de l'Institut de France, Paris, France

CREATED

Drawn in Milan

MEDIUM

Pen and ink on paper

PERIOD

Middle period

A Storm in an Alpine Valley, *c.* 1508–10

Leonardo drew this while in the service of the French during his second stay in Milan. It shows a storm breaking over a valley in the Alps. Above the clouds, the mountain peaks are bathed in sunlight. He drew several of these views, some from the roof of Milan Cathedral. He had a fear of floods and storms, as he described them in his drawings and notes, and he had witnessed the Arno's banks bursting twice, in 1466 and 1478.

For these drawings he recorded both distance and detail, drawing fossil shells found in the mountains and writing about them, proving that he climbed at least part of at least one mountain: 'In the mountains of Verona the red marble is found all mixed with cockle shells turned into stone.... And this may be seen, as I saw it, by anyone who goes up the Momboso (Monte Rosa), a peak of the Alps that divide France from Italy.... And I saw the sky above me quite dark, and the sun as it fell on the mountain was far brighter than in the plains below.'

LOCATION

Royal Collection Trust, Windsor Castle, UK

CREATED

Drawn in Milan

MEDIUM

Red chalk on paper

PERIOD

Middle to Late period

Outer Luminosity of the Moon (*Lumen Cinereum*), 1508–12

Along with his fascination with the world, Leonardo studied the sky, making diagrams of the stars and planets, plotting their positions and often making accurate astronomical discoveries. While most of his contemporaries believed that stars were simply tiny dots in the sky, Leonardo realized that they were probably similar to our sun, but further away. He made the earliest drawings to show the surface of the moon, and he also researched into the nature of the moon's light. Incorrectly, he decided that the moon reflected the light of the sun because it was covered in water.

This page shows how the sun and earth contribute to illuminating the moon; the rays from the sun are reflected on to it from the oceans of the earth. He also discusses the elements of the moon and the indirect causes of its luminosity. He explains that the pale glow on the dark surface of the crescent moon (that he calls an 'ashen surface' or '*lumen cinereum*') is caused by sunlight reflected from the earth. A century later, this phenomenon was proved by the German astronomer Johannes Kepler (1571–1630).

LOCATION

Private Collection

CREATED

Written in Milan

MEDIUM

Pen and ink on paper

PERIOD

Late period

Studies of the Illumination of the Moon, c. 1506–08

This study, as well as the *Outer Luminosity of the Moon* on the previous page, are from Leonardo's *Codex Leicester*, named after its first owner, the Earl of Leicester. Consisting of eighteen sheets of paper, the *Codex Leicester* is a collection of Leonardo's observations and theories in the form of drawings, diagrams and writing on astronomy, geology and light. This is the most famous page in the *Codex*, and shows some of Leonardo's explorations into astronomy, which are quite remarkable considering he had little or no tuition on the subject. While living in Florence as a young man, he may have become acquainted with the doctrines of the astrologer, cosmographer and mathematician Paolo dal Pozzo Toscanelli (1397–1482), but perhaps not, as he never mentions Toscanelli's name, and his fascination with the sky seems to have emerged in later life. The diagrams here illustrate the moon and explain why the light from the moon is not as bright as the light from the sun. At the bottom of the sheet, a drawing illustrates waves of light bouncing off waves on the moon's surface, to show that the light rays are separate and do not mix together.

LOCATION

Private Collection

CREATED

Written in Milan

MEDIUM

Pen and ink on paper

PERIOD

Middle period

Icosahedron Elevatum Vacuum (illustration from De divina proportione), 1509

© Private Collection/Stapleton Collection/Bridgeman Images

From their first meeting at the Sforza court in Milan in 1496, Luca Pacioli and Leonardo became friends. Pacioli gave Leonardo instruction in mathematics and in return Leonardo illustrated Pacioli's treatise on geometry, *De divina proportione* (1509). After the French siege of Milan, the two men left the city and travelled to Mantua. Always enthused by mathematics, Leonardo wrote, 'There is no certainty in science where mathematics cannot be applied,' and Pacioli said of Leonardo's pyramidal drawings, 'these figures … truly no man can surpass'.

For *De divina proportione*, which was published in 1509 as the first in a three-volume set, Pacioli discussed such things as the golden ratio and the properties of polyhedra: three-dimensional shapes with flat faces and straight edges, such as cubes and pyramids. For the book Leonardo devised a new way of drawing polyhedra, as skeletons, with solid edges and hollow faces, so that the reader could see through them. He also drew a geometrically designed alphabet for the book, but it was his ground-breaking way of drawing the polyhedra that became the highlight of Pacioli's book. In his notebooks, Leonardo wrote about the theories of Euclid (fl. 300 BC), a Greek mathematician who is often referred to as the founder or father of geometry.

LOCATION

Private Collection

CREATED

Drawn in Milan

MEDIUM

Lithograph

PERIOD

Middle period

ARTIST

Luca Pacioli (*c.* 1445–*c.* 1517) and Leonardo da Vinci (1452–1519)

icosaedron Eleuatum Vacuum

Human Head from
De divina proportione, 1509

It is possible that Leonardo suggested to Sforza that he invite Pacioli to the Milanese court in 1496 to give instruction in mathematics. This profile of a man's head is one of the illustrations made by Leonardo for Pacioli's *De divina proportione*. The title of the book refers to the golden ratio that was discovered by the ancient Greeks and that had become especially relevant during the Renaissance. Pacioli referred to the golden ratio as 'Divine Proportion', hence the name of his book. The golden ratio is approximately equal to 1.6180 and has been used frequently in geometry, art and architecture, and was revived particularly during the Renaissance when beauty and idealism were emphasized. This woodcut demonstrates how the golden ratio appears in nature through the proportions of the human head. As it is a print, Leonardo's letters are facing the correct direction in order to be read. He spent time in Milan conducting his own research into geometry based on the teachings of Pacioli and Euclid. It seems that during this period, he became obsessed with geometry and virtually stopped painting.

LOCATION

Private Collection

CREATED

Drawn in Milan

MEDIUM

Woodcut

PERIOD

Middle period

Studies of Geometry, Clouds, Plants, Engineering, *c.* 1490

This page of Leonardo's notes, drawings and sketches include a variety of geometrical diagrams, detailed elements of drawing and quick impressions, including an old man in profile, trees, a rearing horse with a rider and a standing warrior seen from the back, two screw presses, a detailed blade of grass and an arum lily, dramatically-lit cumulus clouds, swirling, tumultuous water, shapes, lines and indications of proportions, a mountain and some patterns. Overall, the page reveals how Leonardo was stimulated by a wide range of interests. In 1490, when he was making these notes, he was also creating the decorations for the *Festa del Paradiso* to celebrate the marriage of Gian Galeazzo Sforza to Isabella of Aragon. Additionally, he was working on his grand plans for the *Gran Cavallo* and his illustration of Vitruvian theory on 'the body as architecture' (*see* page 182). Also that year, Salai joined Leonardo's household and he met the architect, engineer, painter, sculptor and writer Francesco di Giorgio Martini (1439–1501), who arrived in Milan to advise on the construction of the lantern for the cathedral that Leonardo hoped to build.

LOCATION

Royal Collection Trust, Windsor Castle, UK

CREATED

Drawn in Milan

MEDIUM

Stylus, compasses, pen and ink, touches of red chalk on paper

PERIOD

Middle period

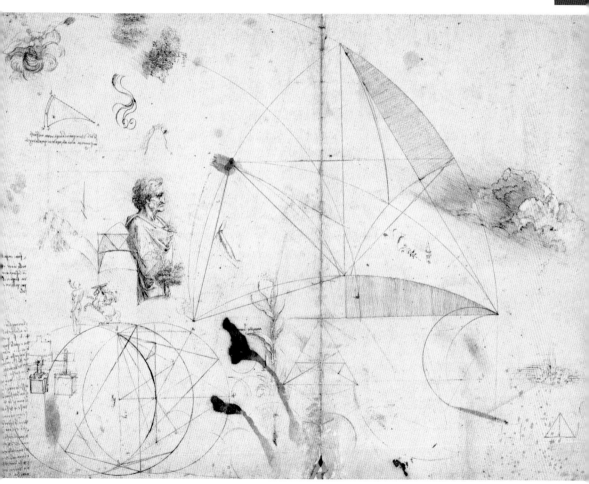

Proportions of the Human Figure (after Vitruvius), c. 1490

© Gallerie dell'Accademia, Venice, Italy/Bridgeman Images

Based on the work of the ancient Roman architect Vitruvius, this drawing and the notes that go with it illustrate the proportions of the human body. Vitruvius described the human figure as being the principal source of proportion in the classical orders of architecture, and here each measurement corresponds to another. For instance, the length from the forehead to the chin is exactly one-tenth of the total height, and the length of two outstretched arms corresponds to the height of a grown man. These measurements can all be subdivided into smaller units of length, and Vitruvius, Leonardo, Pacioli and others all believed that these same principles can — and should — be used when designing buildings. However, Leonardo tried to take these ideas further, and spent a great deal of time searching for connections between the structure of the human body and other patterns in nature. In this drawing, the male height comprises eight head-lengths. The drawing also shows how Leonardo sought to 'square the circle', by drawing a circle and square that have the same area — without measuring.

LOCATION

Gallerie dell'Accademia, Venice, Italy

CREATED

Drawn in Milan

MEDIUM

Pen and ink over metalpoint

PERIOD

Middle period

Arno Landscape, 5 August, 1473

© Galleria degli Uffizi, Florence, Italy/Bridgeman Images

This is the first surviving landscape drawing by Leonardo and it is rare because it is simply a scene with no other purpose, and it is signed by him. Sometimes called *Landscape of Santa Maria delle Neve*, the drawing is dated 5 August 1473, so we know that Leonardo was 22 when he drew it. It has also been called 'the first true landscape drawing in Western art'. Two landscape frescoes by the painter Ambrogio Lorenzetti (c. 1290–1348) in Siena in 1340 were known by then, and in Asian art, landscape was traditional, but views on their own were not common in European art. It seems that Leonardo sketched from first-hand observations. Then, as he did with many drawings and paintings, he amalgamated elements. In the distance are a castle, the Fucecchio marshlands, a waterfall and, on the horizon, the peak of Monsummano. Using firmer pen strokes in the foreground and softer, sketchier marks in the background, it conveys a sense of distance and atmosphere through aerial perspective and, overall, Leonardo seems to have concentrated on capturing the effects of weather and atmosphere.

LOCATION

Galleria degli Uffizi, Florence, Italy

CREATED

Drawn in Florence

MEDIUM

Pen and ink on paper

PERIOD

Early period

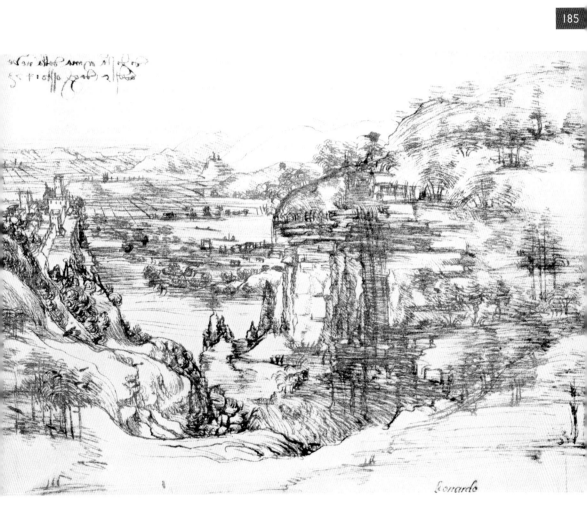

Studies for a Building on a Centralized Plan, *c.* 1487–90

© Institut de France, Paris, France/Bridgeman Images

Built over 500 years beginning in 1387, Milan Cathedral is in the High Gothic style of architecture, but was designed and constructed by numerous architects and masons as political and religious power kept changing in the city. During his time in Milan, Leonardo was consulted about the building, and in 1487 he began working on designs for the dome, which this drawing shows. Just one of several drawings he submitted for the prestigious and challenging project, it shows how he favoured a centralized design for the cathedral. The design focuses on the use of the square and circle, as Leonardo believed this would create physical harmony to complement the spiritual harmony in the building. Although this is not an architectural plan, the dome is seen from different angles, in perspective and from a bird's eye view, with written notes at the bottom on the left-hand side. Ultimately, Leonardo's dome was never built, but the exercise affected the rest of his career, as from then on he began to use mathematics and to incorporate geometry into much of his work.

LOCATION

Bibliothèque de l'Institut de France, Paris, France

CREATED

Drawn in Milan

MEDIUM

Pen and ink and wash over black chalk

PERIOD

Early to Middle periods

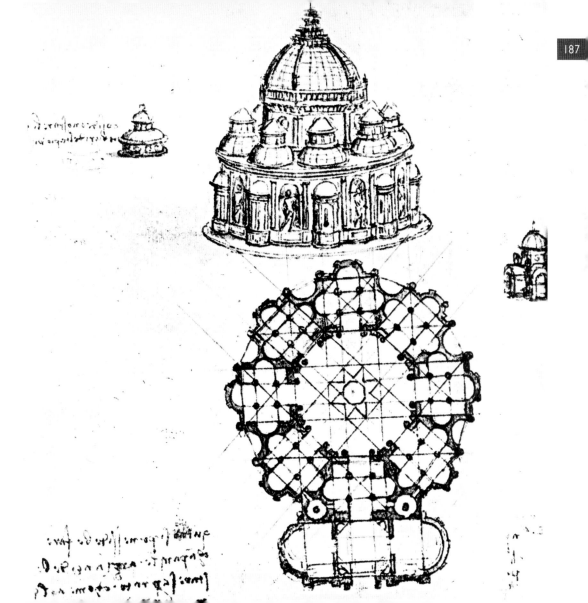

A Bird's Eye Map of Western Tuscany, c. 1503–04

Cartography was another area in which Leonardo excelled, and he produced some of the most detailed and creative maps of the time. This map may have been made especially for military purposes while he was employed by Cesare Borgia, or he may have drawn it as part of his plans to build a canal from Florence to the sea. Either way, this map is a detailed overview of western Tuscany, from Lucca to Campigli. It shows Pisa beside the River Arno in the north-west and Volterra in the south-east, and includes over 100 km (60 mi) of coastline. Leonardo focused on the rivers, perhaps because they were important strategically in military matters, or because he was fascinated by them, or because he was showing the Florentine government how successful the diversion of the River Arno would be for them. The sea and rivers are coloured with ultramarine, made from costly lapis lazuli from Afghanistan, and the towns are painted with raw sienna, while the hills are modelled with a light sepia wash and everything is outlined and labelled in ink.

LOCATION

Royal Collection Trust, Windsor Castle, UK

CREATED

Drawn and painted in Romagna

MEDIUM

Pen and ink, wash, and blue bodycolour, over black chalk

PERIOD

Middle period

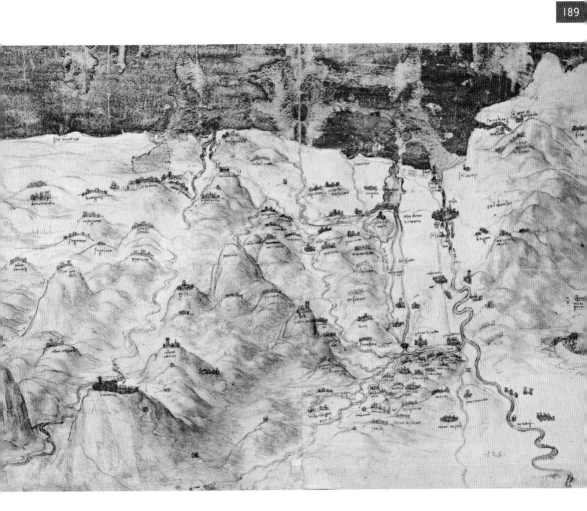

A Plan of Imola, 1502

This is the largest and most important of Leonardo's maps; a plan of the town of Imola, to the south-east of Bologna. In May 1502, Leonardo had started working for Cesare Borgia as senior military architect and general engineer, and he produced this map in that role. Borgia's forces had taken Imola in 1499, and as his chief military engineer in charge of the design of machines, warfare equipment and fortifications, land surveys and map-making, Leonardo drew the map to give Borgia a clear understanding of the territory. It also plots the course of the Arno, to show how he could divert the river. Enclosed in a circle, the map features lines that form eight points of the compass across the map, and on these lines, Leonardo wrote the names of the winds. Using careful, exacting measurements, he included every street, plot of land, church, gate and square. To create this map with accurate proportions and relationships between land features, it is possible that he used his inventions, the odometer and magnetic compass (the former measured distances, while the latter measured directions).

LOCATION

Royal Collection Trust, Windsor Castle, UK

CREATED

Drawn in Romagna

MEDIUM

Pen and ink, with coloured washes, and stylus lines, over black chalk

PERIOD

Middle period

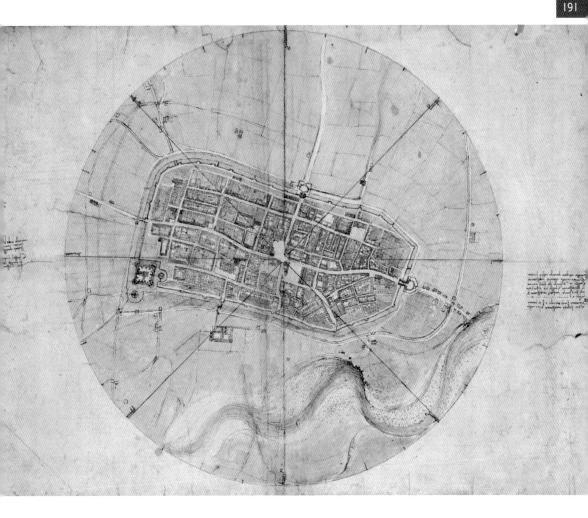

Map of the Val di Chiana, *c.* 1503–04

Probably made during Leonardo's employment with Cesare Borgia, this is a general map of Tuscany and the Chiana Valley. Dominated by Lake Trasimeno and the Val di Chiana, it includes Arezzo, Perugia, Borgho san Sepolcro, Chiusi and Siena. The territory of the Val di Chiana extends over 22 municipalities. From the north, the valley runs southwardly from Arezzo and westward to Cortona. Using pen and ink and delicate, diluted pigments of ultramarine, sienna and sepia, Leonardo carefully recorded place and river names, but all the same there is no indication of importance. His marks and tonal areas make this a cross between a map and a landscape drawing. It is most likely that it was made as a strategic map for Borgia and probably also relates to the same campaign for which the *Plan of Imola* was drawn. Alternatively, it may have been made while Leonardo was working for the Florentine government and proposed building a tunnel to divert water from the River Tiber to Lake Trasimene, expanding it to fill the Val di Chiana so that the Arno would not dry up in summer.

LOCATION

Royal Collection Trust, Windsor Castle, UK

CREATED

Drawn in Romagna or Florence

MEDIUM

Pen and ink, watercolour and bodycolour over black chalk

PERIOD

Middle period

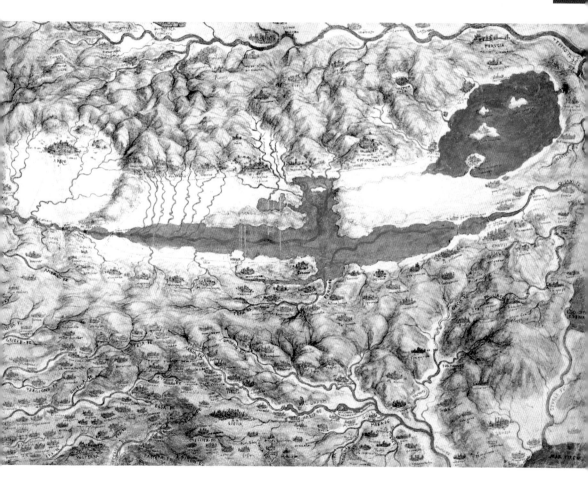

Study of Arms

In his fascination with the world and how things work, and his determination to produce the most lifelike works of art possible – as well as his belief that science and art were mutually dependent – Leonardo studied the structure and workings of the body more closely than most artists of the time, and his interest in anatomy became an important part of his research. Starting in the 1480s, he began studying the body especially closely, and by the early sixteenth century he often worked with Marcantonio della Torre (1481–1511), a Professor of Anatomy at the Universities of Pavia and Padua. He observed and made notes as Marcantonio dissected. In Florence he was given access to corpses at the Ospedale di Santa Maria Nuova. By the turn of the sixteenth century, Leonardo had made over 750 detailed anatomical drawings with annotations. In c. 1520, the physician and historian Paolo Giovio wrote: '... in the medical faculty he learned to dissect the cadavers of criminals under inhuman, disgusting conditions, because he wanted to (examine and) draw the different deflections and reflections of limbs and their dependence upon the nerves and the joints.' This drawing of arm muscles by an unknown artist appears to have derived directly from Leonardo's diagrams.

LOCATION

Musée du Louvre, Paris, France

MEDIUM

Pen and ink on paper

ARTIST

Artist unknown

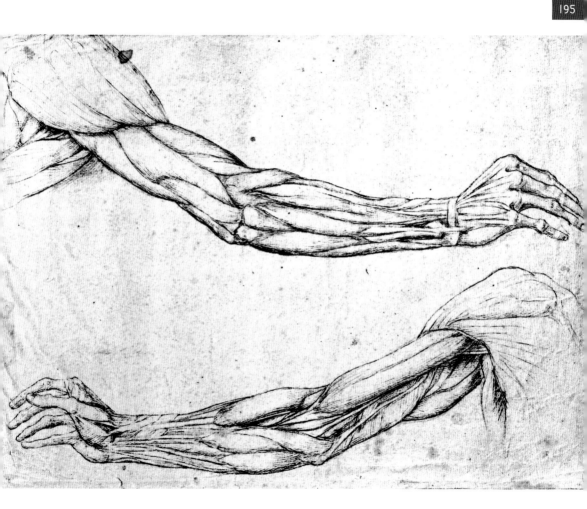

The Head of a Horse, *c.* 1503–04

In early 1503, Leonardo agreed to paint the huge mural of *The Battle of Anghiari* in the Sala del Gran Consiglio in the Palazzo Vecchio in Florence. The painting was to depict a celebrated victory of 1440 when the Florentine army defeated the Milanese. Work on the cartoon began in 1503, but as there were many interruptions, little progress was made. Then in May 1506, Leonardo was requested to return to Milan, initially for three months, to work for the French occupiers of that city; however, he never returned to the project and only a portion of the centre of the painting, depicting a confrontation, generally known as the *Fight for the Standard*, was completed. However, he had made extensive preparatory studies, and this horse's head formed part of them. It is on a sheet filled with several other drawings in which he explored the differences and similarities between the muscles of humans and of horses. Leonardo wrote about the details he wanted to include and the emotions he aimed to portray in his mural, and this horse's head conveys the action of the battle.

LOCATION

Royal Collection Trust, Windsor Castle, UK

CREATED

Drawn in Florence

MEDIUM

Pen and ink with traces of black chalk

PERIOD

Middle period

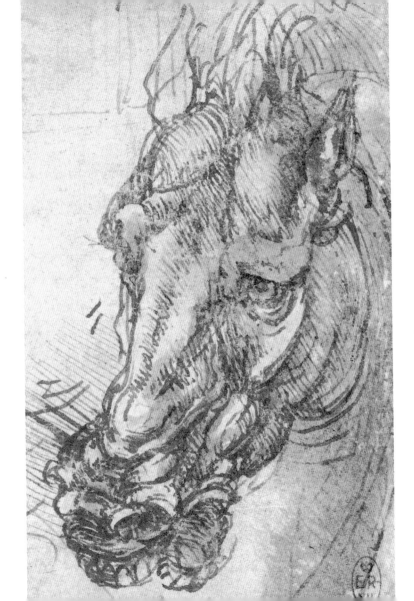

A Dog's Head and Chest and Hind Leg

From his earliest days living in the countryside with his Uncle Francesco, Leonardo spent hours studying animals, watching how they moved, and then drawing them, capturing their textures, movements and mannerisms. Later, he dissected several animals to understand their anatomy, and as a result of this scrutiny the animals he featured in many of his paintings appear incredibly lifelike, some moving, some sitting, and some standing still, such as in his *St Jerome* (*see* page 32), *Lady with an Ermine* (*see* page 50), *The Adoration of the Magi* (*see* page 98) and *Madonna with the Cat*. Horses were Leonardo's favourite animals, though he seems to have had at least one pet dog and he drew many sketches of cats.

It is not known whether it was for the whole of his life or for just a part of it that Leonardo was a vegetarian, but he was certainly empathetic towards all living creatures. According to Vasari: '... often when he was walking past the places where birds were sold he would pay the price asked, take them from their cages and let them fly off into the air, giving them back their lost freedom.'

LOCATION

Royal Collection Trust, Windsor Castle, UK

MEDIUM

Red chalk on paper

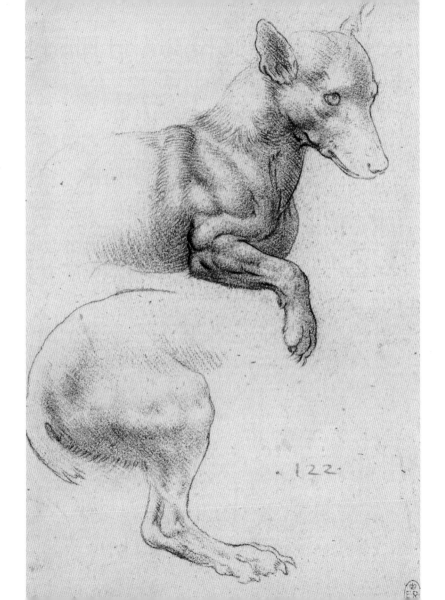

·122·

Anatomical Studies of the Muscles of the Neck and Shoulder, *c.* 1512–13

Royal Collection Trust © Her Majesty Queen Elizabeth II, 2018/Bridgeman Images

The first evidence we have of Leonardo's anatomical drawings are from the late 1480s. From that time, he began documenting the human body exactingly, but although he was pioneering, he was not alone. Other artists, such as Antonio del Pollaiuolo, who was almost 20 years his senior, was said to have dissected corpses. Although that has not been substantiated, Pollaiuolo's figure drawings and paintings are extremely lifelike. A certain amount of study of anatomy was part of all art students' training, but this was relatively superficial – only bones and muscles, and not as detailed as this diagram. Leonardo's anatomical studies went much further than those of most artists; they were more in line with doctors' studies of the time.

In 1498 Leonardo began filling a notebook that he intended would focus solely on anatomy. He studied all parts of the body, including the brain, eyes and other organs, and this drawing is part of a series that he created around this time – and was possibly among some of his last drawings. It features extraordinary detail of the layers of skin, bone, muscle and surrounding tissue.

LOCATION

Royal Collection Trust, Windsor Castle, UK

CREATED

Drawn in Milan

MEDIUM

Pen and two shades of brown ink on blue paper

PERIOD

Late period

Foetus in the womb, *c.* 1510

Had Leonardo's treatise on anatomy that he started in 1489 been published, it would have contributed to the advance of medical science. This page includes a large drawing of an embryo inside a human uterus with a cow's placenta, a smaller sketch of it, written notes about it, more drawings of the placenta and uterus, a diagram showing binocular vision and a note on relief in painting and on mechanics. He studied dissections undertaken by his friend Marcantonio della Torre at a time before refrigerators existed.

Leonardo is commonly thought to be the first person to correctly depict the human foetus in its proper position within the womb and for the womb to be drawn accurately; most of his contemporaries believed that the womb was divided into numerous chambers. The embryo is also curled up in the accurate foetal position, with the umbilical cord visible. Leonardo drew these studies at a time when there were many social and religious taboos about investigating the human body, and when most doctors still relied on the ancient Greek beliefs of Hippocrates (*c.* 460–*c.* 375 BC), Galen (*c.* 130–*c.* 210) and Aristotle.

LOCATION

Royal Collection Trust, Windsor Castle, UK

CREATED

Drawn in Milan

MEDIUM

Pen and ink over red chalk

PERIOD

Late period

Side View of Human Skull in Sagittal Section, with Cranial Nerves, 1489

Contemporary religious opinion condemned anatomical investigations as being against the will of God. In the Church's opinion, humans were God's creation, made in his image and so should not be interfered with. Yet from the 1480s, Leonardo's scientific studies were as important to him as his artistic activity. For this drawing, Leonardo was investigating the veins, nerves and cavities inside the human skull. As far as we know he was not religious until a short time before his death.

To produce this drawing, he sawed a section of the cranium, vertically and horizontally, at a 90 degree angle, and drew the skull from a three-quarter view using methods of perspective, which was as original as his scientific investigations. With a quarter of the cranium cut away, he exposed the interior, and in his notes beneath the drawing he wrote about his observations. Although they are scientific notes about the way the components of the head function together, Leonardo was also learning about the functions of the body in order to paint portraits as well as he could; for him, science and art were inseparable.

LOCATION

Royal Collection Trust, Windsor Castle, UK

CREATED

Drawn in Milan

MEDIUM

Pen and brown ink on paper

PERIOD

Middle period

The Lungs, Heart and Abdominal Organs of a Pig, *c.* 1508

In 1508 Leonardo dissected an old man and a woman in the Ospedale di Santa Maria Nuova in Florence. By that time, he was renowned as an artist and in August he completed his second version of *The Virgin of the Rocks*. He also painted *Leda and the Swan* and continued further anatomical studies, both in Florence and when he moved to Milan to work for Charles d'Amboise. Although it is not clear exactly what he produced during his second period in Milan, the new French rulers paid him more than his previous patrons.

This detailed drawing of lungs, a heart and abdominal organs are generally thought to be of a pig. Leonardo believed that the anatomy of certain animals, including the ox and the pig, was related to the anatomy of humans, so he made comparative explorations and drawings of the organs of these animals. Over the following few years, he dissected approximately 30 human corpses and an unknown number of other animals, making detailed drawings, combining his developing understanding of physical structure and his exceptional skills as a draughtsman.

LOCATION

Royal Collection Trust, Windsor Castle, UK

CREATED

Drawn in Florence

MEDIUM

Pen and three shades of brown ink over chalk on paper

PERIOD

Middle period

Drawing of the Ironwork Casting Mould for the Head of the Sforza Horse, *c. 1491–93*

© Biblioteca Nacional de España, Madrid, Spain/Bridgeman Images

From early in his life, Leonardo was fascinated by horses and he was also in awe of the statue he probably saw being planned in 1479 in Verrocchio's studio, *Equestrian Statue of the Mercenary Leader Colleoni*, that Verrocchio completed in 1488. Following Greco-Roman ideals, during the Renaissance equestrian statues were a fashionable way to honour rulers, and so Leonardo was delighted when he was asked by Ludovico to design the equestrian sculpture to proclaim the importance of the Sforza dynasty in Milan. He made many studies of other equestrian statues as well as actual horses.

Initially he planned to represent his horse rearing, but he could not make this work in bronze, so he created different designs of the horse as if it was walking. In 1493, he made the life-sized clay model in the courtyard of the Sforza castle, and then he began making technical studies. This drawing shows how he developed a completely new method of casting bronze; it represents the head and neck sections of the negative mould, reinforced by fittings. Leonardo divided the mould to simplify its removal after casting.

LOCATION

Biblioteca Nacional de España, Madrid, Spain

CREATED

Drawn in Milan

MEDIUM

Red chalk on paper

PERIOD

Middle period

An Ear of Greater Quaking Grass (*Brisa maxima*), Violets (*Viola spec*) and perhaps Pear Blossom (*Pyrus communis*), c. 1481–83

© De Agostini Picture Library/Bridgeman Images

Although Leonardo drew flowers and plants from his childhood, some of his later studies of these are among the worst preserved of all his observational sketches. Most are delicate and carefully drawn, as in this range of flowers and plants, and pay close attention to all their individual details. When he lived in Milan and was organizing many of his studies, Leonardo included 'many flowers drawn from nature'. He drew these partly out of his general fascination for everything, as scientific studies, and sometimes to incorporate them in his paintings. Despite his innovations, studies of plants were fairly common at the time; works of art the world over featured flora and fauna in some form or another, as many cultures perceived them as part of God's creation. In Europe there was also a tradition of herbals, books that illustrate and describe plants and their medicinal properties. This drawing was made in the early part of Leonardo's career, but later on he became increasingly interested in plant growth and understanding their reproductive processes, as he worked out that they relied on water and sunlight.

LOCATION

Gallerie dell'Accademia, Venice, Italy

CREATED

Drawn in Milan

MEDIUM

Pen and ink over metalpoint on brownish prepared paper

PERIOD

Early period

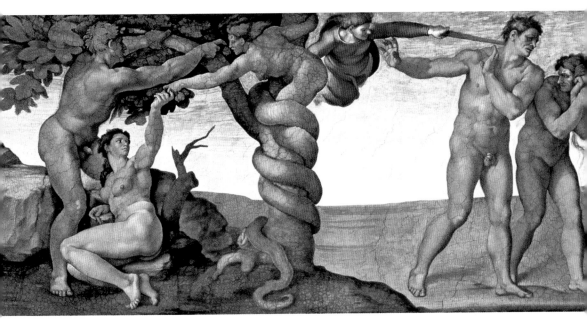

Sistine Chapel Ceiling:
The Creation of Adam, 1511–12

© Vatican Museums and Galleries, Vatican City/Bridgeman Images

Part of Michelangelo's Sistine ceiling, this is the Creation of Adam, depicting the meeting of the material and spiritual worlds, as Adam extends his hand to receive life from God.

In 1859, Charles Darwin (1809–82) published *The Origin of Species*, explaining his theory that humans evolved from earlier species and that our closest relatives are apes. Since then, DNA evidence confirms that we are similar to chimpanzees. Darwin's theories were exceptionally controversial: central to Christian teaching, the idea of Man being created by God in his likeness as painted here by Michelangelo was suddenly being refuted: Darwin's theory contradicted centuries of belief.

Yet almost 400 years before Darwin wrote of it, Leonardo anticipated his discovery and always believed that it was obvious that humans are closely related to apes, writing notes about his observations and studies. In his plan for a book on anatomy, he intended to write a chapter on 'The description of man, which includes that of such creatures as are almost of the same species, as Apes, Monkeys and the like, which are many'.

LOCATION

Vatican Museums and Galleries, Rome, Italy

CREATED

Painted in Rome

MEDIUM

Fresco

ARTIST

Michelangelo (1475–1564)

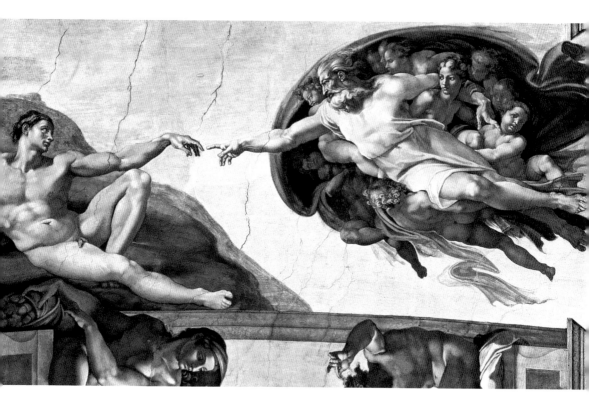

The Last Judgement, 1536–41

A contemporary author known as the Anonimo Gaddiano or Anonimo Fiorentino (the Anonymous Florentine) records an altercation on the streets of Florence when Michelangelo retorted to an imagined slight by Leonardo: 'You who designed a horse to cast in bronze, and couldn't cast it, and abandoned it out of shame.' Their rivalry was established. However, Michelangelo was probably inspired to create ever more lifelike art with greater animation because of Leonardo's precedent. Vasari recounts that when others saw Michelangelo's cartoon of *The Battle of Cascina*, 'all the other artists were overcome with admiration and astonishment, for it was a revelation of the perfection that the art of painting could reach'. Soon after, Leonardo left Florence. Even though he criticized images that exaggerate the muscularity of figures, his later anatomical drawings show Michelangelo's influence.

Pope Clement VII (1478–1534) commissioned Michelangelo to paint a scene on the altar wall of the Sistine Chapel. Michelangelo painted the Second Coming of Christ and the Final Judgement of all humanity by God. The vivid realism and dynamism of Michelangelo's figures continue Leonardo's legacy.

LOCATION

Vatican Museums and Galleries, Rome, Italy

CREATED

Painted in Rome

MEDIUM

Fresco

ARTIST

Michelangelo (1475–1564)

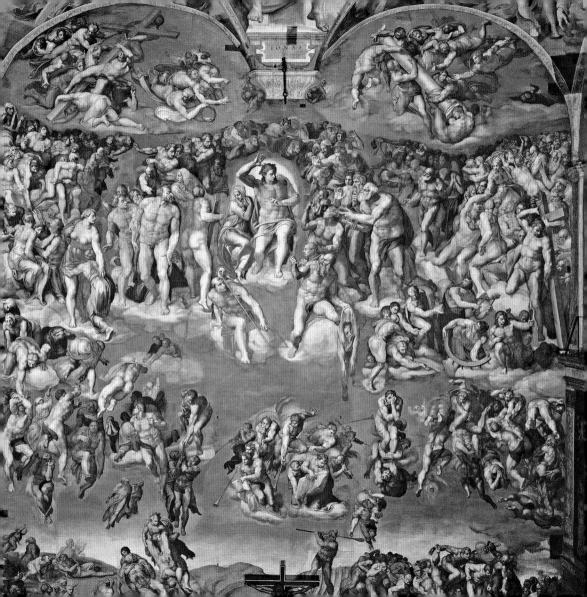

Mona Lisa, 1503–19

As he built on his elevated reputation, Leonardo's workshops — that he established where he lived and worked, including in Florence and Milan — became extremely busy, attracting many pupils, assistants, associates and followers. Among these were Salai, Boltraffio, Marco d'Oggiono, Melzi, Ambrogio de Predis, Bernardino de' Conti (1470–c. 1523), Francesco Napoletano (1470–1501), Andrea Solario (c. 1465–1524), Giovanni Antonio Bazzi, known also as Il Sodoma (1477–1549), Giovanni Francesco Rustici (1475–1554), Giampietrino (active c. 1500–50) and Cesare da Sesto (1477–1523). Also known as Leonardeschi, all these artists learned from Leonardo by copying his works either as he painted them or after they were completed. This replica of the *Mona Lisa* was probably painted by either Salai or Melzi. It is likely that it was painted alongside Leonardo as he painted the original, as alterations were made to it that replicate the changes that Leonardo made, such as to the outline of the veil and the position of the fingers. In addition, as marks on the original that Leonardo added later have not been added to this work, it implies that the copy was painted in Italy before Leonardo went to France.

LOCATION

Museo del Prado, Madrid, Spain

CREATED

Probably painted in Florence

MEDIUM

Oil on walnut panel

ARTIST

Workshop of Leonardo da Vinci

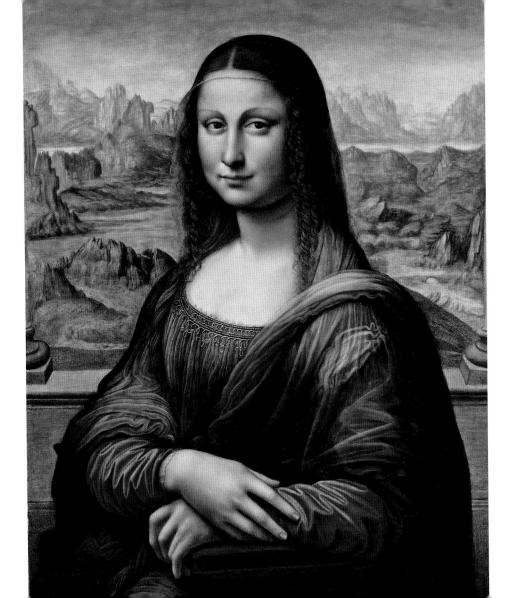

The Three Archangels, 1517

In common with many of Leonardo's pupils and associates, Marco d'Oggiono, usually known simply as Marco, was from a wealthy family from Oggiono, north of Milan. He probably entered Leonardo's studio after completing his apprenticeship elsewhere. A note written by Leonardo in 1490 refers to life in his studio, mentioning Marco and Salai: 'On 7 September (Salai) stole a pen worth 22 soldi from Marco, who was living with me. This pen was silverpoint and he took it from Marco's study....'

In the Catholic Church, the three archangels, Michael, Gabriel and Raphael, are said to protect humanity. Marco created this painting as a large altarpiece for the church of Santa Maria in Milan, following Leonardo's style closely, depicting the angel Michael, in the centre, killing Satan with a sword.

While Leonardo's many followers emulated his style, in turn, when he was learning he was influenced by other artists, including Verrocchio and Benozzo Gozzoli (*c.* 1421–97), who painted a particularly lavish work in the Medici chapel in Florence, *The Procession of the Magi* (1459). Leonardo admired this work, which included depictions of members of the Medici family.

LOCATION

Pinacoteca di Brera, Milan, Italy

CREATED

Painted in Milan

MEDIUM

Oil on panel

ARTIST

Marco d'Oggiono (*c.* 1470–*c.* 1524)

The Wedding at Cana, 1519–22

© Mondadori Portfolio/Electa/Sergio Anelli/Bridgeman Images

Vasari refers to Boltraffio and Marco at the end of his biography of Leonardo: 'Another of Leonardo's pupils was Marco Uggiono (sic), who in Santa Maria della Pace painted the Assumption of the Virgin and the Marriage of Cana in Galilee.' As mentioned, Marco was probably not Leonardo's pupil when he joined the workshop, but a newly qualified artist learning his trade. This is possibly one of the paintings to which Vasari refers. The Wedding (or Marriage Feast) at Cana was a popular subject among artists of the Renaissance, and this was executed in the immediate aftermath of Leonardo's death. At that time, many artists were seeking to emulate his style and approach, especially those who had trained or worked with him. Here, Marco borrowed heavily from Leonardo's *The Last Supper* (*see* page 320), especially in the composition and the poses and gestures of the dining figures. In addition, Marco has aimed to create a sense of dynamism with the lunging central figure and the flowing, swirling fabric. However, this work does not match Leonardo's naturalism nor his sensitive handling of colour and sfumato.

LOCATION

Pinacoteca del Castello Sforzesco, Milan, Italy

CREATED

Painted in Milan

MEDIUM

Arched fresco transferred to canvas

ARTIST

Marco d'Oggiono (*c.* 1470–*c.* 1524)

Madonna and Child with Sts John the Baptist and Sebastian Between Two Donors, *c.* 1500

© Louvre, Paris, France/Peter Willi/Bridgeman Images

One of his most accomplished pupils, Giovanni Antonio Boltraffio was first recorded in Leonardo's *bottega* in 1491. According to Vasari, Boltraffio was from an aristocratic Milanese family and as he developed as an artist, while emulating Leonardo, he also developed ideas of his own. By 1498, he started acquiring his own independent commissions for altarpieces, portraits and small devotional paintings. Once again, however, like all of Leonardo's pupils and assistants, Boltraffio could not match the soft sfumato qualities of Leonardo, and his paintings feature firmer, harder edges than those of his master. After the French took over Milan and Leonardo went to Mantua, Boltraffio also left and he painted this work in Bologna, where he worked for the Casio family from 1500 for at least two years. Commissioned by Giacomo Marchione de' Pandolfi da Casio (dates unknown) and his son Girolamo Casio (1464–1533) for their family chapel in the church of Santa Maria della Misericordia near Bologna, it depicts a traditional Madonna and Child with St John the Baptist and St Sebastian – with the donors, Giacomo and Girolamo Casio kneeling in prayer at either side.

LOCATION

Musée du Louvre, Paris, France

CREATED

Painted in Bologna

MEDIUM

Oil on poplar panel

ARTIST

Giovanni Antonio Boltraffio (1466–1516)

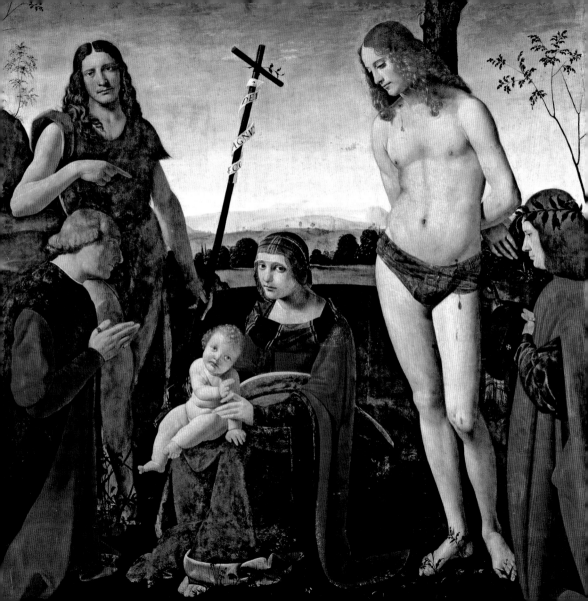

Leda and the Swan, *c.* 1510–15

Giovanni Antonio Bazzi became nicknamed Il Sodoma as a joke because of his homosexuality, but he decided to use it as his byname. He was not apprenticed to Leonardo, but he was influenced by him and is usually grouped with the other Leonardeschi. Although Vasari is dismissive of his work, as an artist Il Sodoma was highly respected in his lifetime, and for 300 years this painting was attributed to him. However, as it is a direct copy of Leonardo's 1508 painting *Leda and the Swan* and it was in France with Leonardo at the time of his death and then inherited by Salaì, its attribution is still doubtful. Experts suggest that it may have been painted by another follower of Leonardo's, perhaps Cesare da Sesto. Another copy of this painting by da Sesto is in the Wilton House Collection in the UK.

Leonardo began making preparatory works for his painting *Leda and the Swan* in 1504 (*see* page 72 and 286), and completed it in 1508. As here, the painting depicted a standing nude cuddling the swan with children next to their broken eggshells.

LOCATION

Galleria Borghese, Rome, Italy

CREATED

Possibly painted in Rome

MEDIUM

Tempera on panel

ARTIST

After Leonardo

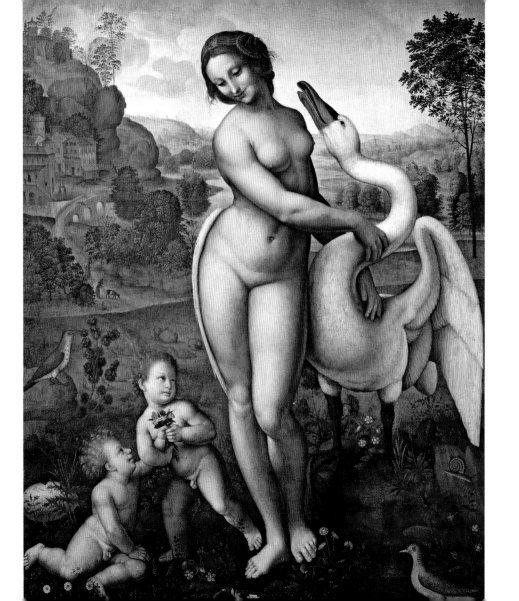

Head of a Woman, *c.* 1495–97

Probably a design for a painting of a Madonna, this drawing has been attributed to Boltraffio while he worked in Leonardo's studio in Milan, under his master's close guidance, as can be seen by the style and the expression on the model's face. The young female model seems to have been used by Boltraffio for his *Madonna and Child* (1490s) of the same period, now in the Museum of Fine Arts in Budapest. The use of metalpoint on a greyish sheet of paper was the technique and style that Boltraffio was learning from Leonardo at the time, while, additionally, the regular hatching – sometimes soft, close lines, sometimes firmer and further apart – can be seen to directly follow Leonardo's method. Although drawn by a right-handed artist, the hatching compares to the left-handed application of Leonardo. Boltraffio was a precise and careful artist who spent his life emulating Leonardo and trying to achieve a similar sublimity of approach. It is difficult to attribute many of the contemporary works that so closely copy Leonardo's style, but Boltraffio was one of the most successful.

LOCATION

Sterling and Francine Clark Art Institute, Massachusetts, USA

MEDIUM

Metalpoint on grey-green prepared paper

ARTIST

Giovanni Antonio Boltraffio (1466–1516)

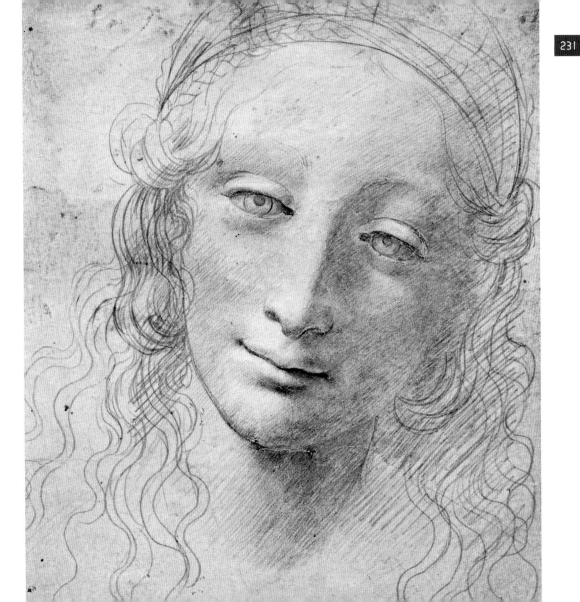

Leonardo da Vinci, 1878

John Argyropoulos (c. 1415–87) was one of the exiled Greek scholars from Constantinople who through his writing, teaching, translating and lecturing, helped to inspire the revival of Classical learning in Italy. Among others, he befriended Cosimo de' Medici, and under Cosimo's patronage he taught in Florence from 1456–70 and tutored Cosimo's grandson Lorenzo. Later, from 1471–87, he taught in Rome. While he was living in Florence as an apprentice, Leonardo probably attended lectures given by Argyropoulos.

This engraving of Leonardo featured in a book written in 1878 entitled *François Premier*, written by author and historian Mathurin François Adolphe de Lescure (1833–92). Lescure writes of François's 'courage, taste and liberality: the future hero of the epics of Italy, the future founder of the Collège de France, the future builder of Chambord and restaurateur of Fontainebleau, the future protector of Du Bellay, Marot, Estienne, Leonardo da Vinci, Benvenuto Cellini and of the Primate', and 'Here is the king of the gentlemen, the king of poets, the king of the ladies, the king of the novel in history, parading and riding in his theatre, accompanied by Leonardo da Vinci.'

LOCATION

From *François Premier* (1878)

MEDIUM

Engraving

ARTIST

Artist unknown

Leonardo da Vinci Presenting Architectural Plans to Ludovico il Moro, 1841

The Tribune of Galileo was built in 1841 in Florence to commemorate the famous scientist, Galileo Galilei (1564–1642) and to house some of his scientific instruments. Nicola Cianfanelli (1793–1848), a Neoclassical painter and restorer, painted seven lunettes for the interior, portraying the development of experimental science with Galileo at the centre. However, this, the first lunette, is not of Galileo, but depicts Leonardo who died 45 years before Galileo was born. It portrays him standing before Ludovico Sforza, wearing orange and green, holding architectural plans and indicating the figure next to him, the Franciscan monk and mathematician Luca Pacioli. Leonardo and Galileo had several things in common. Both were born in the Duchy of Florence and both were polymaths, fascinated with the universe and how it functions. Perhaps most of all, they both invented the telescope.

While the concept and design of the telescope is generally attributed to Galileo, Leonardo was the first to explore its possibilities. The designs in his notebook show how to make his telescope, including the dimensions and materials required, and he described the instrument as being able to 'magnify the moon'.

LOCATION

Tribune of Galileo, Florence, Italy

CREATED

Painted in Florence

MEDIUM

Fresco

ARTIST

Nicola Cianfanelli (1793–1848)

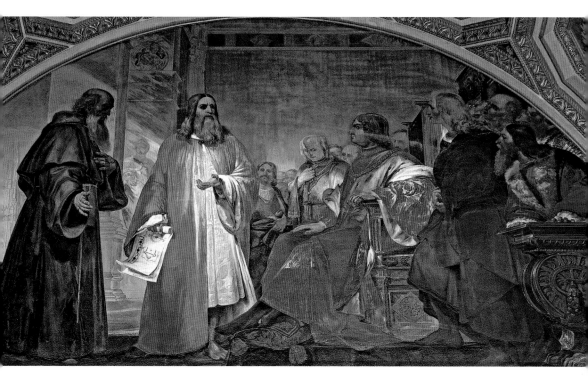

Apotheosis of the Renaissance, 1888

Mihály Munkácsy (1844–1900) was a Hungarian painter who, after a local apprenticeship, studied at both the Vienna and Munich Academies. He visited Paris to see the Exposition Universelle of 1867, then attended the Kunstakademie Düsseldorf. Inspired by his teachers and experiences, his style lightened and he used broader brushstrokes with brighter colours. His work became internationally famous, and in 1886 he was commissioned to paint a fresco for the ceiling of the Kunsthistorisches Museum in Vienna. Using dramatic foreshortening and perspective, he created an image featuring some of the greatest artists and architects of the Renaissance. In a loggia, the pope – possibly Julius II – can be seen as the greatest patron of the arts of the time, and in front of him are Leonardo and Raphael on the left-hand side of the staircase, with Michelangelo on the right behind the balustrade. At the top of the stairs, Titian gives painting lessons, and towards the back, Paolo Veronese (1528–88) paints on a scaffold. The classical space and surrounding elements epitomize the architecture that follows Alberti's suggestions in *De Re Aedificatoria* (1452).

LOCATION

Kunsthistorisches Museum, Vienna, Austria

CREATED

Painted in Vienna

MEDIUM

Fresco

ARTIST

Mihály Munkácsy (1844–1900)

Leonardo da Vinci painting Mona Lisa, 1863

The Sienese painter and sculptor Cesare Maccari (1840–1919) began studying sculpture at a young age and then enrolled at the Institute of Fine Arts in Siena in 1865, when he was 15. He started working as a sculptor before meeting the painter Luigi Mussini (1813–88) who was a great admirer of the French Neoclassical painter Jean-Auguste-Dominique Ingres (1780–1867) and medieval and Renaissance painting. He encouraged Maccari to paint more, which he did, inspired by Mussini's style, and also in particular by the art of the Renaissance. Working with oils and fresco, he produced many detailed, colourful images, often depicting imagined scenes, such as here in this elegant depiction of Lisa del Giocondo sitting for Leonardo who concentrates on her and his painting, while minstrels entertain her – and one gazes incredulously at her cool, serene beauty. In the foreground on the left-hand side, another young man – probably one of Leonardo's assistants – tries to restrain a pet dog, which could be Lisa's or Leonardo's. In the background one of his pupils is preparing paints while also sneakily glancing at the beautiful sitter.

MEDIUM

Oil on panel

ARTIST

Cesare Maccari (1840–1919)

239

Leonardo da Vinci gives the *Mona Lisa* to Francis I, 1909

In the early twentieth century, the French author, novelist, playwright, journalist and historian Edouard Henri Georges Toudouze (1877–1972), who wrote under several pseudonyms, including Georges-Gustave Toudouze and Georges-G. Toudouze, collaborated with the illustrator, etcher, lithographer, caricaturist and novelist Albert Robida (1848–1926). One of the books they produced was for children, a history of King Francis I, entitled *François Ier: Le Roi Chevalier* (Francis I: the Knightly King). From start to finish, the book was magnificently illustrated.

Robida was born in Compiègne, in northern France. He studied to become a notary, but realized that he was more interested in caricature, and he edited and published *La Caricature* magazine for 12 years. He also illustrated tourist guides, works of popular history and literary classics, and this print shows how skilful he was. Set presumably in Amboise, traditional French buildings surround the figures in the foreground. The king reposes on a chair, surveying the portrait of Mona Lisa that Leonardo holds in front of him, while members of the court gather round. Using artistic licence, Robida has made the *Mona Lisa* look larger than it really is.

LOCATION

Private Collection

MEDIUM

Colour lithograph

ARTIST

Albert Robida (1848–1926)

Portrait of a Lady with a Unicorn, *c.* 1506

Raphael was 31 years younger than Leonardo. The son of a painter, he grew up in the city of Urbino, ruled by the da Montefeltro family. There, Raphael learned of the celebrated artist and engineer, Leonardo da Vinci. From 1504 to 1508, Raphael spent time in Florence, studying the work of other artists and witnessing Leonardo and Michelangelo's preparations for *The Battle of Anghiari* and *The Battle of Cascina* in the Salone dei Cinquecento (Hall of the Five Hundred) in the Palazzo Vecchio. It is likely that Leonardo and Raphael met and that Raphael visited Leonardo's workshop. With its realism, sfumato and figures that integrate with their surroundings, Leonardo's art was unlike anything that Raphael had seen. While in Florence, he painted several works, but two portraits in particular show his knowledge of the *Mona Lisa*: the *Portrait of Maddalena Doni* (1506) and this work. The unknown sitter, pyramidal composition, three-quarter length format, sitter's pose, secret smile, landscape background, arm positions and the edges of the columns of the loggia being used to frame the image, all echo elements of the *Mona Lisa*.

LOCATION

Galleria Borghese, Rome, Italy

CREATED

Painted in Rome

MEDIUM

Oil on panel, transferred to canvas

ARTIST

Raphael (1483–1520)

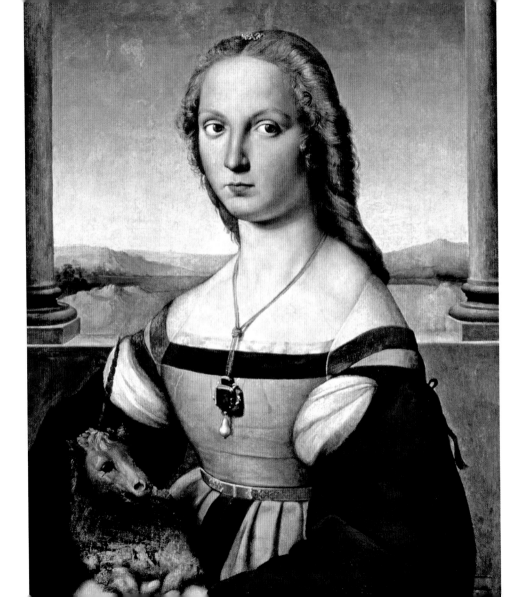

The School of Athens, 1509–11

By 1508, Raphael was 25 and had established his reputation. He received his first commission for a Florentine altarpiece and towards the end of the year, soon after Michelangelo, he was called to Rome to work for the pope on the decoration of some apartments in the Vatican Apostolic Palace. The following year, he began painting four frescoes in the Stanza della Segnatura, a room where the pope signed and sealed important documents.

Rather than creating traditional allegories, on one wall he painted a huge scene in which the greatest thinkers and philosophers of history are gathered together in a large, classical architectural setting. He based the architecture on the remains of the Basilica of Constantine in the Roman forum and Bramante's vision for the new St Peter's Basilica. He included portraits of some of the greatest contemporary artists and architects for some of the figures, including Leonardo as Plato, who was one of the most revered philosophers at that time. He stands in the centre, under the arch, pointing up to the sky and holding his book *Timaeus* in his other hand.

LOCATION

Apostolic Palace, Vatican, Rome, Italy

CREATED

Painted in Rome

MEDIUM

Fresco

ARTIST

Raphael (1483–1520)

The Sistine Madonna, 1513

While in Florence, Raphael had also copied one of Leonardo's cartoons of the standing *Leda and the Swan*, which is evidence that he had seen Leonardo's original version. The triangular composition, soft facial expressions and gentle chiaroscuro demonstrate how much of an influence Leonardo remained to him. This was one of Raphael's last Madonna paintings before his untimely death. It was believed that the Benedictine abbey church of San Sisto (St Sixtus) in Piacenza held the relics of Pope Sixtus II and St Barbara, and this painting was installed on the high altar of the church.

In a stage-like setting, the figures stand on a bed of clouds, framed by heavy curtains. The barefoot Madonna holds the Christ Child, wrapped in the veil of her dress, close to her cheek, and both look directly at the congregation. St Sixtus looks up at her while pointing outwardly to the faithful, and St Barbara looks down at two winged putti who rest on their arms while looking up, close to the tiara of the former Pope Sixtus II on the painting's frame.

LOCATION

Gemäldegalerie Alte Meister, Dresden, Germany

CREATED

Painted in Rome

MEDIUM

Oil on canvas

ARTIST

Raphael (1483–1520)

The Transfiguration, c. 1519–20

This was Raphael's last painting. Originally commissioned for a cathedral in France, it was subsequently kept in Rome after his untimely death. Illustrating two episodes from the Gospel of Matthew – the Transfiguration of Jesus and the Miracle of the Possessed Boy – Jesus floats in an aura of light and clouds, flanked by Moses and Elijah. The raised hands of the crowd below seem to be pointing up at Jesus, although they are part of another story. The kneeling woman in the front was described by Vasari as 'the principal figure in the panel'. Her contrapposto pose, in which her shoulders and hips twist in opposite directions, was a direct influence from Leonardo's *Leda*, which Raphael had copied while in Florence. Raphael featured similar figures in other works.

He may have heard of Leonardo's death in France in 1519, but Raphael's own death the following year at only 37 was unexpected and shocking. Pope Leo X was said to be 'sunk in measureless grief'. Raphael's body was laid in state at the Vatican and this painting was carried before him in the funeral procession.

LOCATION

Pinacoteca Vaticana, Rome, Italy

CREATED

Painted in Rome

MEDIUM

Oil on panel

ARTIST

Raphael (1483–1520)

The Pietà, *c.* 1542

© Private Collection/Photo © Christie's Images/Bridgeman Images

Most remembered now for his *Lives of the Most Excellent Painters, Sculptors and Architects*, Giorgio Vasari was also a painter and architect. He was highly respected for his paintings, and had many prominent patrons in Florence and Rome, including members of the Medici family. This work was commissioned by the pope's banker, Bindo Altoviti (1491–1557).

Vasari stayed with Altoviti from the autumn of 1542 until the following summer at his Roman palazzo, where he painted this *Pietà*, blending Christian and mythological elements. He wrote: 'I went to Rome, where having been received by the above-named Messer Bindo with many kindnesses, I painted for him a picture in oils a Christ the size of life, taken down from the Cross and laid on the ground at the feet of His Mother; with Phoebus in the air obscuring the face of the Sun, and Diana that of the Moon. In the landscape, all darkened by that gloom, some rocky mountains, shaken by the earthquake that was caused by the passion of the Saviour, are seen shivered into pieces, and certain dead bodies are seen rising again.'

LOCATION

Private Collection

CREATED

Painted in Rome

MEDIUM

Oil on canvas

ARTIST

Giorgio Vasari (1511–74)

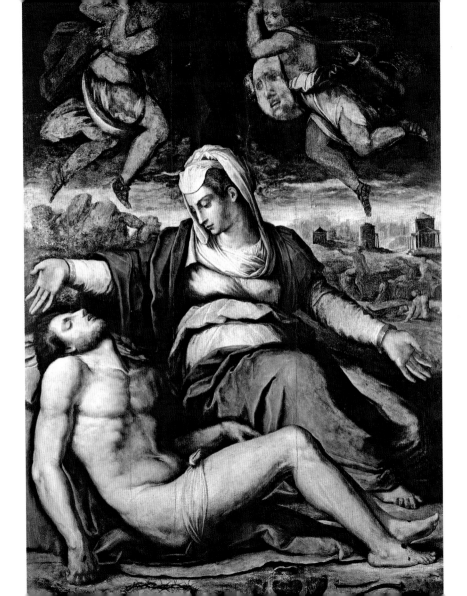

251

Presentation of Jesus at the Temple, 1544

Although Vasari had no first-hand knowledge of Leonardo, as he was born and grew up in Arezzo, and was only 11 years old when Leonardo died, he knew people who knew him, possibly including his cousin, the painter Luca Signorelli (c. 1450–1523), who was a contemporary of Leonardo's and who was in Florence when Leonardo was in Verrocchio's workshop. As well as writing his *Lives of the Most Excellent Painters, Sculptors and Architects*, Vasari was a painter and architect, and among several prestigious works, he designed the Uffizi in Florence, which was built as offices for the Tuscan government.

Painted for the high altar of the Sant'Anna dei Lombardi, also known as Santa Maria di Monte Oliveto, in Naples, this painting is based on a woodcut of the *Presentation of the Virgin* (c. 1503) by Albrecht Dürer. In the second edition of his *Lives* published in 1568, Vasari added an extra section praising Dürer's prints. Although his painting style uses firmer contours and darker tonal contrasts than Leonardo's, the poses and gestures here can be seen to have been influenced by Leonardo's painting style.

LOCATION

Museo di Capodimonte, Naples, Italy

CREATED

Painted in Naples

MEDIUM

Oil on canvas

ARTIST

Giorgio Vasari (1511–74)

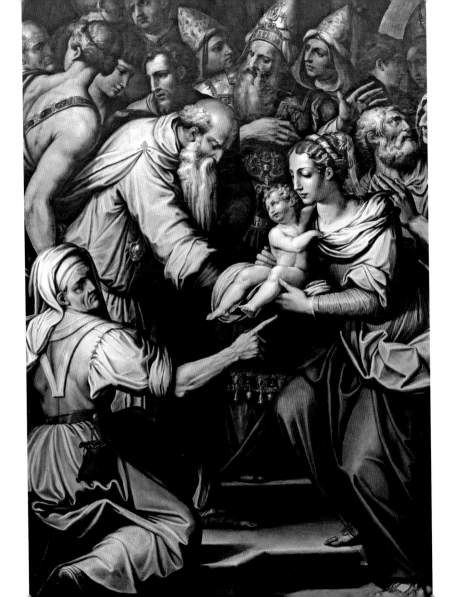

Perseus and Andromeda, 1570–72

During his lifetime, Vasari was famous for his architectural works and his paintings, and admired because he could complete commissions quickly. From 1570–75, with the monk Vincenzo Borghini (1515–80), he designed a *studiolo* – or small study – in the Palazzo Vecchio for Francesco de' Medici (1541–87), the Second Grand Duke of Tuscany. The room was part of the duke's private apartments and accessible only from his bedroom, and as it was built specifically to house precious belongings, including valuable heirlooms, it was designed to resemble a giant jewel box. The ceilings and walls were decorated profusely and cabinets were built into the walls behind oval paintings that form the doors to the cabinets. Borghini arranged each side of the *studiolo* to be devoted to one of the four natural elements: earth, water, fire and air.

This painting of the mythological story of Perseus and Andromeda is on the water side of the room. It shows Perseus freeing Andromeda, who had been tied to a rock and left for a sea monster to devour her. Perseus kills the monster with Medusa's head and his sword.

LOCATION

Palazzo Vecchio, Florence, Italy

CREATED

Painted in Florence

MEDIUM

Oil on slate

ARTIST

Giorgio Vasari (1511–74)

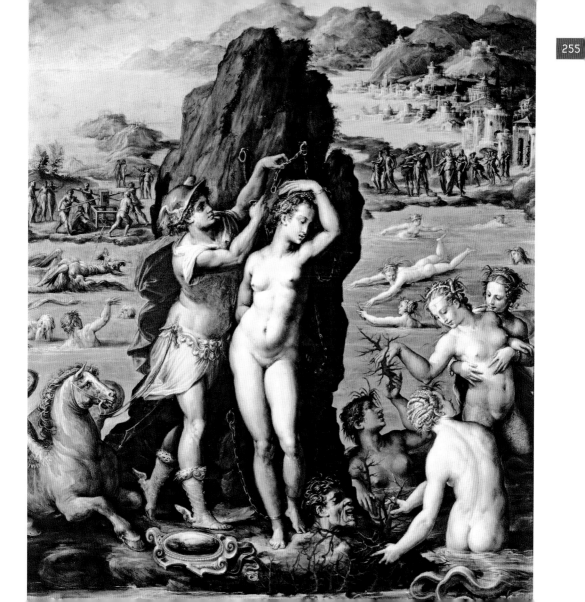

The Last Judgement, 1572–79

During the Renaissance, churches were designed to represent heaven on earth, so vaults – or the interiors of domes – were often painted to represent the sky, featuring various spiritual scenes and holy figures. Brunelleschi had intended the vault of his dome to be painted gold, but by 1572, over 120 years after his death, it was still only whitewashed. Then Cosimo de' Medici commissioned Vasari to paint it. Vasari planned a representation of the Last Judgement, but he died within two years, after completing just a third of the work. Two years later, Federico Zuccaro (c. 1540/41–1609) took over the project, and completed it in 1579. Corresponding to elements of the Bible, Vasari divided the vault into eight sections, which were filled with figures, including the elders of the Apocalypse; angels holding instruments of the Passion; saints; personifications of the gifts of the Holy Spirit; and Jesus between the Madonna and St John. Zuccaro did not follow Vasari's method of *buon fresco*, preferring *fresco secco*, a technique he learned for theatrical backdrops. He also modified the figures and colours, and as he did so, losing Vasari's Leonardo-inspired subtlety.

LOCATION

Duomo, Florence, Italy

CREATED

Painted in Florence

MEDIUM

Fresco

ARTIST

Giorgio Vasari (1511–74) and Federico Zuccaro (c. 1540/41–1609)

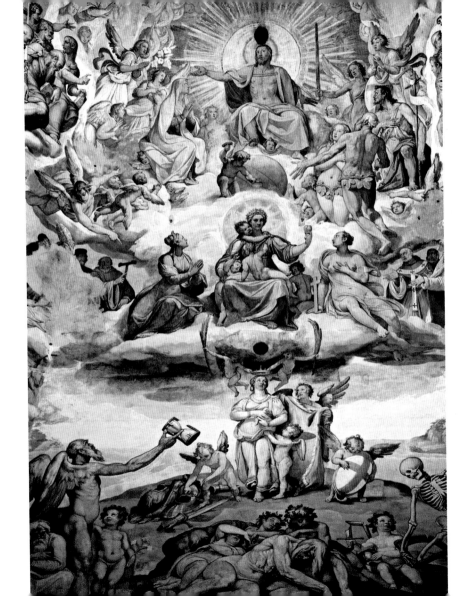

Virgin and Child, *c.* 1514–16

Often described as one of Leonardo's 'disciples' and as one of the Leonardeschi because his style was so influenced by Leonardo, Bernardino Luini (*c.* 1480–*c.* 1532) became the most famous Milanese painter of the early sixteenth century. Little is known about his life, and it is not clear whether or not he was a pupil of Leonardo's, but he worked with him and followed his style so closely that many of Luini's works were later attributed to Leonardo. He worked in Milan and other parts of Lombardy, and many of his paintings closely emulate Leonardo's compositions, use of chiaroscuro and his graceful female figures with gentle faces. This painting of the Madonna and Child, with the Child holding a flower derives directly from Leonardo's *The Madonna of the Carnation* (*see* page 38). Luini painted it in fresco on the wall of the monastery complex in Pavia, the Certosa di Pavia. In 1510, Leonardo was in Pavia with Marcantonio della Torre conducting dissections at the University of Pavia. It may be that Luini was there with them, although this work is usually dated a little later.

LOCATION

Certosa di Pavia, Italy

CREATED

Painted in Pavia

MEDIUM

Fresco

ARTIST

Bernardino Luini (*c.* 1480–*c.* 1532)

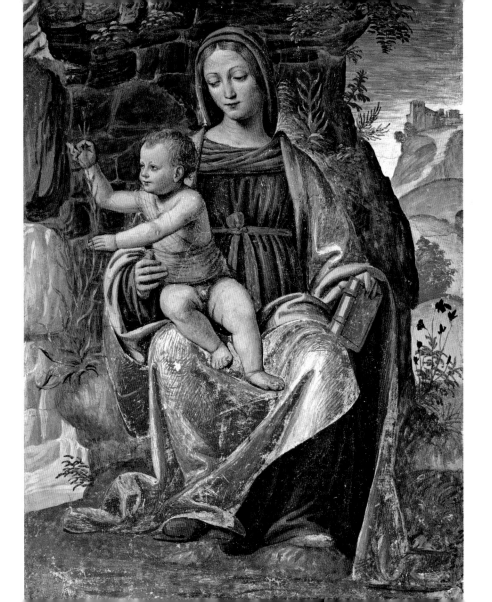

The Adoration of the Magi, *c.* 1520–25

Set against a stage-like setting, this traditional biblical subject has been depicted in an enclosed composition. The Virgin Mary is sitting with the Christ Child standing on her lap, raising his hand in blessing to the three Magi who are paying homage to him and bearing gifts. Behind the Virgin Mary and Jesus is a light-haired, pale-skinned Joseph, while seen through the stable window in the background on a hill are many animals and figures, all coming to the stable to greet the Child. The gentle expressions, soft light and tonal contrasts can be seen to have derived directly from Leonardo's style, while the sixteenth-century costumes and the representations of Gaspar, Melchior and Balthazar adhere to traditional depictions of the story at that time. However, the colours, austerity of elements of the composition, the rigidity of the poses and placement of each figure is harsher and less naturalistic than in Leonardo's paintings. This is one of three frescoes that Luini painted on the walls of the Litta villa, the home of the noble Milanese family, for whom the *Litta Madonna* was painted (*see* page 102).

LOCATION

Musée du Louvre, Paris, France

CREATED

Painted in Milan

MEDIUM

Fresco

ARTIST

Bernardino Luini (*c.* 1480–*c.* 1532)

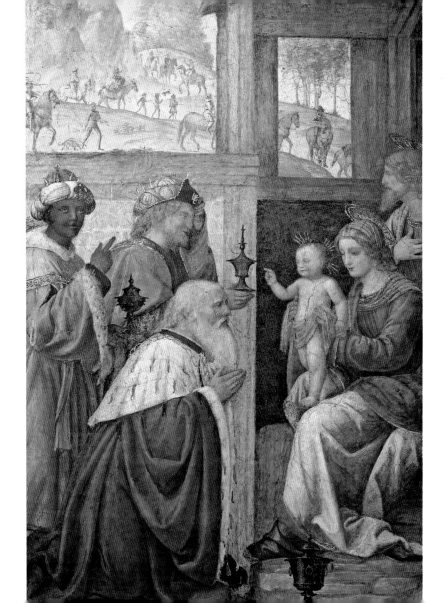

The Young Bacchus, *c.* 1598

Approximately 60 years after Leonardo was last there, Michelangelo Merisi de Caravaggio (1571–1610) was born in Milan. Five years later, to escape the plague, his family moved to Caravaggio where his father worked. From 1584, Caravaggio (he was not known by his name, Michelangelo) was apprenticed for four years to the Milanese artist Simone Peterzano (*c.* 1535–99) who had studied with Titian, and in 1592 he left Milan for Rome where he entered the workshop of the Mannerist painter Giuseppe Cesare, called Cavaliere d'Arpino (1568–1640). Although he denied it, from his earliest paintings Caravaggio shows a familiarity with Leonardo's work, as well as Luini's. He probably saw Leonardo's *The Last Supper* in Milan (*see* page 302) and perhaps other works by him, as well as several by Luini and other Leonardeschi, as the traditions established by Leonardo were proudly continued in Lombardy.

This painting is one of Caravaggio's early works. At that time he painted several half-length portraits, and here he demonstrates all he learned in painting naturalistic still lifes, with Arpino in particular. In 1595 he had joined the household of Cardinal Francesco Maria del Monte (1549–1627) who probably commissioned the work.

LOCATION

Galleria degli Uffizi, Florence, Italy

CREATED

Painted in Rome

MEDIUM

Oil on canvas

ARTIST

Caravaggio (1571–1610)

The Supper at Emmaus, 1601

When he first began his career in Rome at del Monte's court, Caravaggio did not follow Leonardo's serene style, as so many other Lombardian artists had but the positions and gestures of his figures are nonetheless evidence of Leonardo's legacy. In Rome there was plenty of work for artists to decorate the many new churches and palazzos. In addition, the Church was seeking ways of promoting Catholicism to challenge the threat of Protestantism. Caravaggio's response was to exaggerate Leonardo's sfumato into dramatic chiaroscuro and theatrical compositions.

Once again, here, as in the last painting, Caravaggio has created a detailed and lifelike still life. Depicting the story of the meal taken by Jesus and two of his apostles at Emmaus after his resurrection, this is the moment when two of his apostles realise who he is. The Bible story relates '... he took bread, and blessed it, and brake and gave to them. And their eyes were opened, and they knew him; and he vanished out of their sight'. Caravaggio portrays Christ at the moment he blesses the bread and so reveals his identity.

LOCATION

National Gallery, London, UK

CREATED

Painted in Rome

MEDIUM

Oil and tempera on canvas

ARTIST

Caravaggio (1571–1610)

The Death of the Virgin, 1601–05/06

Although Caravaggio declared that he was influenced by no other artist, and despite their apparent differences in some ways, his style can be seen to have been influenced by Leonardo. This was the largest painting that Caravaggio had yet produced. Commissioned for the church of Santa Maria della Scala in Rome, it was ultimately rejected by the monks who were horrified by it. The Virgin Mary lies on a bed in a red dress, a thin halo revealing her holiness. Her arms fall to the side, her swollen body and legs suggest a recent illness. Surrounding her in shadow and grief are her son's apostles. The elderly man on the left could be St Peter and kneeling at his side is perhaps St John. The woman in despair in the foreground could be Mary Magdalene. The monks disapproved of Caravaggio's handling of a holy subject, including his use of a prostitute as the model for the Virgin, her exposed legs and swollen body, and because this seems to be an ordinary death, with no hint of the traditional Catholic celebration of Mary's assumption into heaven.

LOCATION

Musée du Louvre, Paris, France

CREATED

Painted in Rome

MEDIUM

Oil on canvas

ARTIST

Caravaggio (1571–1610)

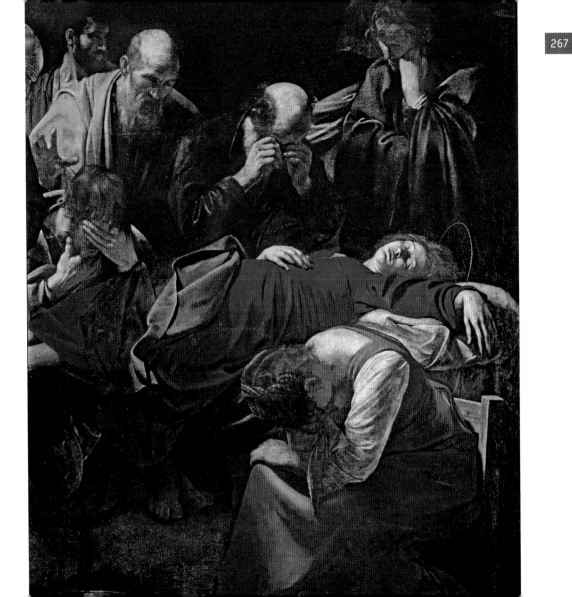

The Battle for the Standard (After Leonardo), *c.* 1603

The only time that Leonardo and Michelangelo worked together in the same room was in 1505 when they were preparing their battle paintings for the Hall of the Five Hundred. Leonardo kept his preparatory drawings for the work that would have been filled with horses and men fighting. Vasari described one of his drawings: '... rage, fury and vindictiveness are displayed both by the men and by the horses.... It is impossible to convey the fine draughtsmanship ... incredible skill he demonstrated in the shape and features of the horses, which Leonardo, better than any other master, created with their boldness, muscles and graceful beauty.' Leonardo built a scaffold in the Hall that could be raised or folded down for ease of painting and began painting in oils rather than fresco, but in the end, he did not finish the painting, and it is now lost.

A century later, Peter Paul Rubens (1577–1640), a huge admirer of Leonardo, made this powerful drawing from an engraving of 1553 by the artist Lorenzo Zacchia (1524–87) that was either taken from Leonardo's actual painting or from one of his cartoons. Rubens appears to have captured the fury, emotion and sense of power that Vasari described.

LOCATION

Musée du Louvre, Paris, France

MEDIUM

Oil on canvas

ARTIST

Peter Paul Rubens (1577–1640)

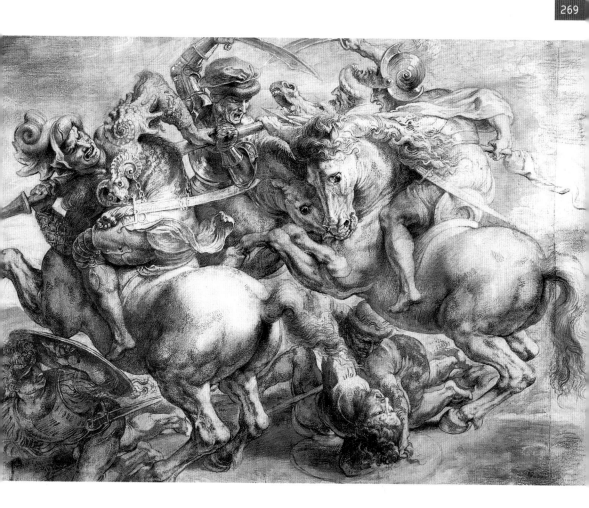

Samson and Delilah, *c.* 1609

Known for his dramatic portraits, landscapes, altarpieces and historical, mythological and allegorical scenes, Rubens painted dynamic, colourful and sensuous images.

As a Catholic, Rubens often painted religiously inspired works. He began his career at the age of 13 as a page to a countess, and at 14 he entered an artists' workshop as an apprentice. After studying with three different artists, in 1600 he travelled to Italy where he remained for nine years, and became especially inspired by the painting styles of Titian, Caravaggio, Michelangelo, Raphael and Leonardo. After returning to Belgium in 1609, he was appointed court painter to Albert VII, Archduke of Austria and Infanta Clara Eugenia (1566–1633), and his circle of patrons and friends expanded. This painting was commissioned by one of these friends, the alderman Nicolaas Rockox (1560–1640) for his home. From the Old Testament, it depicts the story of Samson's fatal passion for Delilah and how she betrays him by cutting off the source of his strength – his hair. Overall, the work shows the influence of Italian paintings, in particular that of Michelangelo, Caravaggio, Titian and Leonardo's light touch, fluid lines and sense of animation.

LOCATION

National Gallery, London, UK

CREATED

Painted in Antwerp

MEDIUM

Oil on panel

ARTIST

Peter Paul Rubens (1577–1640)

Battle of the Amazons, 1615

In Greek mythology, Amazonomachy was a battle between the ancient Greeks and the Amazons, a mythical race of warrior women in Asia Minor. The Amazons were portrayed as savage and barbaric, while the Greeks were civilized. Crowded with figures and action, this painting is based on aspects of Leonardo's *The Battle of Anghiari*, full of furious energy, foreshortening, swirling lines, colour, and exacting, accurate detail. Although a question remains as to whether the work was painted by Rubens or Anthony van Dyck (1599–1641), it demonstrates both artists' skills and their great admiration of Leonardo. Within the thrusting, lively composition, figures and horse are hurled together, apart and on top of each other as the raging battle ensues. Men, women and horses attack, twist, rear and fall. The Amazons are hurled from their horses down into the river at the base of the picture, while a horse rears up towards the upper frame, and the wounded fall into the background. Despite the many clear similarities with the *The Battle of Anghiari*, however, this almost chaotic, highly theatrical composition is more dramatic Baroque than naturalistic Renaissance.

LOCATION

Alte Pinakothek, Munich, Germany

MEDIUM

Oil on panel

ARTIST

Peter Paul Rubens (1577–1640) or Anthony van Dyck (1599–1641)

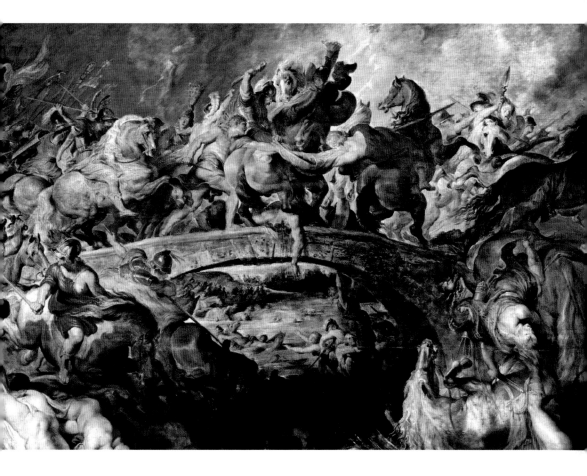

The Three Graces, *c.* 1630–35

Rubens painted this theme several times during his life, and this late work especially emphasizes his admiration of the art of ancient Greece and Rome, which had been such an influence on Italian Renaissance art. The three nude figures form a circle, one with her back to viewers. They represent the three Graces from Greek and Roman mythology, emulating Botticelli's depiction in *Primavera* (1477–82) that Rubens would have seen in Florence. The Graces were minor goddesses who spread happiness, and Rubens's figures in a landscape beside a fountain, under a garland of flowers represent charm, beauty, temptation, virtue and fertility. His choice of subject and its treatment shows how much the influences of the Italian Renaissance remained with Rubens for the whole of his career, for as well as Botticelli the painting shows influences of Michelangelo and Leonardo. Leonardo's investigations into the natural world and anatomy inspired many later artists, and this work continues that precedent. The soft tonal contrasts also recall elements of Leonardo's sfumato style that has been described as 'blending light and shadow without trait or sign, like smoke'.

LOCATION

Museo del Prado, Madrid, Spain

CREATED

Painted in Antwerp

MEDIUM

Oil on oak panel

ARTIST

Peter Paul Rubens (1577–1640)

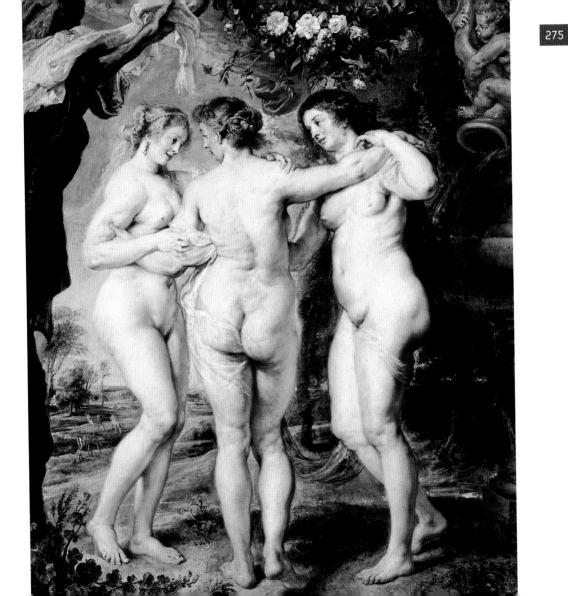

Leonardo da Vinci

Styles & Techniques

The Baptism of Christ by John the Baptist, 1473–75

© Galleria degli Uffizi, Florence, Italy/Bridgeman Images

A clear example of the way in which artists and assistants collaborated in Verrocchio's workshop, this painting is made up of different styles, as it was painted by more than one artist. The composition was Verrocchio's, and he began painting it with tempera. Then Leonardo added the kneeling angel at the far left with curling hair, as well as the landscape background. He also painted over the figure of Christ with an oil paint glaze. Compared with the figure of St John the Baptist, Jesus is more delicately modelled, conveying a greater sense of realism. Leonardo had spent a lot of his apprenticeship learning to paint draped fabrics, and the angel's clothing shows that he had learned his lessons well. Botticelli may have painted the right-hand angel. Close inspection reveals the delicate flicks of the brush and curves that create Leonardo's angel's curls that later became a characteristic aspect of his style, along with landscape backgrounds. The painting was sold as Verrocchio's, which was usual when assistants worked on artworks, although unusually, it was documented that Leonardo painted an angel in the image.

LOCATION

Galleria degli Uffizi, Florence, Italy

CREATED

Painted in Florence

MEDIUM

Oil and tempera on wood

ARTIST

Andrea del Verrocchio (c. 1435–88), with Leonardo da Vinci (1452–1519) and possibly Sandro Botticelli (c. 1445–1510)

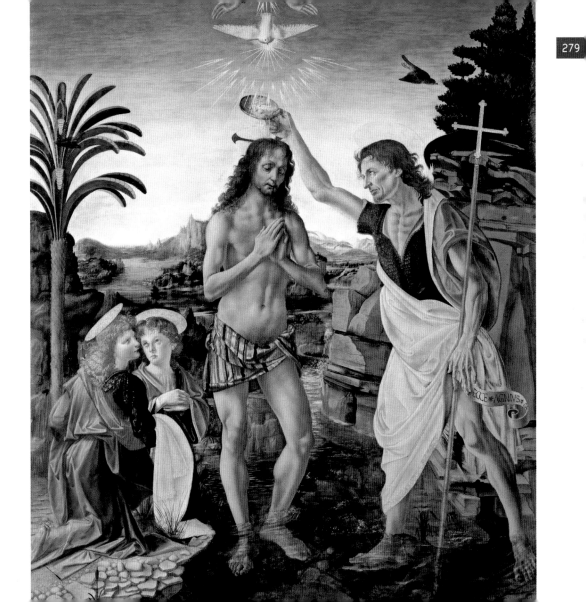

Female Head, *c.* 1516–17

© Gallerie dell'Accademia, Venice, Italy/Alinari Archives, Florence, Italy/Bridgeman Images

Profoundly influenced by Leonardo, Cesare da Sesto is usually classed as one of his 'disciples' or Leonardeschi. Although he did not study with Leonardo, da Sesto would have learned to draw initially from another master and then with Leonardo in his studio, although he also spent time with Raphael in Rome. Little is known about his early artistic education, but his drawings and paintings reveal a close understanding of Leonardo's themes, style and expression. About drawing, Leonardo wrote of 'becoming like a mirror', as one looked, judged and then reproduced the subject, which needed to be done rapidly before the image was forgotten; despite often not finishing commissions, Leonardo could draw quickly. He taught his apprentices and assistants thoroughly and wrote down many of his theories for them and future generations, such as when drawing faces: '... for ... the expression of a face, first make yourself familiar with a variety of ... heads, eyes, noses, mouths, chins and cheeks and necks and shoulders: And to put a case: Noses are of 10 types: straight, bulbous, hollow, prominent above or below the middle, aquiline, regular, flat, round or pointed.'

LOCATION

Gallerie dell'Accademia, Venice, Italy

CREATED

Drawn in Naples

MEDIUM

Sanguine on red prepared paper

ARTIST

Cesare da Sesto (1477–1523)

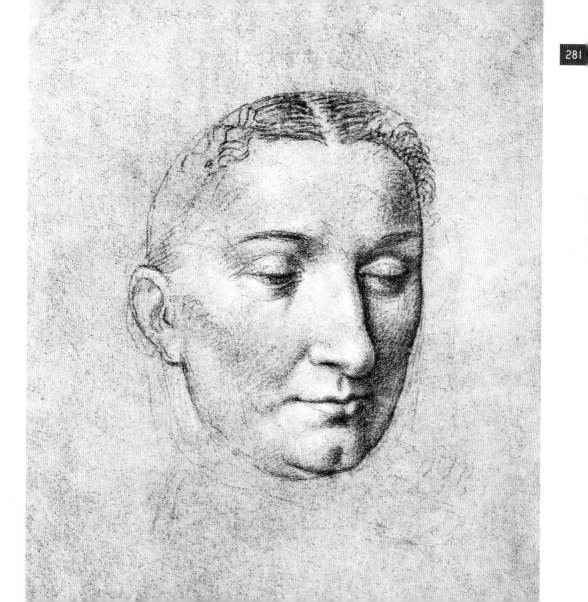

Heraldic Emblem of Ludovico il Moro (detail), 1498–99

In the 1450s, Francesco Sforza reconstructed a fourteenth-century castle in Milan, and in the late 1490s Ludovico commissioned Leonardo to paint the Sala delle Asse, a large vaulted room. Since his earliest years working as an artist, Leonardo had drawn many designs of knots and intertwined elements. Even his drawing for *Leda* (*see* page 286) had intricately braided and woven hair. So his creation of the mulberry tree design in the Sala delle Asse was an extension of this preference, with the branches forming various knot patterns. The thick canopy of entwined branches rises from 16 tree trunks along the walls, across the ceiling and around the central coat of arms of Ludovico Sforza and his wife Beatrice d'Este. As an acute observer of nature, Leonardo's rendition of the mulberry tree is lifelike, while the emblems are contrastingly graphic. The snake in the upper part of the Sforza emblem is the 'vipera' that was aligned with the Moors and Ottoman Turks, as the *Montivipera xanthina* is a venomous species of viper found in north-eastern Greece and Turkey. It was adopted by Ludovico, 'Il Moro' as part of the coats of arms of the House of Sforza.

LOCATION

Sala delle Asse, Sforza Castle, Milan, Italy

CREATED

Painted in Milan

MEDIUM

Tempera on plaster

PERIOD

Middle period

The Virgin of the Rocks, 1483–86

Set in a rocky landscape are the Virgin Mary, Jesus and St John the Baptist. This was the central part of a polyptych, commissioned by the Brotherhood of the Immaculate Conception for a chapel in the church of San Francesco Grande in Milan. The first major painting that Leonardo is known to have painted in Milan, it can be seen to develop from his earliest works, with its pyramidal composition, gestures and diffused light, and many of his followers emulated its style.

Leonardo's innovations were extensive for the time, as he moved away from established Renaissance imagery. For instance, he includes his own symbolism: the angel's hand pointing between the space formed by the Virgin's hand and Christ's head, creating a cross. All the figures interact through gestures and glances; the angel glances at the viewer while pointing to St John, who looks at Jesus. Then there is the mysterious background that contrasts with the plain gold backgrounds of earlier altarpieces. As they recede, forms become less distinct, conveying the effects of aerial perspective, while depth and solidity are shown through sfumato and perspective.

LOCATION

Musée du Louvre, Paris, France

CREATED

Painted in Milan

MEDIUM

Oil on wood transferred to canvas

PERIOD

Early period

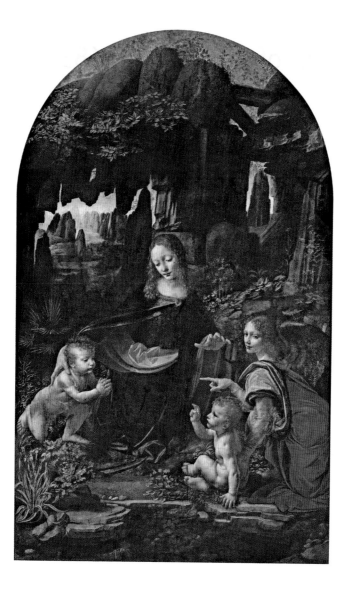

Studies for the Head of Leda, c. 1505—06

A three-quarter profile drawing of the head of a woman looking down with elaborate braids in coils over her ears, this is a study for Leonardo's lost painting of *Leda and the Swan*. He worked on two versions of the subject, one in which Leda kneels, the other in which she stands, and eventually executed a painting of the standing version that was subsequently destroyed.

Here Leonardo gives his female model a demure downward glance that he used for many of his Madonnas, and concentrates on her intricate hairstyle. Using his anatomical knowledge, as well as observations of women's hair, he created this softly drawn, sensitive page of studies, developing lifelike imagery in pen and ink with some softer areas in chalk. He probably invented the hairstyle to suit the image he had in mind for the painting. He began using these curving, dynamic hatched lines that follow the contours of elements in his drawings from around 1500. Previously his hatched lines were predominantly straight. Always fascinated by water, he wrote that the wisps and curling, straying strands imitate water in circular motion.

LOCATION

Royal Collection Trust, Windsor Castle, UK

CREATED

Drawn in Milan

MEDIUM

Pen and ink and chalk on paper

PERIOD

Middle period

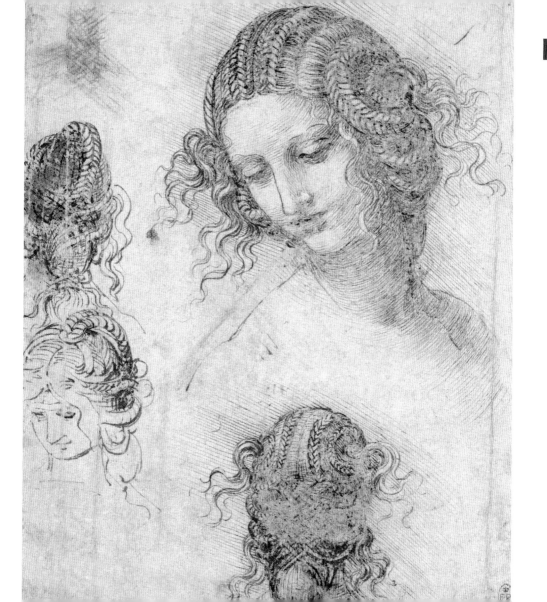

Drawing of a Duck in Flight

Ink was an important drawing material during the Renaissance, applied with a quill pen, which enabled artists to draw quickly using different marks, capturing movement and energy and recording fine details. Maso Finiguerra often worked with ink as here, and the addition of watersoluble paint to convey realism. He created this precisely drawn duck in flight long before a photograph could capture it and his accuracy is remarkable. Graphite pencils were not invented until 1564, the year in which Finiguerra died, so he and other artists, including Leonardo used a point of silver or other metal in a wooden holder, known as silverpoint or metalpoint. To make a mark, the artist or an assistant would cover the paper with a rough material such as bone ash, rabbit-skin glue and coloured ground pigment. Powdery, hard, dry materials that they used to draw softer elements are usually referred to as chalks even though they were not all, strictly chalk. For instance, artists' black drawing material was a form of carbon-rich clay, which was applied then smudged with the fingers. The paper Finiguerra and Leonardo used was made from good quality mashed linen fibres.

LOCATION

Galleria degli Uffizi, Florence, Italy

MEDIUM

Pen and ink with watercolour on white paper

ARTIST

Maso Tommasoii Finiguerra (1426–1464)

Dancing Women, *c.* 1515

Conveying a remarkable sense of movement, this drawing expresses the rhythm of the women's gestures through their dishevelled hair, swirling dresses and twirling bodies. They are dancing in the open air and the wind has caught the hems of their gowns. Their positions resemble those of ancient works of sculpture and also recall Leonardo's studies of water and other elements in his plant and landscape drawings.

This drawing may have been one of his studies for a painting he planned, or it may have been taken from an observation of one or more women dancing, but overall the work shows his remarkable skill with pen and ink; some lines are faint, others are bolder, and despite quills being notoriously scratchy and difficult to handle, Leonardo was able to vary the width and density of his lines. This drawing is an example of how he selected only the barest information he needed; what he omitted actually strengthens the image. He was also sparing with tonal contrasts. Unlike Caravaggio, for instance, Leonardo rarely used the darkest tones, as most of his imagery features only light to mid-tones, as here.

LOCATION

Gallerie dell'Accademia, Venice, Italy

CREATED

Drawn in Rome

MEDIUM

Pen and ink on paper turned yellow and preserved

PERIOD

Late period

Flora, 1517–21

Until the nineteenth century, this work was believed to have been painted by Leonardo. There are two known copies of it, and it is possible that Francesco Melzi painted it in France, either while Leonardo was still alive or soon after his death. The model resembles the Virgin in *The Virgin and Child with St Anne, and the Infant St John the Baptist* that Leonardo drew *c.* 1499–1500 (*see* page 64). The young woman's demure expression and the precise details, including the delicate flowers and draped clothing, closely follow Leonardo's painting style. The painting also resembles Melzi's *Pomona and Vertumnus* of 1517–20 in the Staatliche Museen, Berlin.

The subject here appears to be Flora, the ancient Roman goddess of vegetation, included by Botticelli in his 1477–82 painting *Primavera*. The flowers are all symbolic: the delicate jasmine in Flora's right hand represents lost chastity; the columbine in her left hand and her bare breast on that side both symbolize fertility; and the anemones in her lap suggest a new life. The painting is often alternatively called *Columbine* to emphasize the sitter's fertility.

LOCATION

State Hermitage Museum, St Petersburg, Russia

CREATED

Possibly painted in Amboise

MEDIUM

Oil on panel

ARTIST

Francesco Melzi (1491–*c.* 1570)

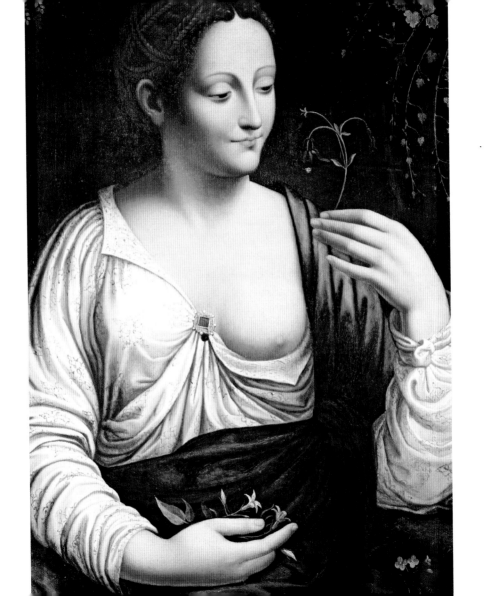

Head and Shoulders of a Christ Figure, c. 1490–95

With an expression of intense suffering on his face, this figure turns to look over his shoulder at viewers. It is a sketch made by Leonardo of Christ carrying the cross as he walked to his Crucifixion. With a minimum of lines and marks, Christ's agony is conveyed as he bears the great weight of the cross. His crown of thorns and long hair and beard are drawn with fluid, sinuous marks as his face shows fear, pain and anguish, all conveyed with a few sensitively applied, expressive lines. Firm lines bring depth to the features, including the eyes, nose, mouth and parts of the hair that contrast with softness in other parts of the drawing, emphasizing the most expressive parts of the face.

In the early and middle periods of his career, Leonardo often used metalpoint for drawings, as here, but later he found the fluidity of pen and ink more versatile. With both materials, he uses subtle, gestural lines to create dynamism, rhythm and interest. Metalpoint was first used by artists during the fourteenth century and soon became particularly popular in Italy.

LOCATION

Gallerie dell'Accademia, Venice, Italy

CREATED

Drawn in Milan

MEDIUM

Metalpoint on grey prepared paper

PERIOD

Middle period

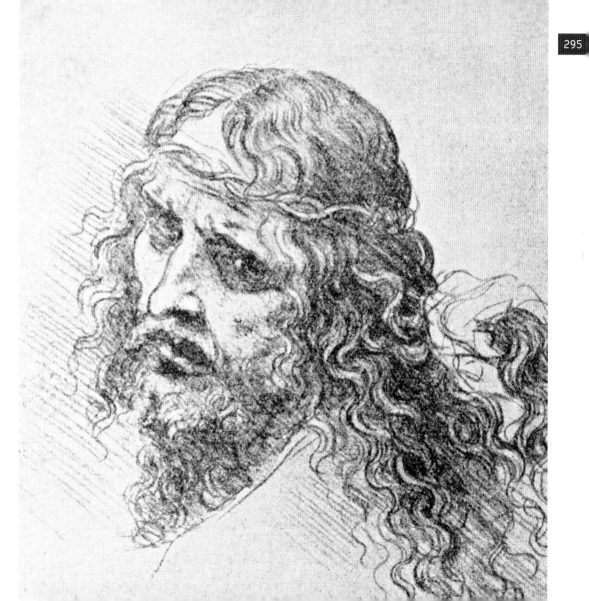

Allegory with a Wolf and an Eagle, *c.* 1516

A carefully depicted image from Leonardo's later years, this drawing has no accompanying notes, so various interpretations have formed about it. Some believe that it is an allegory about river navigation, which fascinated Leonardo, and he often spent time studying the waterways around Florence and Rome. Others insist that it has a political meaning, that the boat represents the Church, with the wolf helmsman representing Pope Leo X who is heading for the imperial eagle, or King Francis I wearing a crown displaying the fleur-de-lys of France. Others suggest that the boat represents Fortune, being moved without control and affected by the forces of nature. Instead of a mast, the ship has an olive tree. The wolf has his right paw on a compass while his left paw holds the tiller. The compass points at the eagle that stands on a globe of the world, resting on the shore, and a rocky landscape forms the background. The chalk used here contained iron oxide, which gave it its red colour. It allowed Leonardo to make both firm lines and soft tonal gradations.

LOCATION

Royal Collection Trust, Windsor Castle, UK

CREATED

Drawn in Milan

MEDIUM

Red chalk on brown-grey prepared paper

PERIOD

Late period

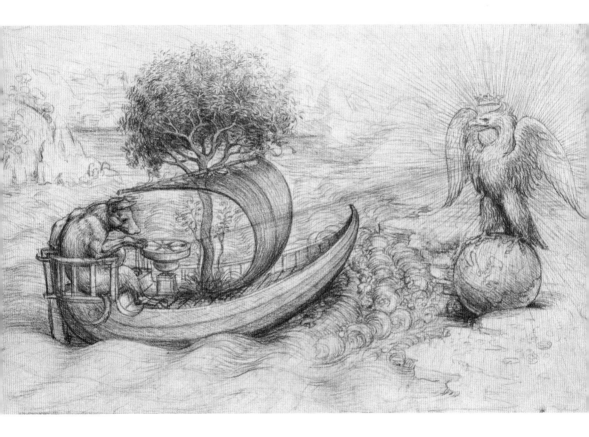

Sketch of a Roaring Lion, *c.* 1515–17

The Palazzo Vecchio, the town hall of Florence, was originally called the Palazzo della Signoria, and then various other names over its history. When Cosimo de' Medici took control of Florence in 1434, he had many elaborate rooms created within and around the building, including the Lion House in which he kept a menagerie of lions that he brought out for festivals and other celebrations. In his notes, Leonardo recalls the Room of the Lions behind the Palazzo Vecchio, so he was familiar with them, and during his career he created at least one mechanical lion for festivities. For instance, on 1 October 1517, the Mantuan ambassador to France reported attending a festival in the town of Argentan, 193 km (120 mi) west of Paris, where he witnessed a spectacular festival featuring a mechanical lion designed by Leonardo that walked several steps. When the king struck the lion with a 'magic wand', it opened to reveal a white fleur-de-lys – the symbol of France – in the lion's chest. This lively drawing may have been made by one of Leonardo's assistants at that time.

LOCATION

Musée Bonnat, Bayonne, France

CREATED

Possibly drawn in Amboise

MEDIUM

Red chalk on paper

PERIOD

Late period

ARTIST

Follower of Leonardo da Vinci

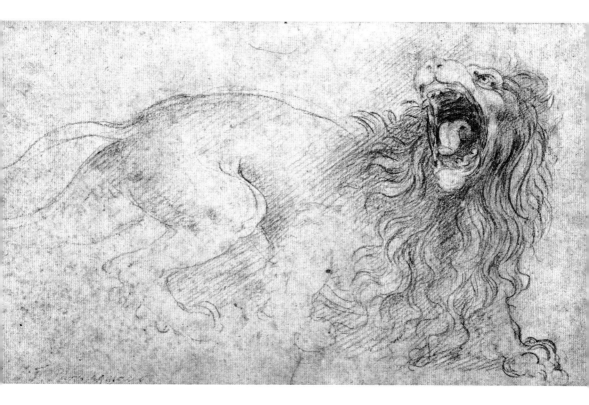

The Annunciation, *c.* 1472

One of Leonardo's earliest paintings, created when he was working in Verrocchio's studio, this was probably painted for the monastery of San Bartolomeo at Monte Oliveto, in the hills south-west of Florence. Many Christians observe the Feast of the Annunciation on 25 March and it was a common subject in European art.

By the Renaissance, most of the great masters had painted a version of the story. In the foreground, the angel Gabriel kneels before Mary, offering her a lily, while she raises a hand in astonishment at seeing him. She is pale and elegant, with slender fingers and delicate golden curls beneath her halo. Traditionally depicted as a scholar, she was reading when the angel interrupted her. She sits by a grand house, but in the open air. The angel's wings are based on those of a huge bird of prey, and both wear the garments of wealthy fifteenth century citizens. In the background, a small town nestles in front of towering mountains, while boats sail on a vast lake. In the middle distance, dark, stylized trees create a sense of depth.

LOCATION

Galleria degli Uffizi, Florence, Italy

CREATED

Painted in Florence

MEDIUM

Oil and tempera on panel

PERIOD

Early period

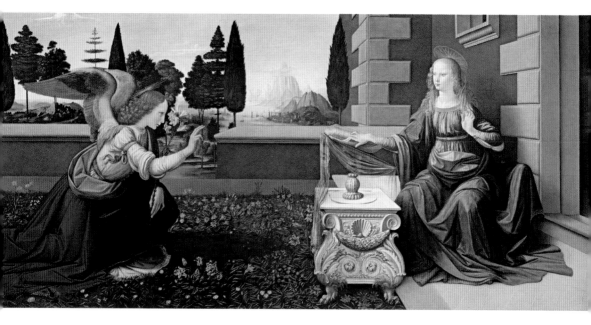

Study for the Infant Christ, *c.* 1501–10

One of Leonardo's drawings that can be linked to a painting, these preparatory sketches were made by him for *The Virgin and Child with St Anne* (*c.* 1503–19). Through the pyramidal composition, he created close interactions between the figures. Clearly based on life, this baby has been closely observed. With so many much younger half-siblings and patrons with children, Leonardo had plenty of first-hand experience of babies and his naturalism was quite unusual, with few artists portraying babies and children so realistically. In addition, these sketches display his interest in creating focal points of action with each figure.

For Leonardo, chalk was essential for this kind of preparation, as he used it to work out figures and their positions, as well as their values. He worked out many alternatives for the composition, and using this image of Christ, created a final black chalk drawing – or cartoon – which his assistants pricked, then held it on the prepared poplar board to be used for the painting and dusted over a pouch filled with black chalk that filtered through the pricked holes, creating the outline.

LOCATION

Gallerie dell'Accademia, Venice, Italy

CREATED

Drawn in Florence

MEDIUM

Red chalk and white heightening on reddish prepared paper

PERIOD

Middle to Late periods

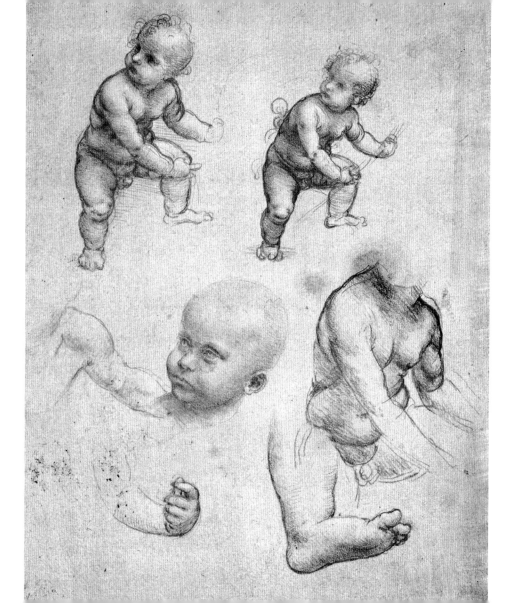

Portrait of Isabella d'Este, 1499–1500

After Leonardo left Milan in December 1499, he stopped in Mantua for several weeks as the special guest of the Marchioness, Isabella d'Este. She had written to Leonardo in Milan the year before to let him know that she would like him to paint a portrait of her. So while he was staying with her in Mantua, he began preparing her portrait. This is thought to be a sketch for the painting; the shoulders are in three-quarter view and the head in profile. The pose was possibly the choice of Isabella herself.

By March 1500, Leonardo had left Mantua and was in Venice, where the musical instrument-maker Lorenzo da Pavia (d. 1517) wrote to Isabella saying: '... here in Venice is Leonardo da Vinci, who has shown me the portrait of Your Ladyship, which is very true to nature and beautifully done.' This is evidence that Leonardo had at least started the painted portrait, but either lost or later abandoned it. In this sketch, he used black, red and ochre chalk, applied with delicate lines as well as hatched and smudged marks.

LOCATION

Musée du Louvre, Paris, France

CREATED

Drawn in Mantua

MEDIUM

Black, red and ochre chalk on paper

PERIOD

Middle period

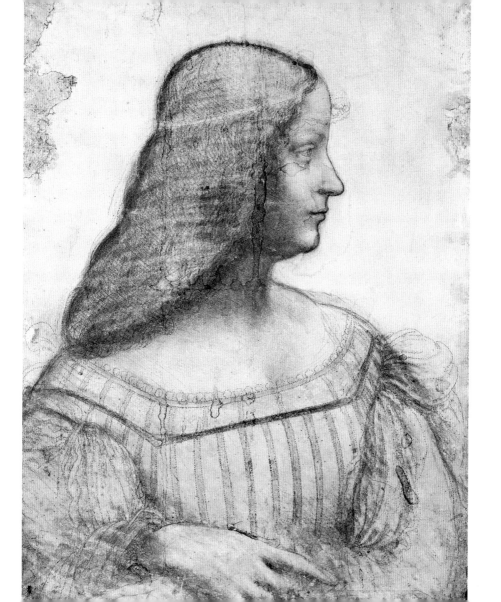

Perspective Study for the Background of *The Adoration of the Magi, c. 1481*

This preparatory study for *The Adoration of the Magi* includes tiers of steps in the foreground, emphasized by touches of white that draw the viewer into the space. Striking for its detail, the drawing was constructed by Leonardo following the theories of linear perspective that Brunelleschi had introduced in *c.* 1415, as well as the *c.* 1474–78 book *De prospectiva pingendi* (On the Perspective of Painting) by Piero della Francesca. He had been taught to represent linear perspective by Verrocchio, which had the effect of making the viewer believe they were looking into another world, but it was still relatively new. The guidelines from the bottom of the picture towards the vanishing point can still be seen. Leonardo then drew a plan of the buildings, finally animating the scene with human figures and animals. To transfer the drawing on to his larger wooden panel, he used a millimetre ruler, a pointed stylus and fine threads. Some differences can be observed between the preparatory drawing and the final painting of *The Adoration of the Magi*. For one, Leonardo moved the viewpoint, compressing the background space.

LOCATION

Galleria degli Uffizi, Florence, Italy

CREATED

Drawn in Florence

MEDIUM

Pen and ink on paper, water coloured-brown ink and white lead with metalpoint traces on light brown paper

PERIOD

Early period

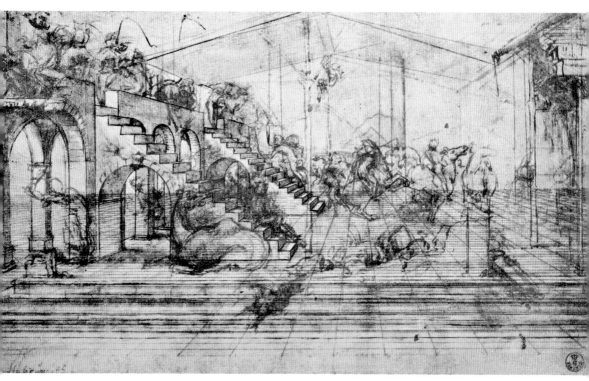

Study of the Heads of Two Soldiers, 1504

Although neither the wall painting nor the cartoon of *The Battle of Anghiari* have survived, various other accounts of the image, preparatory drawings and sketches, plus copies by other artists (such as the painting by Rubens on pages 268–69) remain. This is one of Leonardo's preparatory studies for the section of the battle that he did paint; the *Fight for the Standard*, a central scene of four men riding war horses engaged in a battle for possession of a standard.

These sketches are of the young Florentine nobleman, Pietro Giampaolo Orsini (d. 1443) as he is about to wrench the standard from the Milanese condottiero Niccolò Piccinino (1386–1444). The largest head drawn in three-quarter view represents Piccolo Cappuccino. Clearly captured from direct observation of live models, the drawing conveys his anger as he screams in the effort of holding on to the standard. When Leonardo began this painting towards the end of 1504, he used an unusual technique of his own invention: rather than fresco, he painted with oil paints and wax – a method that dried erratically and was ultimately unsuccessful.

LOCATION

Szépum vészeti Múzeum, Budapest, Hungary

CREATED

Drawn in Florence

MEDIUM

Black and red chalk over metalpoint

PERIOD

Middle period

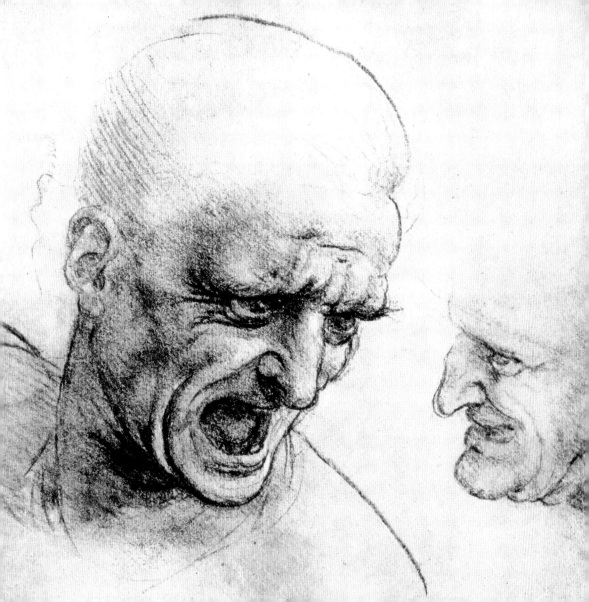

Cats, Lions and a Dragon, *c.* 1513–18

Filled with close studies taken directly from life of fleeting movements, this sheet features more than 20 drawings of cats and a lioness in a variety of positions; sleeping, fighting, sitting, stalking, washing, playing and startled, with an arched back and fur standing on end. In the midst of all this, drawn diagonally between them in the lower half of the sheet, is a study of a dragon, with a curling tail and twisting neck. These carefully observed studies are lightly drawn with characteristic sensitivity and empathy. Leonardo was familiar with domestic cats and also with the lions that were kept behind the Palazzo Vecchio (*see* page 298). Acutely observed, the animals are captured with tiny broken marks to show outlines, twisting, curving spines, tails, textures, expression, movement and tonal ranges. Leonardo also created a similar sheet of horses and a dragon. At the bottom of this sheet, he wrote: 'This animal species, of which the lion is the prince because of its spinal column which is flexible....' These drawings were intended for a treatise he planned on 'the movements of animals with four feet'.

LOCATION

Royal Collection Trust, Windsor Castle, UK

CREATED

Drawn in Rome or Amboise

MEDIUM

Pen and ink with wash over black chalk

PERIOD

Late period

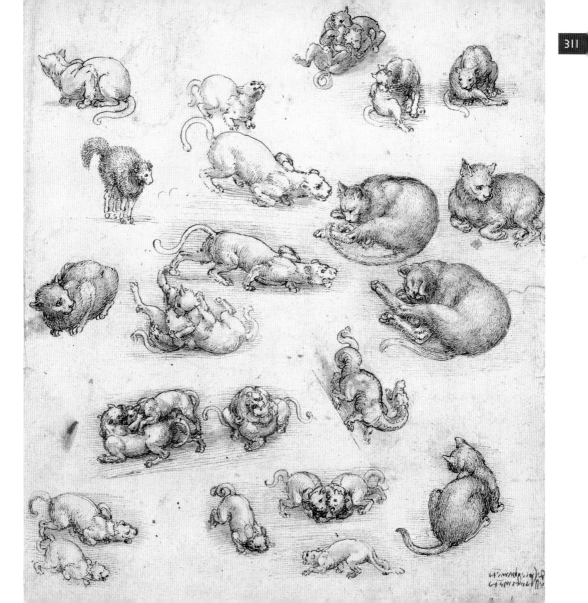

Four Grotesque Heads, including a Caricature of Dante, *c.* 1517–20

To draw the human face, Leonardo advised young artists to select and combine the best features of the people they see around them. In a similar way, he drew caricatures, exaggerating and combining prominent features, such as a bulbous nose with a protruding chin, or shaggy eyebrows with fleshy lips. He began producing these grotesque faces – that contrasted with his demure angels and Madonnas – in pen and ink during the 1490s. Vasari wrote: 'He was always fascinated when he saw a man of striking appearance, with a strange head of hair or beard.'

This sheet of caricatured heads is probably a copy by Melzi of some of Leonardo's earlier drawings. At the top right is a female in profile with a receding chin and bulging head, facing a grotesque man with a fringe, snub nose and large chin. At the lower right is a caricature of Dante grinning foolishly at an old woman in a hat. His hand is on her waist, so she is probably meant to be Beatrice, his true love. These were among the first ever caricatures and they were widely copied.

LOCATION

Royal Collection Trust, Windsor Castle, UK

CREATED

Possibly drawn in Amboise

MEDIUM

Chalk on paper

ARTIST

After Leonardo (attributed to Francesco Melzi, 1491–*c.* 1570)

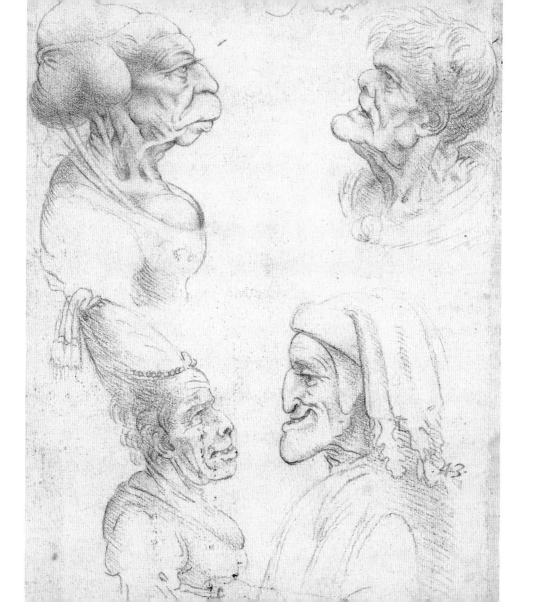

313

Man Leaning on a Staff, *c.* 1500–01

A nude man facing left leans forward against a staff that he holds by his left shoulder. Although this was originally ascribed to Tarantino (*c.* 1456–*c.* 1530) who worked as a painter and architect in Milan and was profoundly influenced by Leonardo, more recently experts believe that it is probably by Francesco Gallic, known as Francesco Napoletano (1470–1501) who was one of Leonardo's most gifted pupils in the 1490s. One of the Leonardeschi, Napoletano worked in the Milanese bottega with Boltraffio, Marco, de' Conti, Solario and Salaì. However, little is known about him and his life except that he died of the plague at the age of 30, leaving a wife and two young children. Subsequently, only a few works are attributed to him. Another suggestion is that the drawing may be by Giovanni Francesco Caroto (1480–1555), a Veronese artist who became influenced by Leonardo after spending some time in Milan. The strong modelling of the limbs with extremely dark tones and white highlights convey solidity, and the formations of the muscles seem to have been directly inspired by Leonardo's drawings informed by investigations into anatomy.

LOCATION

Biblioteca Ambrosiana, Milan, Italy

CREATED

Possibly drawn in Milan

MEDIUM

Silverpoint on light-blue paper

ARTIST

Attributed to Francesco Napoletano (1470–1501) or Francesco Caroto (1480–1555)

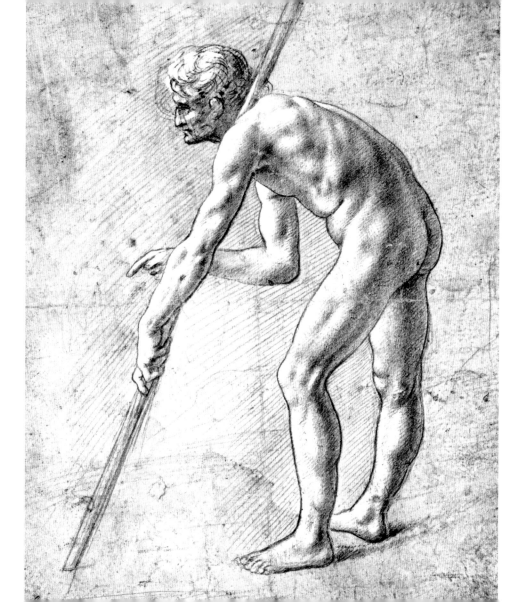

Hercules and the Nemean Lion, *c.* 1504–08

During Leonardo's apprenticeship, Verrocchio was inundated with commissions for sculpture, and Leonardo learned comprehensive skills of carving and using bronze. (Vasari testified to his skills in Verrocchio's workshop, *see* page 17). Although Leonardo is known to have made sculpture independently in his early years and several works by him have been described, nothing has been verified as his, and neither the huge, bronze equestrian statue for Francesco Sforza nor a later monument for the aristocrat and condottiero Gian Giacomo Trivulzio (1440/1–1518) that he designed from 1506–11, were brought to completion.

This drawing was related to a plan Leonardo had for another large-scale sculpture that he never executed. He was planning a bronze of the mythological story of Hercules and the Nemean Lion, at the same time as he was working on the cartoon for *The Battle of Anghiari*. This is Hercules from the back, with the lion at his feet. There were also other drawings from different angles. Leonardo was moving back and forth between Milan and Florence when he was planning this sculpture, but experts believe that it was for a Florentine patron.

LOCATION

Biblioteca Reale di Torino, Piedmont, Italy

CREATED

Drawn in Florence

MEDIUM

Black chalk or charcoal on paper, incised for transfer

PERIOD

Middle period

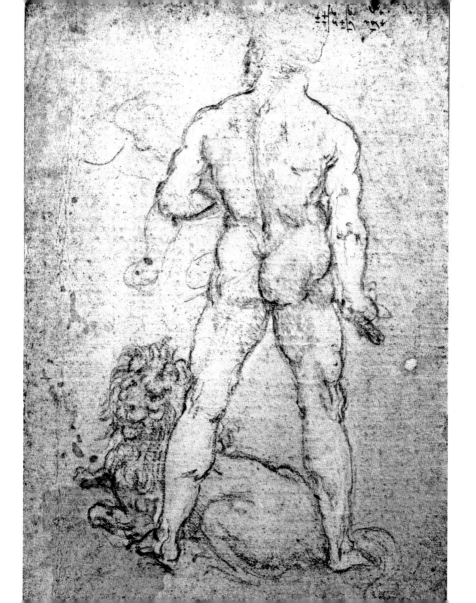

Neptune, *c.* 1504–05

This energetic image is of Neptune, the god of the sea, holding a trident aloft in one hand, his body in Leonardo's frequently used contrapposto position, steering his lively seahorses with his other hand. Within the maelstrom of thundering horses and surging water are fish tails and hidden faces. Vasari recounts that Leonardo created an image of Neptune for his good friend, the Florentine banker Antonio Segni, who had been the director of the papal mint since 1495: 'Leonardo drew on a sheet of paper a Neptune, executed with such fine draughtsmanship and diligence that it was utterly convincing. In this picture could be seen the restless ocean and Neptune's chariot drawn by seahorses and the sprites, the sea monsters and the winds.' This drawing, however, is not Segni's picture, but it is probably a preliminary drawing for it. Leonardo may have been inspired by a relief he saw in Florence and his picture of Neptune – either this or Segni's version – inspired Raphael's fresco *Triumph of Galatea* that he painted in the Villa Farnesina in Rome in 1514.

LOCATION

Royal Collection Trust, Windsor Castle, UK

CREATED

Drawn in Florence

MEDIUM

Chalk on paper

PERIOD

Middle period

The Last Supper, 1495–98

© Santa Maria delle Grazie, Milan, Italy/Bridgeman Images

The largest of Leonardo's paintings, this fresco took him about three years to complete. Before he began the painting, as with all his commissions he produced extensive notes and preparatory drawings. Although it is painted in a form of fresco, it is not a traditional method. *Buon fresco* uses water, egg and pigment on damp plastered walls. *Fresco secco* is water, egg and pigment on dry plastered walls.

Here, Leonardo began with the traditional fresco method of a freshly plastered wall to which was applied an *intonaco*, or thin layer of plaster, then a layer of gesso, then one of lead white and finally an experimental oil-based medium that dried more slowly than normal fresco. This gave him time to consider the work and to gradually build up soft tonal contrasts. However, this refectory wall was fairly damp, and as soon as it was finished, the paint surface quickly deteriorated. To create the one-point perspective of the scene, Leonardo made a slight hole on Christ's temple with a nail to mark the vanishing point. Each figure's gesture and pose convey his individual thoughts.

LOCATION

Santa Maria delle Grazie, Milan, Italy

CREATED

Painted in Milan

MEDIUM

Fresco

PERIOD

Middle period

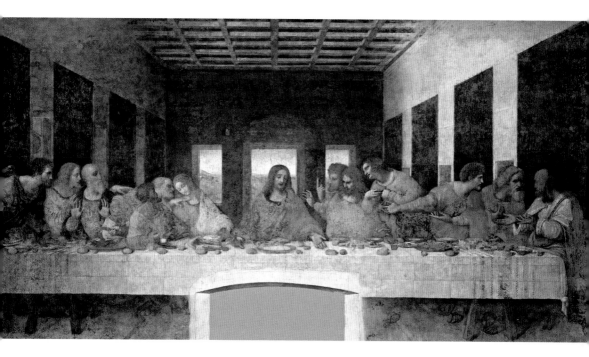

Preparatory Drawing for
The Last Supper, c. 1494–95

© Gallerie dell'Accademia, Venice, Italy/Bridgeman Images

Drawn by one of Leonardo's students, this portrays the moment when Jesus announces his imminent betrayal. Leonardo was also making many preliminary drawings for his commission to paint *The Last Supper* at this time and the back-to-front or mirror writing proves that he also used this sheet of paper. There was no traditional, established composition for the subject, so Leonardo could be innovative in his approach and he encouraged his students to be similarly creative. In this loosely drawn sketch, Jesus and the apostles are sitting at two separate tables. Jesus is speaking, and next to him St John is prostrating himself in despair. Judas, the one who will betray Jesus, is isolated, sitting on the opposite side of the table. Philip in the front has his hand on his chest, as if declaring it will not be him. Unlike Leonardo's fresco in the Santa Maria delle Grazie, this image is drawn from a high viewpoint. Also, here the figures are grouped into pairs, except for Jesus and Judas who are on their own. In Leonardo's fresco, they are arranged in groups of three.

LOCATION

Gallerie dell'Accademia, Venice, Italy

CREATED

Drawn in Milan

MEDIUM

Sepia ink on linen paper

ARTIST

Workshop of Leonardo

Four Studies of the Musculature of the Leg, *c.* 1506–08

With the rise of humanism, artists began trying to emulate the real world through their art more than ever, and so the study of bones and muscles was a natural development and became part of an artist's study. Leonardo, however, went deeper. He wanted to know how the body worked as well as how to draw it. As such, over his career, he made many anatomical drawings and performed dissections. He first studied anatomy in the late 1480s, and he was given permission to dissect human corpses at the Ospedale Santa Maria Nuova in Florence, later in Milan at the Ospedale Maggiore and also in Rome at the Ospedale Santo Spirito. From 1510 to 1511 he collaborated in his studies with his friend Marcantonio della Torre. He wrote of his dissections that some medical knowledge was essential 'because of the greatest confusion which arises from the mixture of membranes which are all mingled with veins, arteries, nerves, tendons, muscles, bones and blood'. Most of Leonardo's anatomical drawings have accompanying notes in his 'mirror-writing' (being left-handed, this was quite natural for him).

LOCATION

Royal Collection Trust, Windsor Castle, UK

MEDIUM

Pen and ink with black chalk on paper

PERIOD

Middle period

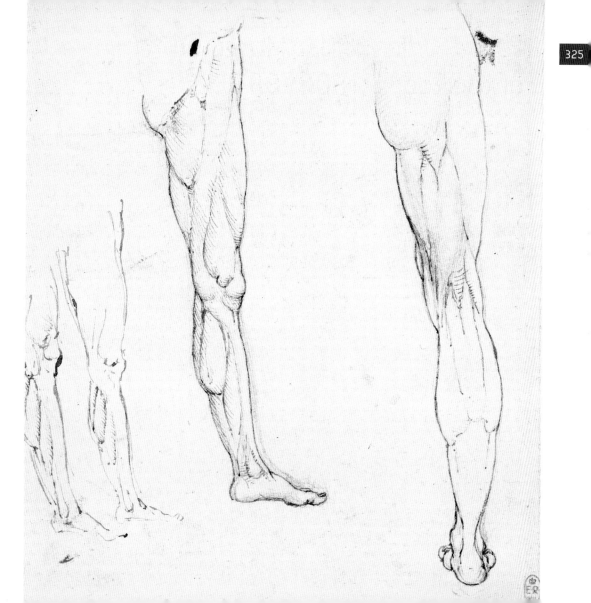

Anatomical Study of a Bear's Foot, c. 1490

Leonardo's early anatomical drawings of the human body in the 1480s relied on what he could learn from external observation, from the Greek anatomist Galen, and also by applying his knowledge of the anatomy of other animals. This is a fairly accurate drawing of the bones, muscles and tendons of a bear's foot. During that time, there was a fashion among many of the ruling families of the Italian city-states to have menageries of exotic animals. Among these were lions and a giraffe in Florence, cheetahs in Ferrara, and an elephant and various other animals in Rome. So it is possible that Leonardo drew the bones, muscles and ligaments of a bear's foot from a dissection (although he did not see any human dissections until the sixteenth century). In his notes next to other anatomical drawings of animals, he wrote: 'I will discourse ... of each animal to show in what way they vary, as in the bear which has the ligatures of the toes joined above the instep.' He intended to publish a treatise on his comparative anatomical studies, but he never completed it.

LOCATION

Royal Collection Trust, Windsor Castle, UK

CREATED

Drawn in Milan

MEDIUM

Pen and brown ink over metalpoint, heightened with white on blue prepared paper

PERIOD

Middle period

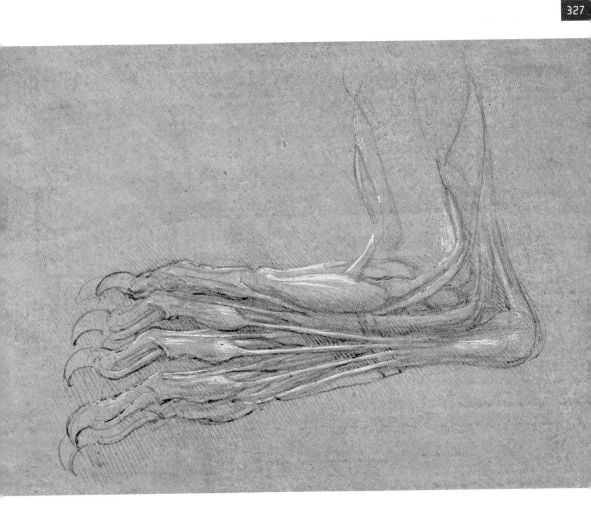

Studies of Hands, *c.* 1481

When looked at with the naked eye, this sheet of paper and another that accompanied it in one of Leonardo's notebooks appears to be completely blank. As other pages in the album were filled with drawings and written notes, historians investigated. They discovered that Leonardo had made drawings on these pages, but they had faded over time and were now invisible to the naked eye because of the high copper content in the stylus that he used. The metallic copper had reacted with the air to become a transparent copper salt and literally appeared to vanish. However, by shining ultraviolet light on the pages, numerous sketches of hands in various poses are revealed.

These elegantly drawn hands with their long, slim, expressive fingers that twist, bend, grasp, curl, point, flex and wave, formed part of Leonardo's preparatory drawings for his *c.* 1481 painting *The Adoration of the Magi* (*see* pages 98–99) that he prepared for the monastery of San Donato a Scopeto in Florence but never completed. Unlike many preceding artists, in his effort to make his art look as lifelike as possible, Leonardo drew from live models.

LOCATION

Royal Collection Trust, Windsor Castle, UK

CREATED

Drawn in Florence

MEDIUM

Metalpoint on pink prepared paper

PERIOD

Early period

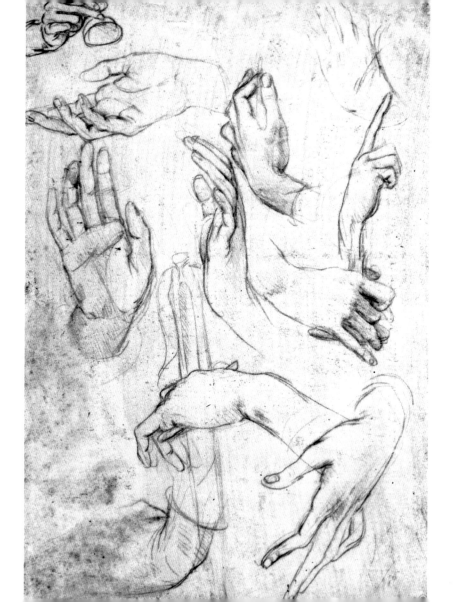

Study of the Head of St Anne, c. 1510–15

For his painting *The Virgin and Child with St Anne* that he worked on from *c.* 1503–19, Leonardo prepared many preliminary works and developed several versions of the composition before executing it. Among a number of changes, he replaced a young St John the Baptist in his first sketch by the Lamb of God, and moved the Infant Jesus from his mother's lap to the ground, making him reach out to the lamb. In another break with tradition, Leonardo gave more importance to St Anne, putting her head at the apex of the pyramidal composition.

This is his study of St Anne's head. At a three-quarter angle and looking down demurely, he drew this with black chalk, dampening the darkest parts of the hair with his characteristic light touch. St Anne was Mary's mother, Christ's grandmother, which is why Leonardo chose to emphasize her loving gaze on the two other figures in the painting. Despite being a grandmother, however, she appears as a young woman, but her position and age meant that she had to cover her head, so Leonardo created an elaborate, twisted headdress.

LOCATION

Royal Collection Trust, Windsor Castle, UK

CREATED

Drawn in Florence

MEDIUM

Black chalk

PERIOD

Late period

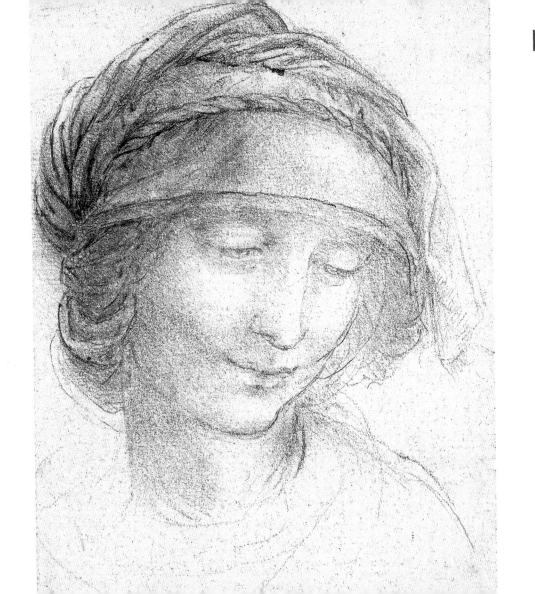

Drapery for a Seated Figure, 15th century

Because signing works of art in the fifteenth century was largely unknown, it is difficult to attribute many works of art created in that period. With most of Leonardo's drawings, his back-to-front or mirror-written notes help to establish his work, but in painted studies such as this, it is less straightforward. Attributions for this work have been given to Albrecht Dürer and Domenico Ghirlandaio, but considering the close resemblance of this image to the skirt worn by the Virgin in his *The Annunciation* (*see* page 300), it is usually attributed to Leonardo as a preparatory work for that painting. However, it also closely resembles the skirt of Ghirlandaio's Madonna in *Madonna and Child Enthroned with Saints*, c. 1483, so it is also often accredited to him.

Painted in tempera on linen, it could have been executed by either a left-handed or right-handed artist, who first coated the linen evenly with a brown or grey preparation, then, using a brush, drew the outlines and areas of shadow in black, gradually building up the tones from dark to light, conveying the hang, fall and volume of the heavy fabric.

LOCATION

Musée du Louvre, Paris, France

CREATED

Probably painted in Florence

MEDIUM

Brush and greyish-brown tempera with white heightening on grey prepared canvas

PERIOD

Early period

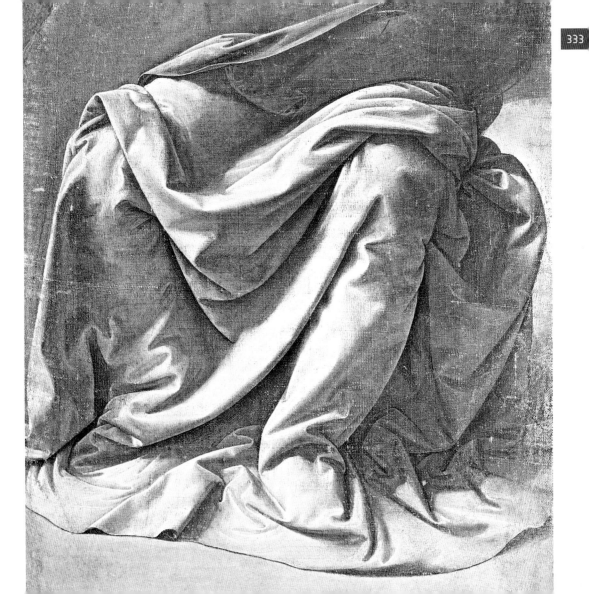

The Head of the Virgin, 1510–13

While the attribution of this softly drawn head is often in question, it follows Leonardo's head of the Virgin in *The Virgin and Child with St Anne*. The amount of overworking on it, however, has made it particularly difficult to substantiate as being by Leonardo, but many of the parallel-hatched marks have been made by a left-handed artist, although further marks by another artist have been layered on top. The misty sfumato technique is especially prominent, with almost imperceptible changes of tonal contrast created through the layering and smudging of soft red and black chalks. Structurally, the delicately curved strokes reveal the sensitive application and technical virtuosity of Leonardo. It could have been one of many preparatory works used to formulate the design of *The Virgin and Child with St Anne*. Some have suggested that it was a *bozzetto* – a small-scale rough draft for the final work – made by Leonardo with later changes and additions by him and perhaps some later touches by Bernardino Luini, who followed Leonardo's innovative technique of drawing with two chalks.

LOCATION

Metropolitan Museum, New York, USA

CREATED

Possibly drawn in Florence

MEDIUM

Black chalk, charcoal, and red chalk, with some traces of white chalk

remains of framing outline in pen and brown ink at upper right (not by Leonardo)

PERIOD

Late period

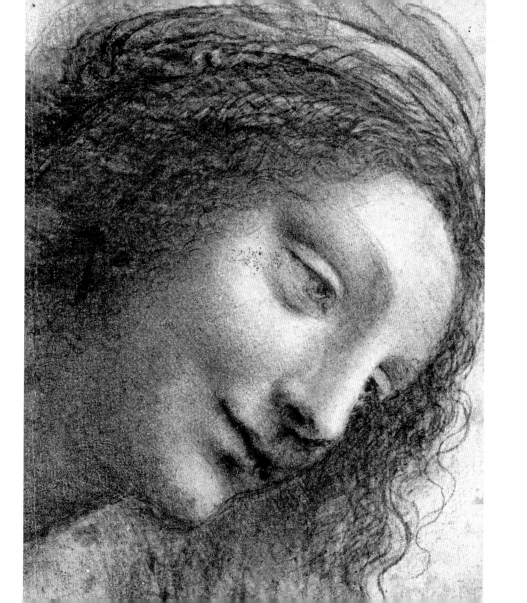

Head of the Madonna, *c.* 1510–15

With a headdress that echoes those in the drawing of St Anne on page 330, and in the painting *The Virgin and Child with St Anne*, this is a study of the Madonna's head in Leonardo's typical three-quarter view and looking down. The veil over her forehead is held in place by a twisted scarf, and this elaborate headdress is the only verified part of the image to have been drawn by Leonardo. The face was worked later by another artist, following Leonardo's style and methods. As in the drawing on the previous page, this has been created with the two-chalk method that Leonardo originated. He worked with chalk increasingly in his later career, and using red (usually called sanguine) and black chalk together in one drawing allowed him to create soft transitions of light and shade with ease. Leonardo began working with sanguine early in his career because it was versatile, could be used effectively to model tones, and was effective not only for life drawing and landscapes, but also for sketches and more detailed drawings. He began using black chalk a few years later.

LOCATION

Royal Collection Trust, Windsor Castle, UK

CREATED

Drawn in Milan or Rome

MEDIUM

Red and black chalk, brush and dilute ink and white heightening on pale red prepared paper

PERIOD

Late period

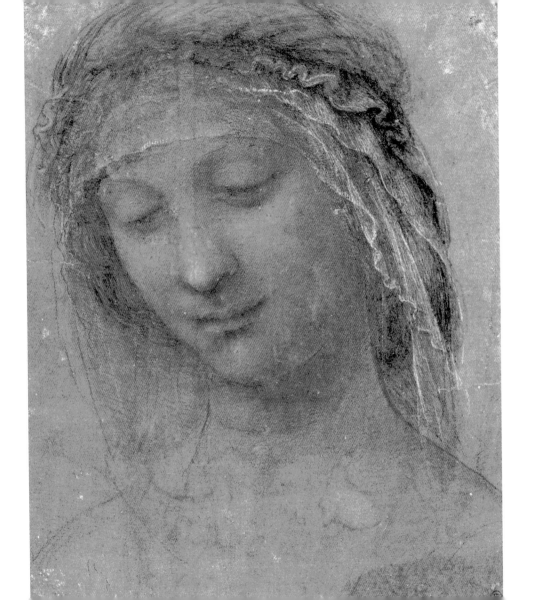

A Branch of Blackberry (Rubus fruticosus) *c.* 1505–10

Perhaps in preparation for his painting *Leda and the Swan*, Leonardo made several studies of branches of blackberry. This drawing is both vigorous and detailed, drawn with the sharpened tip of a piece of red chalk, and conveys a powerful sense of realism. Through his handling of the chalk, he portrays the heavy branches and lightweight fruit and leaves. Leonardo was always fascinated by plants and animals, but after 1502 he drew even more plants in even more detail than before, as he planned his treatise on them. He wrote accompanying notes with many of his plant sketches, although this was one of his more finished drawings that he produced on single sheets, with careful rending of thorns, rough-edged leaves and fruit. For this reason, it is generally believed that this was a preliminary drawing for a finished illustration in the treatise he planned. To create his characteristic range of tones, he worked up gradations of red chalk and then added white heightening to capture the momentary effects of light, which anticipated some later artistic developments by several hundred years.

LOCATION

Royal Collection Trust, Windsor Castle, UK

CREATED

Drawn in Florence

MEDIUM

Red chalk with touches of white heightening on pale red prepared paper

PERIOD

Middle period

Head of a Woman, *c.* 1500

Possibly drawn by one of Leonardo's apprentices, assistants or followers, this work has not been attributed to any particular artist, but it can be seen to have been influenced by the style of the master. The characteristic three-quarter view, the demure downward gaze and some modelling have been used, but the tonal contrasts are not as sensitively gradated as those of Leonardo. In addition, it has been drawn by a right-handed artist. Leonardo wrote: 'It seems to me that a painter shows not inconsiderable grace when he paints his figures well. If he does not possess this grace by nature, he can acquire it ... make an effort to collect the good features from many beautiful faces, but let their beauty be confirmed rather by public renown than by your own judgement.'

This drawing was probably made as a preparatory work for a painting, but no definitive connection has been made, although elements of it – such as the hair and the eyes – compare with the Virgin in the painting known as the *Sforza Altarpiece*, painted in 1494–95 by the Master of the Pala Sforzesca, who was one of Leonardo's Lombard followers.

LOCATION

Musée Bonnat, Bayonne, France

MEDIUM

Metalpoint heightened with gouache

ARTIST

Workshop of Leonardo

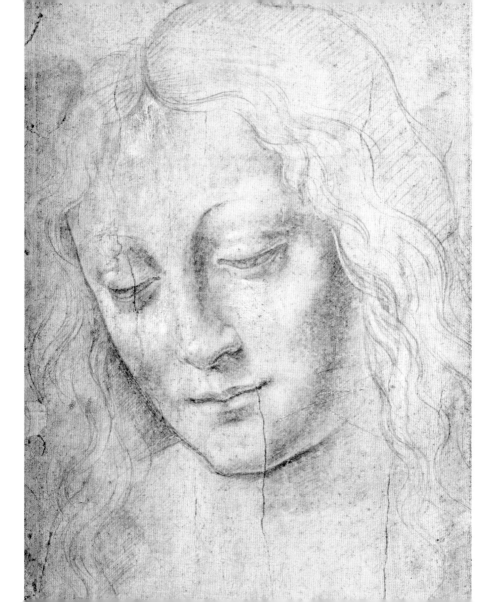

The Muscles of the Shoulder and Arm, and the Bones of the Foot, *c.* 1510–11, The Muscles and Tendons of the Lower Leg and Foot, *c.* 1510–11

© Museo Nazionale della Scienza e della Tecnologia 'Leonardo Da Vinci', Milan, Italy/Tarker/Bridgeman Images

Far in advance of his time, Leonardo's remarkably observed anatomical drawings were without precedent, and it is only since he made these detailed illustrations that images have been used extensively in medical science. On the left-hand sheet here, he shows a dissection of the shoulder muscles, while others explore the shoulder and right arm, and among his detailed notes is a small diagram of the respiratory muscles and the bones of a left foot, plus part of a leg. On the right-hand sheet, he has drawn the arrangement of bones, tendons and muscles in the lower leg and foot. Over his career, Leonardo dissected approximately 30 corpses, and in the earliest biography of him in *c.* 1523–27, Paolo Giovio wrote that he 'dissected the corpses of criminals, undismayed by the brutal and repulsive nature of this study and only eager to learn'. Giovio also wrote that Leonardo intended to publish his studies as a series of copperplate engravings, but at his death in 1519, the drawings remained among his private papers, where they were not seen for approximately four centuries.

LOCATION

Royal Collection Trust, Windsor Castle, UK

CREATED

Drawn in Milan

MEDIUM

Pen, three shades of brown ink and wash over traces of black chalk

PERIOD

Late period

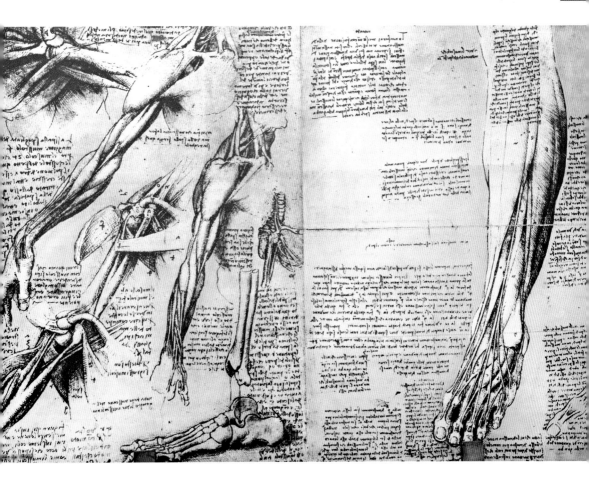

A Skull Sectioned, *c.* 1489

Leonardo's extensive notebooks are testament to his remarkable mind. He not only studied, drew, designed and wrote about an incredible diversity of subjects, he was also astonishingly adept at everything he did. Highly intelligent, thoughtful and skilled, he became an expert in art, mathematics, engineering and architecture, and was also an enlightened inventor and a gifted writer. For his times and for many centuries to follow, his designs and inventions were revolutionary, and although his interests sometimes diversified or became more intense in certain fields, he never lost his inquiring mind and his determination to learn more about the universe and improve the lot of his fellow creatures, justly earning his description of '*l'uomo universale*' or 'Renaissance Man'. Even his weapons that appear to be intent on destruction really aimed for ultimate peace, as he wrote: 'To preserve Nature's chiefest boon, that is freedom.' This drawing is one of hundreds that he made from corpses of humans and other animals that he dissected and is one of the many anatomical structures that were drawn in detail for the first time in medical history.

LOCATION

Royal Collection Trust, London, UK

MEDIUM

Pen and ink over black chalk on paper

PERIOD

Early period

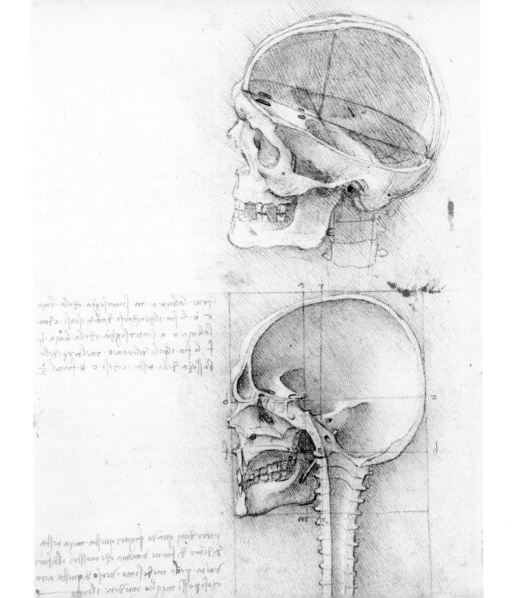

Author Biographies

Susie Hodge (author)

Susie Hodge is an art historian, author and artist with over 120 books published, mainly on art and history. She also writes articles, web resources for museums and galleries, and gives workshops and lectures at schools, universities, museums, galleries, businesses and societies. She often contributes to radio and TV documentaries and has taught in schools and colleges. She has an MA in the History of Art and is a Fellow of the RSA.

Michael Kerrigan (foreword)

Michael Kerrigan is author of *Modern Art* from the 'World's Greatest Art' series and *100 Great Art Masterpieces*, as well as co-author of *The Architecture Style Spotter's Guide* along with a great many other books and articles on art, culture and history. He lives in Edinburgh, where he writes regularly for the *Scotsman* newspaper and is a book reviewer for the *Times Literary Supplement* and the *Guardian*.

Picture Credits: Prelims and Introductory Matter

Further Reading

Anderson, Maxine, *Amazing Leonardo da Vinci Inventions*, 2006

Blatt, Katy, *Leonardo da Vinci and The Virgin of the Rocks*, 2017

Clayton, Martin and Philo, Ron, *Leonardo da Vinci: Anatomist*, 2014

Donnithorne, Alan, *Leonardo da Vinci: A Closer Look*, 2019

Enz, Tammy and Shephard, Dave, *Leonardo da Vinci: A Graphic History of the Renaissance Man*, 2019

Farthing, Stephen, *Leonardo da Vinci: The Anatomical Drawings*, 2019

Galland, Richard, *The Leonardo da Vinci Puzzle Codex*, 2014

Herbert, Janice, *Leonardo da Vinci for Kids: His Life and Ideas*, 1999

Isaacson, Walter, *Leonardo da Vinci: The Biography*, 2017

Kemp, Martin, *Leonardo da Vinci: The 100 Milestones*, 2019

Landrus, Matthew, *Leonardo da Vinci*, 2018

Nicholl, Charles, *Leonardo da Vinci: Flights of the Mind*, 2005

Ormiston, Rosalind, *The Life and Works of Leonardo da Vinci*, 2017

Schumacher, Andreas, *Florence and its Painters*, 2018

Vezzosi, Alessandro, *Leonardo da Vinci: The Complete Paintings in Detail*, 2019

Zollner, Frank and Nathan, Johannes, *Leonardo da Vinci: The Complete Paintings and Drawings*, 2015

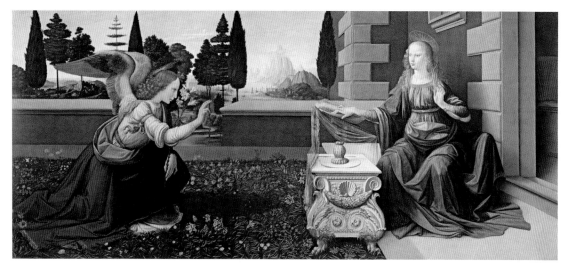

Index by Work

General Index